TURNER **CLASSIC** MOVIES

MUST-SEE
SCI-FI

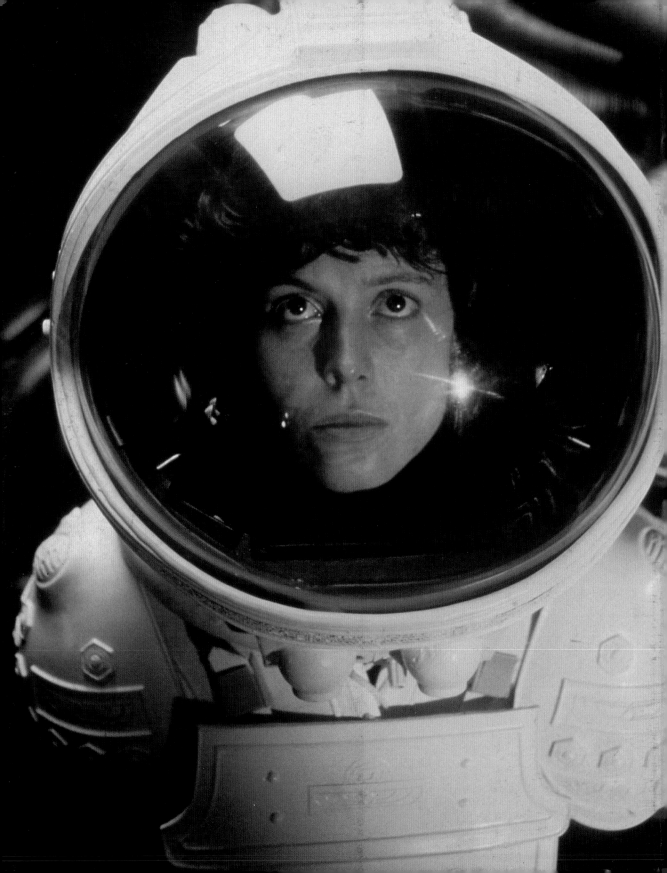

TURNER **CLASSIC** MOVIES.

MUST-SEE
SCI-FI

SLOAN DE FOREST

FOREWORD BY ROGER CORMAN

Photo Editor: David Del Valle

RUNNING PRESS
PHILADELPHIA

Page 2: Sigourney Weaver
in *Alien* (1979)

Opposite: Kenneth Villiers
and Pearl Argyle in *Things to
Come* (1936)

Running Press
Hachette Book Group
1290 Avenue of the Americas, New York, NY 10104
www.runningpress.com
@Running_Press

Printed in China

First Edition: May 2018

Published by Running Press, an imprint of Perseus Books, LLC, a subsidiary of Hachette Book Group, Inc. The Running Press name and logo is a trademark of the Hachette Book Group

The Hachette Speakers Bureau provides a wide range of authors for speaking events. To find out more, go to www.hachettespeakersbureau.com or call (866) 376-6591.

The publisher is not responsible for websites (or their content) that are not owned by the publisher.

Print book cover and interior design by Jason Kayser.

Library of Congress Control Number: 2017962962

ISBNs: 978-0-7624-9152-0 (paperback),
978-0-7624-9153-7 (ebook)

1010

10 9 8 7 6 5 4 3 2 1

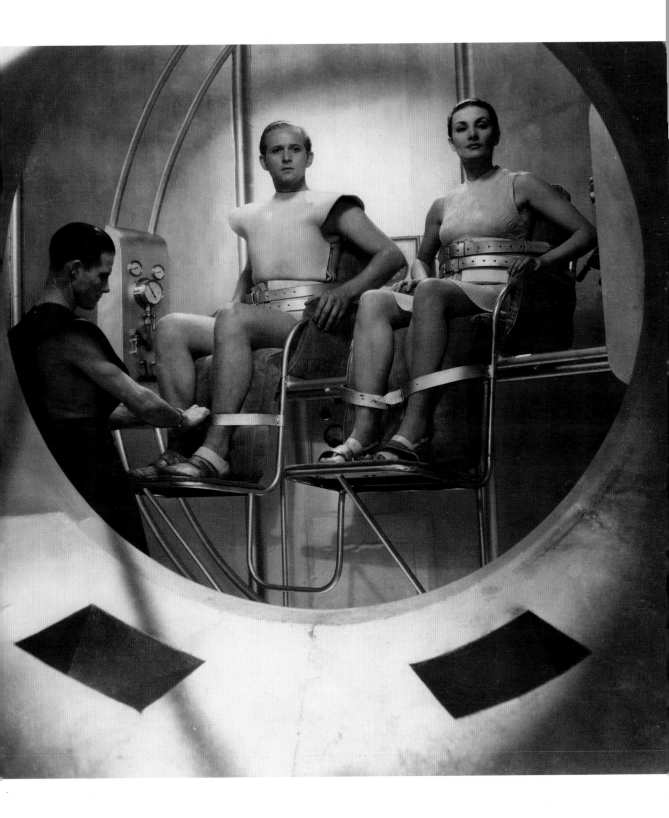

CONTENTS

FOREWORD
BY ROGER CORMAN

I remember going to see my first science-fiction movie as a kid in 1936. It was a Saturday matinee of *Things to Come*, an awe-inspiring, futuristic epic from the brilliant mind of H. G. Wells. It ignited my imagination, inspiring a lifelong interest in the genre. As a director, writer, and producer, science fiction, like horror, is a genre I keep returning to again and again throughout my career, in part because it has such a devoted following. Sci-fi fans not only buy movie tickets, they love to discuss every detail they have absorbed from watching and re-watching their favorites.

The first film I ever produced, *Monster from the Ocean Floor*, was about a creature that had mutated due to atomic radiation. It was made in 1954, the same year *Them!* and *Gojira* were released. It was part of a money-making trend (atomic mutants were all the rage), but it also had a few underlying themes and political statements. Working outside of the Hollywood establishment, we were able to experiment, to play, to have fun—and to use science fiction to question and comment on society. Science fiction was synonymous with low budgets in those days. Because there were no big stars in the pictures, it

was the genre—the idea—that sold tickets. Therefore, the more outrageous the concept, the better.

Since then, science-fiction movies have undergone an incredible evolution. When I started in the business, it was all about monsters. In the world of low-budget filmmaking, we had little money for special effects, and of course we did not yet have the computer technology of today. So we relied heavily on imagination. Over the past sixty years, I have seen science fiction grow from papier-mâché-and-wire monsters (which could be very effective indeed—look at George Pal's *The War of the Worlds*, for one) to lifelike computer-generated graphics. I've observed the genre as atomic monsters of the 1950s gave way to the hallucinogenic extraterrestrial experiences of *2001: A Space Odyssey* (1968), witnessed first-hand the impact *Star Wars* (1977) had on cinema, and watched as James Cameron went from spending $6 million on *The Terminator* in 1984 to over $230 million on *Avatar* in 2009. And the budgets just keep getting bigger.

But even in the age of expensive wonders, making a science-fiction movie still boils down to imagination. All the money and sophisticated technology in the world cannot produce an entertaining film unless there is an idea behind it. It's always disappointing to go and see a big-budget extravaganza with spectacular effects, but to leave the theater feeling empty because the story had nothing original to say. Unforgettable science-fiction stories stimulate the mind just a little, in addition to their sheer entertainment value. After all, fun is what we go to the movies for. That's why classic sci-fi movies remain so enjoyable: they offer thrills, chills, and sometimes laughs, but they also make you think.

The "must-see sci-fi" movies in this book are considered classics because they were made with imagination. Whether a timeless Hollywood favorite like James Whale's *Frankenstein* (1931) or a modestly budgeted independent like John Sayles's *The Brother from Another Planet* (1984), each of these fifty films transcends its era. Each has a universal quality that allows it to live on for future generations to discover. If you're already a fanatic or if you're just discovering them for the first time, I hope you enjoy these movies as much as I have. May your imagination run wild.

INTRODUCTION
DEFINING THE IMPOSSIBLE GENRE

The most memorable science-fiction movies are ones that defy our expectations. Even the experience of writing about science fiction defied my expectations. As I deeply explored the genre, I was struck by the uniqueness of every story—how dissimilar each was from the next—rather than their similarities. What does a comedy like *Back to the Future* (1985) have in common with a thriller like *Alien* (1979)? Does *Barbarella* (1968) share any elements with *The Invisible Man* (1933)? Even categorizing certain titles as science fiction proved more challenging than I had imagined. Like the shape-shifting monster in *The Thing* (1982), sci-fi cinema

takes many forms and is almost impossible to wrangle in an expected direction.

So how do we know a science-fiction movie when we see it? According to writer Phil Hardy, who labeled science fiction "the impossible genre," virtually all sci-fi films "in some way or another call into question the world we live in and accept as absolute." In other words, they question our reality. Science fiction looks at our world and asks, "What if?" What if we could travel back and forth in time? What if there are aliens on other planets? What if everything we believe to be real is, in fact, a computer-generated illusion? Specifically, science fiction confronts the what-ifs of technology by questioning our relationship to scientific progress and projecting advancements that might lie just beyond the horizon. Where is science leading mankind? Unforgettable sci-fi films not only pose such heavy-duty questions, they proceed to answer them in dazzling detail.

Before the birth of science-fiction cinema, writers like Mary Shelley, Jules Verne, and H. G. Wells laid the groundwork for the art form with their highly imaginative literary works. Often using such inspiration, since the nickelodeon days motion pictures dabbled in

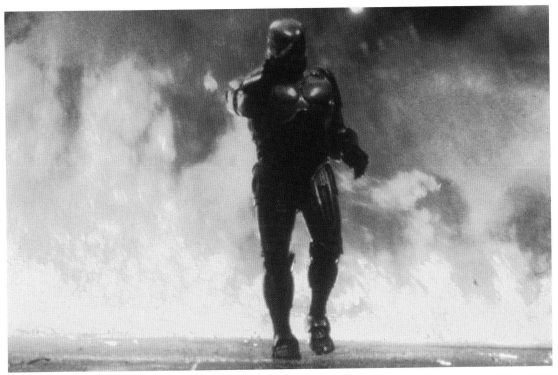

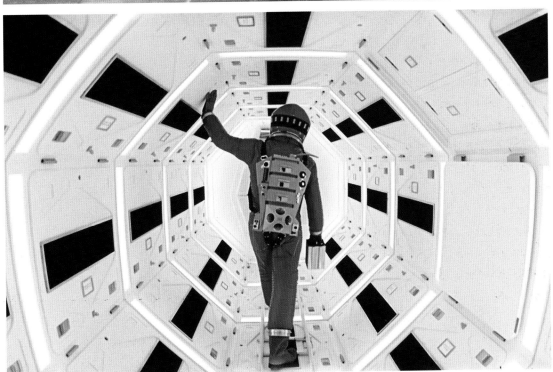

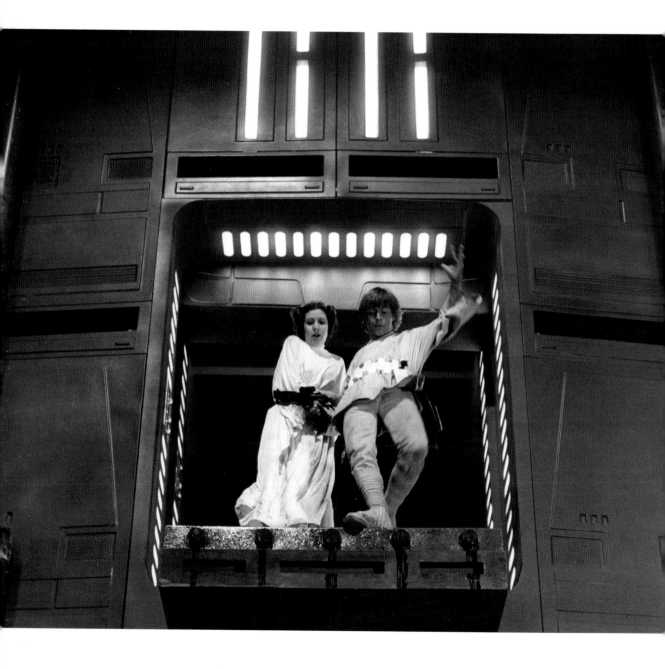

the weird, the unearthly, and the fantastic. But never before have science-fiction films been more respected or more widespread than now, in the twenty-first century. Prompted by technological advancements in our reality—some that eerily resemble the science fiction of yesterday—cinema is experiencing a sci-fi renaissance, and a fan base that seems to grow broader with each passing year. "Science fiction is for everybody," director James Cameron once observed. "We live in a technological world . . . so to say that science fiction is just for the pencil-neck nerds with calculators on their hips is really to miss the point."

Currently, science fiction is a cultural obsession. Franchises like *Star Wars* and *Alien*—and, on television, *Star Trek* and *Doctor Who*—have millions of devoted fans who attend conferences, run websites, and feel passionate about their favorites. The purpose of this book is not to list the greatest or the most popular sci-fi titles, but to highlight some of the movies that have embedded themselves in the depths of our minds, coloring our view of day-to-day reality and fueling a few dreams—and nightmares—along the way. The visual exploration of innovative ideas in these films has shaped our pop-culture past and informed our contemporary society. The hauntingly beautiful metallic android tied to a burning stake in *Metropolis* (1927). The lumbering silver robot carrying Patricia Neal into the spaceship in *The Day the Earth Stood Still* (1951). The hypnotic yellow pupil in the center of HAL 9000's unblinking red light in *2001: A Space Odyssey* (1968). A bald Keanu Reeves waking up in a fluid-filled pod in *The Matrix* (1999). These are the images that remain fixed in our minds after the screen fades to black. These are the films that confront us with questions, answer a few, and prompt us to ask ourselves even more when the end credits roll. These are the essentials.

As you read about and watch these fifty movies, try to seek out their common threads. It can be a challenge, but I believe you'll discover, as I did, that they are all similar in one way: once seen, they cannot be forgotten.

1902

DIRECTOR AND PRODUCER: GEORGES MÉLIÈS SCREENPLAY: GEORGES MÉLIÈS, BASED ON THE NOVELS FROM THE EARTH TO THE MOON BY JULES VERNE AND THE FIRST MEN IN THE MOON BY H. G. WELLS STARRING: VICTOR ANDRÉ (ASTRONOMER), BLEUETTE BERNON (LADY IN THE MOON), BRUNNET (ASTRONOMER), JEANNE D'ALCY (SECRETARY), HENRI DELANNOY (ROCKET CAPTAIN), GEORGES MÉLIÈS (PROFESSOR BARBENFOUILLIS/THE MOON)

A Trip to the Moon

STAR-FILM (FRANCE) • BLACK & WHITE (HAND-COLORED), 16 MINUTES (2011 RESTORATION)

A team of astronomers boards a rocket to the moon, where they encounter a tribe of hostile aliens.

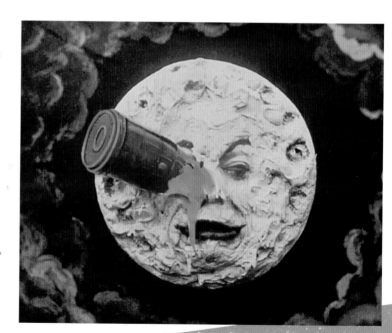

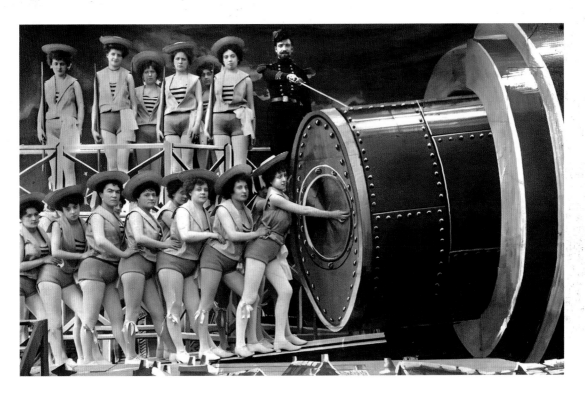

It is appropriate that the first artist to creatively manipulate time and space on film was the first filmmaker to take the movies into outer space. Georges Méliès's *A Trip to the Moon*, or *Le voyage dans la lune*, was not the first film to feature science-fiction elements, but it was the first true sci-fi film. And it was an overwhelming success. In its day, *A Trip to the Moon* was the equivalent of a big-budget Hollywood epic, packed with elaborate special effects in glorious hand-painted colors. At around fifteen minutes (and at a cost of 10,000 francs), it was much lengthier and more elaborate than anything moviegoers had seen.

Méliès, a former illusionist, instantly saw the magical possibilities of motion pictures. He opened his Paris movie studio in 1897, and began shooting films using his signature camera tricks, such as mid-shot replacements and multiple exposures. In 1898, he made *A Trip to the Moon*'s precursor, a three-minute short called *The Astronomer's Dream*, in which a stargazer leaps into the mouth of an animated man in the moon. Four years later, Méliès would retool this moon concept to make his most iconic film, one that remains popular entertainment well over a century after its release. Only this time, the moon would be played by a human face—the face of Georges Méliès himself.

Certain silent-film images have the power to remain emblazoned in our mind's eye, transcending the bounds of language or time. Like

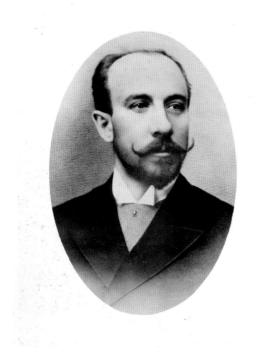

Left: Georges Méliès

Page 14: Méliès as the
man in the moon

Page 15: Female Marines
prepare the rocket
for its launch.

them now lost) began dotting the motion-picture landscape. *A Message from Mars* appeared in New Zealand in 1903; *Les invisibles* was a 1906 invisible-man story from Méliès's rival, Gaston Velle; Thomas Edison's studio produced *A Trip to Mars* in 1910. None captured the public's imagination quite like *A Trip to the Moon*, the granddaddy of cinematic sci-fi. Méliès himself produced a follow-up film, *The Voyage Across the Impossible* (1904), a similar story about a group of scientists who travel to the sun on a magic railway car.

Méliès not only conceived, directed, produced, and edited his films, but acted in them and even painted the backdrops by hand. But by 1912, other directors were making more sophisticated films by refining techniques he had pioneered, and he was left behind. In the 1920s, Méliès and his wife opened a toy shop in the Montparnasse train station, a real-life scenario that inspired Brian Selznick's fictional children's book *The Invention of Hugo Cabret*. Martin Scorsese, who directed the 2011 movie adaptation, *Hugo*, was first exposed to Méliès's work at age thirteen, when he attended a screening of *Around the World in 80 Days* (1956). Before the feature, Scorsese recalled, "They showed *A Trip to the*

the gun being pointed straight at the camera in *The Great Train Robbery* (1903), or Charlie Chaplin's distinct Little Tramp walk, the rocket landing in the eye of the moon's face in *A Trip to the Moon* is a universally recognized symbol of early cinema. But there are other memorable visions in the film: A troupe of chorus girls prepares the rocket to be blasted from a canon. A lunar goddess sprinkles snow over a crew of astronomers as they sleep. A race of Selenites inhabits a bizarre subterranean moon-world filled with mushrooms. Each scene abounds with imagination and energy, with flights of fancy that only a magician could create.

In the wake of Méliès's moon epic, other films that dealt with sci-fi themes (many of

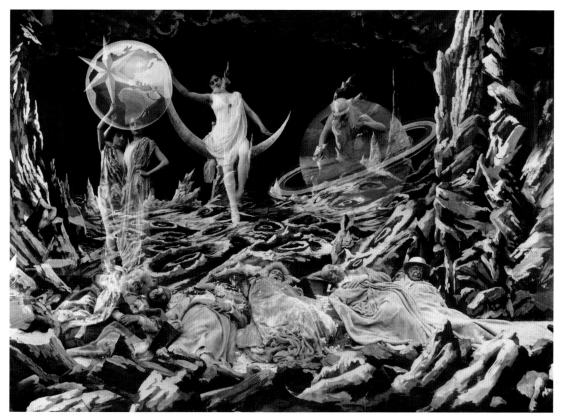

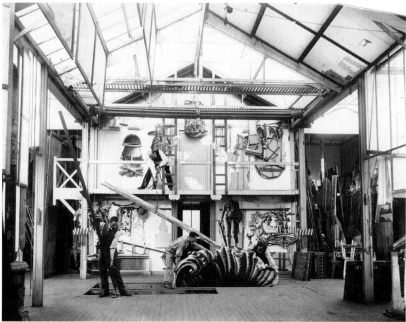

Above: Bleuette
Bernon watches over
the astronomers as they
sleep on the moon.

Left: Behind
the scenes at Georges
Méliès's studio

FAR-OUT FACTS

There were no commercial motion-picture cameras available in France at the turn of the century, so Méliès built his own camera out of a film projector.

Jeanne d'Alcy, an actress who had a small role in *A Trip to the Moon*, married Georges Méliès in 1925.

MIND-BLOWING MOMENT

When the rocket returns to Earth and plummets to the ocean floor, the underwater effects were startlingly realistic for their day. Méliès shot the scene through a tank filled with water and real fish, and painted the backdrops in carefully selected shades of gray and black so they would register on the primitive film stock.

Moon in its entirety. The audience applauded, laughed at the moment when the rocket struck the eye of the moon." The image stayed with the director his whole life.

Believed lost for nearly a century, the color version of *A Trip to the Moon* was found in 1993. In 2011, the film was restored and given a new score by the band Air. With its contemporary music and bold colors, the restoration is a surreal journey back to the early twentieth century, when the first manned craft to land on the moon was still sixty-seven years away. Back then, one man envisioned it all. "It is absolutely necessary to create the impossible," Méliès once said, "then to photograph it so that it can be seen." By launching his rocket to the moon, Georges Méliès launched the art form of science fiction in the movies.

KEEP WATCHING

THE VOYAGE ACROSS THE IMPOSSIBLE (1904)
DESTINATION MOON (1950)

DIRECTOR: FRITZ LANG PRODUCER: ERICH POMMER SCREENPLAY: THEA VON HARBOU, FROM HER NOVEL STARRING: ALFRED ABEL (JOH FREDERSEN), GUSTAV FRÖHLICH (FREDER), BRIGITTE HELM (MARIA), RUDOLF KLEIN-ROGGE (C. A. ROTWANG), FRITZ RASP (THE THIN MAN), THEODOR LOOS (JOSAPHAT), ERWIN BISWANGER (11811), HEINRICH GEORGE (GROT)

Metropolis

UFA/PARUFAMET (GERMANY) • BLACK & WHITE, 148 MINUTES (2010 RESTORATION)

The son of an oppressive future society's ruler joins a working-class revolt incited by a mad scientist's seductive robot.

Fritz Lang's 1927 Masterpiece
Now With 25 Minutes of Lost Footage
THE COMPLETE
METROPOLIS

a Kino International release
Kino Lorber
www.kino.com/metropolis

MUST-SEE SCI-FI

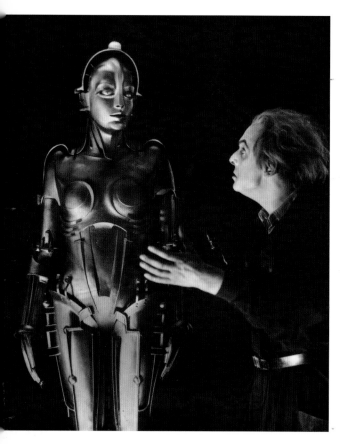

Lang, an Austrian filmmaker schooled in the shadowy style of German Expressionism, found the inspiration for *Metropolis* on his first voyage to the United States in 1924. Struck by the view of the Manhattan skyline from the harbor, Lang immediately envisioned a futuristic film. "I saw the buildings, like a vertical curtain, opalescent and very light, filling the back of the stage, hanging from a sinister sky in order to dazzle, to diffuse, to hypnotize," he remembered. Lang's wife, writer Thea von Harbou, penned a novel based on this vision—a melodramatic mélange of social commentary, romance, Gothic horror, biblical themes, ancient sorcery, and space-age technology originally titled *Metropolis: Fate of a Human Race in the Year 2000*. Von Harbou scripted the adaptation and collaborated with Lang on the production, even discovering actor Gustav Fröhlich among the extras and casting him in the lead role of Freder.

The pampered son of Metropolis's ruler Joh Fredersen (Alfred Abel), Freder spends his days cavorting in sun-drenched gardens until he meets working-class beauty Maria, played by nineteen-year-old Brigitte Helm in her first acting role. Maria opens Freder's eyes to the

Fritz Lang's 1927 masterpiece *Metropolis* is more than a landmark silent movie. It is cinema's first science-fiction epic. Though a financial failure on its initial release, the film's innovative special effects and awe-inspiring imagery impacted popular culture like an earthquake. Nearly a century later, aftershocks can still be felt. An ambitious spectacle contrasting an opulent city of tomorrow with its dark underbelly of enslaved factory workers, *Metropolis* has echoed through the decades across the pantheon of sci-fi, from *Just Imagine* (1930) to *Blade Runner 2049* (2017).

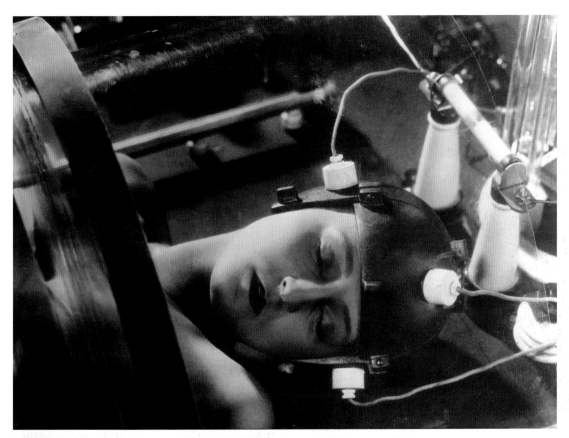

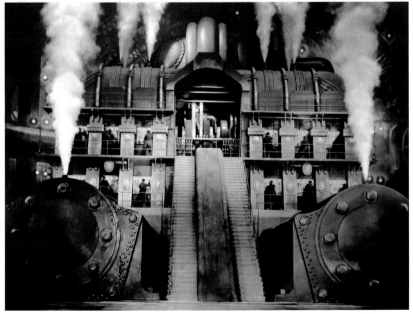

Top: Brigitte Helm

Bottom:
The Moloch Machine

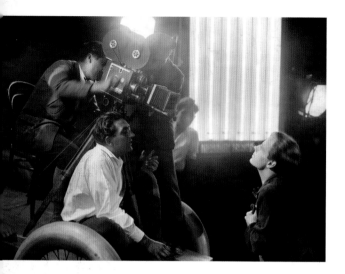

Fritz Lang directs
Gustav Fröhlich.

plight of the masses who toil day and night, operating the Moloch Machine that keeps the city running yet produces nothing. The film's theme, which Lang summarized as "the enormous progress of technology in future times," is brought vividly to life in its sets: colossal skyscrapers, vast highways, and ultra-modern interiors outfitted with video-phones and cutting-edge gadgetry.

Shot over a grueling two-year period and populated with 26,000 male extras, 11,000 females, and 750 children, the production was the biggest (and most expensive) ever mounted in Germany. In its extravagance, *Metropolis* harkens back to grand-scale silent epics such as D. W. Griffith's *Intolerance* (1916), but with two new additions: science fiction and special effects. Lang and von Harbou established the modern mad-scientist archetype with the wild-eyed Rotwang (played by von Harbou's ex-husband, Rudolf Klein-Rogge), whose shock

of white hair and mechanized hand would inspire a range of cinematic spin-offs from the title character in *Dr. Strangelove* (1964) to Doc Brown in *Back to the Future* (1985). Rotwang's often-emulated laboratory—bubbling and buzzing with electrical equipment—is used to create a lifelike robot in the image of Maria. Alluring and dangerous, the Maria-android would become a science-fiction icon, her distinctive metal inner-structure informing the look of cinematic descendants C-3PO and RoboCop. The film's ingenious optical tricks were achieved by stop-motion, superimposition, and a technique called the "Schüfftan process," in which mirrors were used to combine models with live action.

Critics were awestruck by the effects, but less impressed by what one Berlin reviewer described as "an absurd plot bursting at the seams with themes and motifs." Even Lang was not especially fond of *Metropolis*, later dismissing it as "silly and stupid." But the public was enraptured. The prescient allegory of a future in which technology reigns supreme and human beings are irrelevant still haunts us; the mesmerizing visuals have embedded themselves firmly in our culture. There simply

never had been—and probably never will be—anything else quite like it.

Shortly after its premiere, German distributor Ufa withdrew the film and began making cuts. For the American release, Paramount hired playwright Channing Pollock to pare the story down even further. For seventy-five years, the epic was incomplete—lacking over an hour of footage believed to be lost—until discoveries in 2002 and 2008 finally resulted in a near-complete restoration of Lang's original vision. The final twist in the saga may be the revelation that the more missing scenes are found, the less the film resembles pure science fiction. As *Star Wars* (1977) would fifty years later, *Metropolis* uses sci-fi as a means to explore philosophy, theology, and age-old conflicts between good and evil. The hodgepodge of themes and genres—exactly what the critics didn't like in 1927—is what keeps the film fresh and full of surprises today.

KEEP WATCHING

WOMAN IN THE MOON (1929)
THE FIFTH ELEMENT (1997)

MIND-BLOWING MOMENT

The original version of the screenplay ended with Freder and Maria boarding a rocket ship and blasting off into space. Lang and von Harbou cut this from the story, but used it as the basis for their follow-up sci-fi, *Woman in the Moon* (1929).

———◦—⌄—◦———

Confined inside a heavy, stifling armor for her scenes as the robot, Brigitte Helm "had to suffer severely under the strain," recalled costar Klein-Rogge. The cast and crew used to tease Helm by placing coins inside her metallic costume as if she were a machine. She collected the money and used it to buy chocolates.

MIND-BLOWING MOMENT

At once frightening and beautiful, Rotwang's "Maschinenmensch" is wired to the real Maria and endowed with her physical likeness by a mysterious process. Rings of light rise and fall around the robot as a network of internal organs glimmer to life inside her body. To achieve the effect, the same piece of negative was exposed nearly thirty times as layers of separate elements were added.

DIRECTOR: JAMES WHALE PRODUCER: CARL LAEMMLE JR. SCREENPLAY: GARRETT FORT AND FRANCIS EDWARD FARAGOH, ADAPTED FROM THE PLAY BY PEGGY WEBLING AND BASED ON THE NOVEL BY MARY WOLLSTONECRAFT SHELLEY STARRING: COLIN CLIVE (HENRY FRANKENSTEIN), MAE CLARKE (ELIZABETH), JOHN BOLES (VICTOR MORITZ), BORIS KARLOFF (THE MONSTER), EDWARD VAN SLOAN (DOCTOR WALDMAN), FREDERICK KERR (BARON FRANKENSTEIN), DWIGHT FRYE (FRITZ)

Frankenstein

UNIVERSAL • BLACK & WHITE, 71 MINUTES

By piecing together parts from dead bodies, scientist Henry Frankenstein creates a living monster with an abnormal brain.

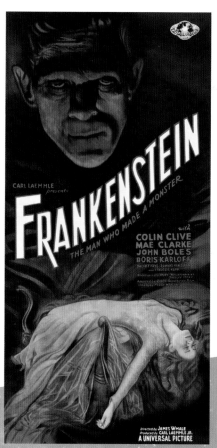

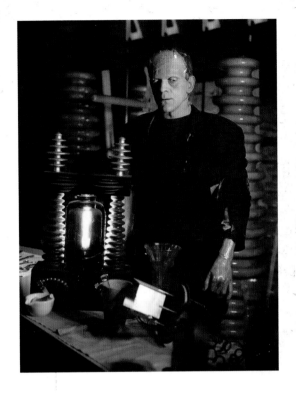

Originally published in 1818, Mary Wollstonecraft Shelley's *Frankenstein; or, The Modern Prometheus* has captured the public's imagination for two hundred years. Though Shelley's novel has been adapted countless times over two centuries, James Whale's *Frankenstein* remains the definitive cinematic version, enduring as a groundbreaking crossover of both sci-fi and horror. As stylish and disturbing today as it was in 1931, *Frankenstein* is an example of 1930s studio-system artistry at its finest.

Mary Shelley gave birth to a science-fiction archetype with her tale of a young scientist creating life from the dead. After playwright Peggy Webling modernized the novel for her 1930 London stage play, Universal bought the film rights for its *Dracula* (1931) star, Bela Lugosi. Director Robert Florey shot a long-lost screen test of Lugosi as the monster, but neither Lugosi nor the studio was happy with the results. Lugosi dropped out and producer Carl Laemmle Jr. switched directors, assigning *Frankenstein* to James Whale, who had crafted the precode melodrama *Waterloo Bridge* (1931) with subtlety and sophistication. Whale jumped at the chance to, as he put it, "dabble in the macabre."

His imagination sparked by German expressionist films like *The Golem* (1920), the director employed extreme camera angles and Gothic settings to cast a dark spell over the audience. *Frankenstein*, a complex story suffused with philosophical and moral themes, is streamlined by Whale, its essence distilled to the shocking story of a man who builds a monster. The film's lack of background scoring, a detriment to some early talkies, works in Whale's favor. Many of the most powerful scenes involve little dialogue and no music: the elevation of the platform as the creature is brought to life in a thunderstorm; our first terrifying look at the monster's sunken face; the woodcutter silently carrying his daughter's lifeless body through the town streets.

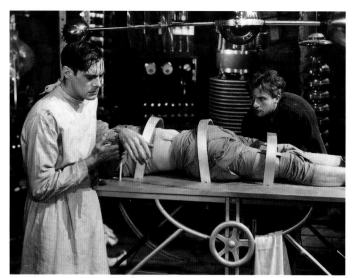

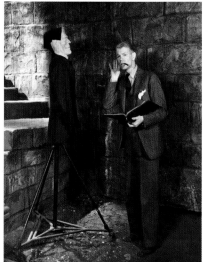

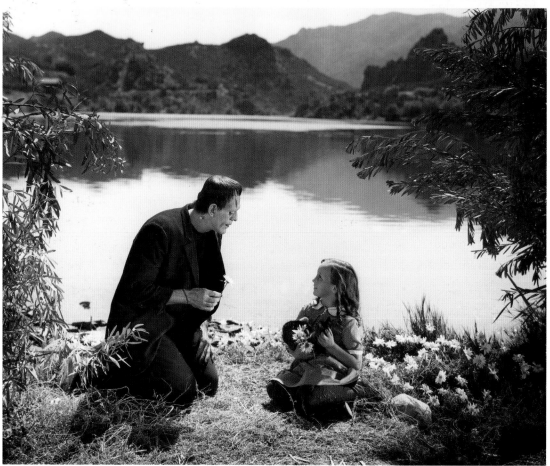

Opposite top left: Colin
Clive as Henry Frankenstein
and Dwight Frye as Fritz
bring the monster to life.

Opposite top right: Director
James Whale poses with
a stand-in for Karloff.

Opposite bottom:
Boris Karloff and Marilyn
Harris as Little Maria.

Right: Cinematographer
Arthur Edeson films
the monster's first
close-up.

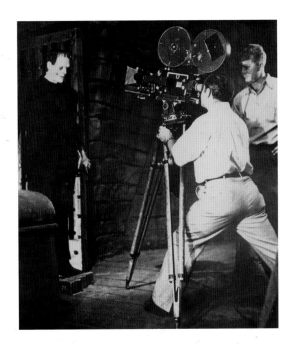

U.K. export Whale not only brought his striking dramatic flair to the production, he brought two English actors who would forever be associated with the roles they created: Boris Karloff and Colin Clive. Karloff was a struggling forty-three-year-old bit player when Whale spotted him in the Universal commissary. With his deep-set, melancholy eyes; exceptional skill at pantomime; and a dental bridge that could be removed to form a hollow indentation in his cheek, Karloff—aided by Jack Pierce's remarkable makeup—embodied Frankenstein's creature so ideally that all subsequent characterizations owe him a debt. The squared-off forehead, the electrodes on either side of the neck, the too-short sleeves and weighted boots—none of these existed until Karloff's menacing yet sympathetic monster appeared on the screen. When the film was released, Karloff became a legend in his own lifetime, and a horror-movie career was launched. "That poor dear abused monster," he once said, "is my best friend."

Often underappreciated is the equally dynamic performance of Colin Clive as Henry Frankenstein. Shelley's scientist, she wrote, felt "an anxiety that almost amounted to agony" as he brought his creation to life, and Clive

exhibits this quality throughout the film. An old knee injury had left the actor in chronic pain and with a crippling alcohol addiction. Using a touch of proto-Method acting, Clive tapped into his personal misery to give Frankenstein a dark ripple of manic torment that makes us believe he might actually rob graves to satisfy his scientific obsession. His iconic "It's alive" scene is perfection. Upon seeing his creation move for the first time, Clive builds from a whisper to a frenzy in twelve seconds, taking his macabre giddiness to the edge of madness without quite going over the top. "Colin was electric," remembered costar Mae Clark, who plays Frankenstein's fiancée, Elizabeth. "When he started acting in a scene, I wanted to stop and just watch." Like Karloff as the monster, no one else but Colin Clive could have embodied Frankenstein so memorably.

FAR-OUT FACTS

The film was originally supposed to take place in nineteenth-century Germany, but was changed to a vaguely a European city in an indistinguishable time period.

Henry Frankenstein's lines, "In the name of God . . . Now I know what it feels like to be God!" were cut from theatrical reissues and TV broadcasts of the film for years.

Kenneth Strickfaden built the elaborate electrical equipment that helps bring the monster to life. The apparatus used in the film *Metropolis* (1927) provided some inspiration.

MIND-BLOWING MOMENT

While wandering the countryside loose, the monster stops to play with a little girl near a lake. Believing she will float, he playfully tosses her into the watery depths, then is dismayed by her disappearance. The effect is surreal and chilling.

Released at a low point in the Great Depression, *Frankenstein* smashed theater records across the country. "People like the tragic best at those times when their own spirits are depressed," a 1932 *Motion Picture Herald* article claimed, speculating that the economic crisis helped to make *Frankenstein* "one of the biggest box-office films in Universal history."

Four years later, Universal had another hit on its hands with *Bride of Frankenstein* (1935), a unique blend of horror, sci-fi, and satire that proved to be one of the most successful sequels of all time. For *Bride*, James Whale pulled out all the stops, giving Karloff's monster a rudimentary vocabulary and a taste for wine, women, and cigars. The Bride, played by Elsa Lanchester, became nearly as celebrated as the monster in a fraction of the screen time. Whale's two classic Frankenstein films spawned a string of sequels and inspired dozens of later works, including *Young Frankenstein* (1974), *The Rocky Horror Picture Show* (1975), and *Weird Science* (1985).

KEEP WATCHING

MAD LOVE (1935)
THE CURSE OF FRANKENSTEIN (1957)

DIRECTOR: ERLE C. KENTON SCREENPLAY: WALDEMAR YOUNG AND PHILIP WYLIE, BASED ON A NOVEL BY H. G. WELLS
STARRING: CHARLES LAUGHTON (DR. MOREAU), RICHARD ARLEN (EDWARD PARKER), LEILA HYAMS (RUTH THOMAS), BELA
LUGOSI (SAYER OF THE LAW), KATHLEEN BURKE (THE PANTHER WOMAN), ARTHUR HOHL (MONTGOMERY), STANLEY FIELDS
(CAPTAIN DAVIES), PAUL HURST (DONAHUE), HANS STEINKE (OURAN), TETSU KOMAI (M'LING)

Island of Lost Souls

PARAMOUNT • BLACK AND WHITE, 70 MINUTES

A shipwrecked man is
held captive on an
uncharted island where a
renegade scientist conducts
gruesome experiments
on animals.

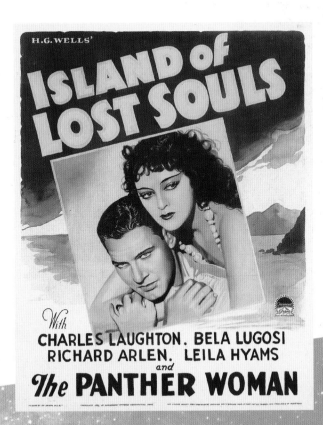

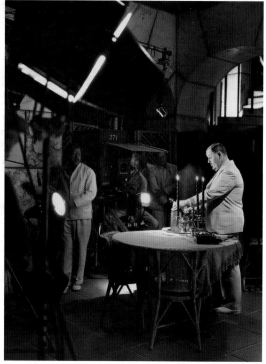

"Horrible to the point of repugnance." This was how the *Los Angeles Times* described *Island of Lost Souls* upon its release in January 1933. Much of the world agreed. England (and eleven other countries) banned the film entirely; several theaters in the United States and Canada showed censored versions with some of the most salacious moments edited out. Today, the film appears far less shocking to twenty-first century jaded eyes, but still retains its uniquely disturbing brand of terror.

In the early 1930s, before the Motion Picture Production Code was strictly enforced, a trend for graphic horror films swept Tinseltown. Studios competed with each other to push the limits of violence, sex, and freaky grotesquerie. Universal had *Dracula* and *Frankenstein* (both 1931), Warner Bros. made *Doctor X* (1932), Paramount released *Dr. Jekyll and Mr. Hyde* (1931), and MGM topped them all with the morbid *Freaks* (1932). When Paramount paid H. G. Wells $15,000 for the film rights to his 1896 novel *The Island of Dr. Moreau*, they hired a team of writers—and dependable studio director Erle C. Kenton—to turn the anti-vivisection parable into a full-blown screen nightmare.

In the book, Dr. Moreau attempts to transform wild animals into humans by experimental and painful surgeries, but his intentions are noble. In the film, Charles Laughton's Moreau is a twisted sadist, an ice-cold psychopath with a God complex and a whip in his hand. He casually slices open his beast-men in a laboratory known as the House of Pain, and seems to enjoy their anguished howls. Laughton, who had made his Hollywood debut as a maniacal killer in *Devil and the Deep* (1932), embodies Moreau so fully that his riveting, restrained performance makes the film. "You can eat and get laughs with every bite, walk and have menace in it," Laughton said of his technique. "It's all in the interpreting of movements to give reality."

The book's minor mention of a puma woman becomes the Panther Woman in the movie, a major publicity gimmick for Paramount. Nineteen-year-old Kathleen Burke won the role after beating out 60,000 other women in a nationwide contest that sought a "feline type of beauty." The Panther Woman raised the hackles of the censors by seducing the unwitting Edward Parker, played by Richard Arlen. Moreau plans to use Parker's attraction to the female beast to mate human with animal; when that fails, he encourages one of his beast-men to mate with Parker's innocent fiancée, Ruth (Leila Hyams). The implications of bestiality and rape are extreme even by today's standards. The controversy these subjects caused fueled the case for self-censorship, leading the Production Code to adopt a stricter approval system in 1934.

A team of makeup experts headed by Wally Westmore transformed dozens of actors—including a fur-covered Bela Lugosi as the Sayer of the Law—into hideous mutations with pointed ears, hooves, and faces like hyenas. The "curiosities," as Dr. Moreau refers to them in the Wells novel, are black, hairy, and always in shadows, while the island's humans are clad in pure white, so bright they almost glow in the dark. Glorious black-and-white film is the perfect medium for a story about contrasts—and frightening similarities—between human and animal, civilization and nature, good and evil. The fog that naturally shrouded the filming location of Catalina Island only helps to blur the lines and create a misty netherworld where anything seems possible.

A decade before the film noir style popularized venetian blind–filtered strips of light, cinematographer Karl Struss streaked shadows across the faces of actors to create atmosphere.

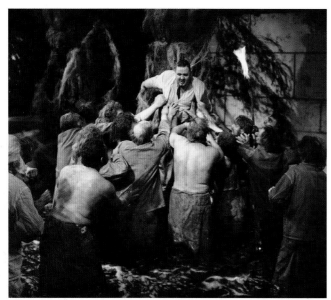

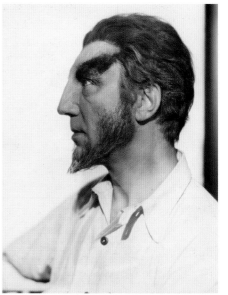

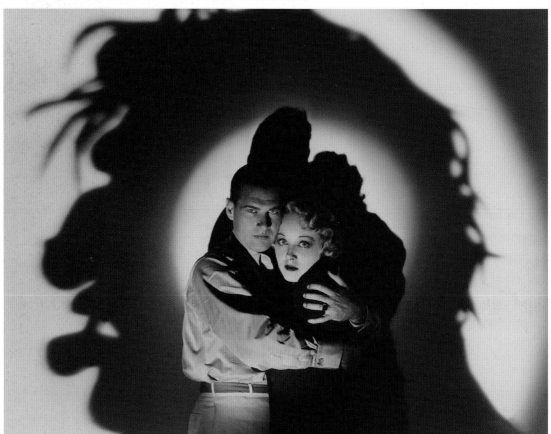

Struss, who had won an Oscar for F. W. Murnau's silent drama *Sunrise: A Song of Two Humans* (1927), employs high-contrast lighting to ideal effect here, using tropical plants, latticework, and window shades to cast ominous silhouettes. Candlelight is used impeccably in a scene just before one of Moreau's creatures attacks. The doctor blows out three candles, the room growing dimmer as each flame is extinguished until the only light source is the whites of his eyes gleaming in a pool of darkness. Without any dialogue or music, we know something sinister is about to happen.

Despite several later attempts to adapt *The Island of Dr. Moreau* on film and television, Kenton's *Island of Lost Souls* remains the classic screen version. As an early hybrid of horror and science fiction, it has inspired generations of filmmakers, from John Landis—who called the film "far more horrific than *Frankenstein*"—to Alex Garland, whose *Ex Machina* (2015), with its human-robot relationship, owes a great deal to Edward Parker and the Panther Woman.

KEEP WATCHING

MURDERS IN THE ZOO (1933)
CAT PEOPLE (1942)

FAR-OUT FACTS

The Paramount makeup department created the Panther Woman's claws by boiling reels of old movies and shaping the melted celluloid onto Káthleen Burke's fingernails.

The 1932 film heavily influenced some later musicians. Devo's 1978 debut album *Q: Are We Not Men? A: We Are Devo!* was inspired by the movie, as was Oingo Boingo's 1983 song "No Spill Blood," and Van Halen's "House of Pain" in 1984. Blondie borrowed the title for their 1981 single "Island of Lost Souls."

MIND-BLOWING MOMENT

When the beast-men form a mob and take their revenge, Dr. Moreau becomes their victim in the House of Pain. To fill out the scene, the studio issued a casting call for extras who naturally resembled pigs, dogs, and wolves to play the beast-men.

1933

DIRECTOR: JAMES WHALE PRODUCER: CARL LAEMMLE JR. SCREENPLAY: R. C. SHERRIFF, BASED ON THE NOVEL BY H. G. WELLS STARRING: CLAUDE RAINS (THE INVISIBLE MAN/DR. JACK GRIFFIN), GLORIA STUART (FLORA CRANLEY), WILLIAM HARRIGAN (DR. ARTHUR KEMP), HENRY TRAVERS (DR. CRANLEY), UNA O'CONNOR (MRS. HALL), FORRESTER HARVEY (MR. HALL), HOLMES HERBERT (CHIEF OF POLICE), E. E. CLIVE (CONSTABLE JAFFERS)

The Invisible Man

UNIVERSAL • BLACK & WHITE, 71 MINUTES

A scientist discovers the secret formula to make himself invisible, but is unaware that the chemical also affects his brain.

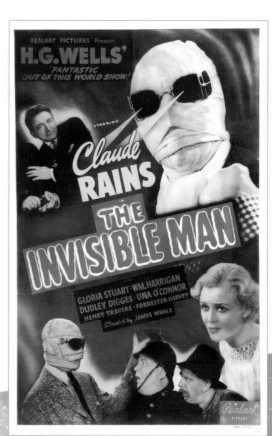

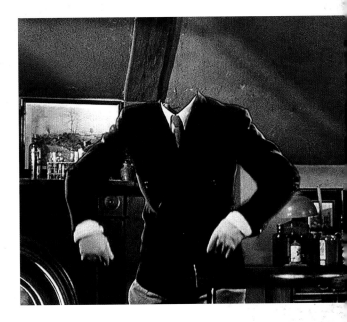

Claude Rains
as the Invisible Man

The Invisible Man is "not, strictly speaking, a horror story at all," a *Los Angeles Times* critic observed in 1933, but "a humorous grotesquerie of unique pretentions." This may be the most serviceable description of a science-fiction classic that is as much fun to watch as it is impossible to categorize. Wasting no time showing us scientists toiling in laboratories or analyzing chemical formulas, the movie throws us right into the delirium our antihero Jack Griffin feels as the invisibility drug eats away at his body—and his sanity. The frenetic pace is miraculously sustained through the entire film.

The project began as a plan to reunite *Frankenstein* director James Whale and star Boris Karloff in another Universal horror hit, an adaptation of the 1897 novella *The Invisible Man* by H. G. Wells. When Karloff dropped out (Universal reportedly cut his pay), Whale replaced him with unknown stage actor Claude Rains in his first Hollywood role. According to Rains's daughter, when searching for his invisible leading man, Whale was heard to exclaim, "I don't care what the man looks like. He just has to have a voice that's mesmerizing!" Few actors in film history have possessed voices as mesmerizing as Claude

Rains, with his rich British baritone that actor Richard Chamberlain once described as "honey mixed with gravel." Rains won the part and soon became an in-demand character star, adding his distinctive voice to such classics as *The Adventures of Robin Hood* (1938), *Casablanca* (1942), and *Notorious* (1946).

As half-mad chemist Griffin in *The Invisible Man*, Rains is tasked with conveying every nuance—from maniacal rage to remorseful contemplation—using only his vocal cords and occasional body movements. Making his grand appearance swathed in bandages, gloves, and dark glasses, Rains quickly peels away these garments and spends most of the movie ostensibly naked and invisible. Perhaps the most unforgettable sequence is the moment when a constable and onlookers gather around the suspiciously clad Griffin,

MUST-SEE SCI-FI

Claude Rains

final seconds of the film—our only fleeting glimpse at Claude Rains.

While the technical tricks broke new ground, it is Whale's playful wit that flavors every frame of the film. Even the scenes of murder are laced with a gruesome levity. Whale knew that invisibility, in itself, is not particularly entertaining, so he focused on the comic reactions of the villagers who encounter the disembodied voice. The innkeeper's wife, played by character actress Una O'Connor, responds to Griffin with a wide variety of over-the-top shrieks and wails; here, Whale's trademark dark, sardonic humor crosses over into high camp. Griffin himself spends much of the movie in a state of demented glee as he delights in his invisibility, using it to rob banks, overturn baby carriages, and terrorize the whole town. Whale also choreographed minor bits of business, such as Griffin rocking in a chair or smoking a cigarette, to spur the viewer's imagination, instead of merely relying on Rains's voice to fill the empty screen space.

who unravels his disguise to reveal nothing underneath—no flesh, bones, or features. Laughing hysterically, Griffin tosses the crowd his false nose as "a souvenir" and they run amok.

Visual effects pioneer John P. Fulton made ingenious use of double exposures and matte shots to achieve the illusion of Griffin disrobing. To make the effect thoroughly convincing, the film was painstakingly hand-retouched with opaque dye in certain scenes. Along with James Whale, Fulton and cinematographer Arthur Edeson were the movie's behind-the-scenes heroes, devising countless clever effects, from making footprints magically appear in the snow to rendering the invisible man visible in the

Though overshadowed by the year's ultimate special-effects picture, *King Kong*, *The Invisible Man* was a critical and commercial winner for Universal. The studio tried

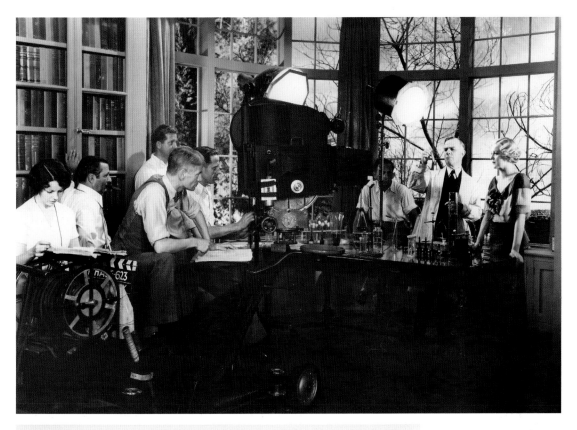

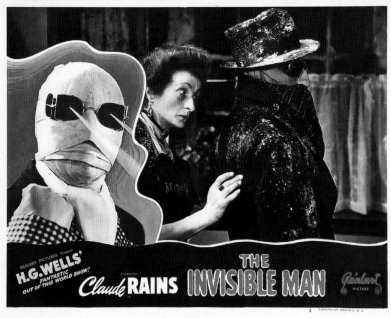

Top: James Whale directs Henry Travers and Gloria Stuart.

Bottom: A lobby card featuring Claude Rains and Una O'Connor

FAR-OUT FACTS

Though H. G. Wells gave the script his official approval, he said he was dissatisfied that the filmmakers took his "brilliant scientist and changed him into a lunatic." Director James Whale candidly responded to Wells that "in the minds of rational people, only a lunatic would want to make himself invisible anyway."

Every object moved by the invisible man, from books to bicycles to chairs, was carefully maneuvered by off-screen technicians pulling wires so fine they are invisible on film.

MIND-BLOWING MOMENT

When Jack Griffin steals a pair of pants, he puts them on and chases a woman across the countryside singing "Here we go gathering nuts in May," while all she sees is a pair of pants running behind her. This scene is typical of James Whale's ability to shock and induce laughter simultaneously.

to recapture that success four more times over the years with sequels like *The Invisible Man Returns* (1940) and *The Invisible Woman* (1940), and even a straight comedy outing with *Bud Abbott and Lou Costello Meet the Invisible Man* (1951), though none had James Whale's deft touch. Aside from Whale's influence on the art of filmmaking in general, which can be seen today in the increasingly popular horror-comedy genre, echoes of *The Invisible Man* live on in *Memoirs of an Invisible Man* (1992), *Hollow Man* (2000), and even in Harry's invisibility-cloaked high jinks in *Harry Potter and the Prisoner of Azkaban* (2004).

KEEP WATCHING

DR. JEKYLL AND MR. HYDE (1931)
X: THE MAN WITH X-RAY EYES (1963)

DIRECTOR: WILLIAM CAMERON MENZIES PRODUCER: ALEXANDER KORDA SCREENPLAY: H. G. WELLS, BASED ON HIS NOVEL STARRING: RAYMOND MASSEY (JOHN CABAL/OSWALD CABAL), EDWARD CHAPMAN (PIPPA PASSWORTHY/RAYMOND PASSWORTHY), RALPH RICHARDSON (THE BOSS), MARGARETTA SCOTT (ROXANA/ROWENA), CEDRIC HARDWICKE (THEOTOCOPULOS), MAURICE BRADDELL (DR. HARDING), SOPHIE STEWART (MRS. CABAL), DERRICK DE MARNEY (RICHARD GORDON), ANN TODD (MARY GORDON)

Things to Come

LONDON FILMS/UNITED ARTISTS (BRITAIN) • BLACK & WHITE, 97 MINUTES

Between the years 1940 and 2036, a scientist—and later, his great-grandson—drive society on toward technological progress and eventual utopia.

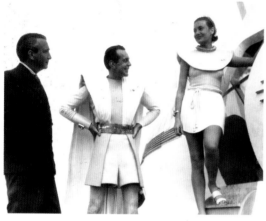

Things to Come, a bold, sweeping vision of the future, landed smack in the middle of the Great Depression like a missile from the moon. Between its post-holocaust barbarism, its fleet of advanced aircraft, and its stream-lined super-cities, no one in 1936 knew quite what to make of it. Even today there is no other movie like it—only Fritz Lang's *Metropolis* (1927) comes close. A monumental collaboration between "father of science fiction" H. G. Wells, producer Alexander Korda, and director William Cameron Menzies, *Things to Come* was the most expensive British film ever

produced when it was made, and remains an unforgettable entry in the sci-fi genre.

Futuristic science-fiction films were scarce in the 1930s and '40s. One year after the stock-market crash of 1929, Fox released *Just Imagine* (1930), an ambitious sci-fi musical comedy set in the year 1980, and an epic box-office failure. In 1933, the studio repeated the formula with *It's Great to Be Alive*, and the results were even more disastrous. Subsequently, most cinematic space-age sci-fi was relegated to cheaply produced serials like *Flash Gordon* (1936) until 1950—at least in Hollywood. In England, eminent filmmaker Alexander Korda and his London Films adapted the 1933 H. G. Wells book *The Shape of Things to Come* for the big screen; Wells himself even wrote the screen-play and supervised the production.

Right off the bat, *Things to Come* accurately predicts a second world war starting in 1940. Wells's message comes through loud and clear via the words of scientist John Cabal (Raymond Massey): "If we don't end war, war will end us." By 1970, civilization is in tatters following a lengthy mega-battle that depletes the planet's resources. The Wandering Sickness—pop culture's first stab at

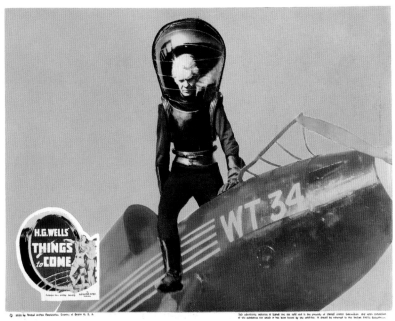

Top: Ann Todd, Derrick De Marney, Ralph Richardson, Margaretta Scott, and Maurice Braddell in the war-torn ruins of Everytown

Left: Raymond Massey as John Cabal

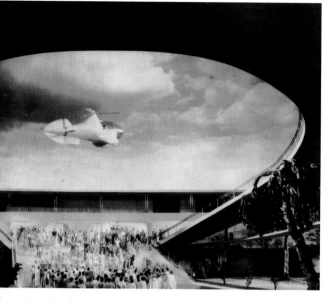

A personal aircraft in the year 2036

a zombie apocalypse—befalls humankind, and soon Everytown (a stand-in for London) is governed by a makeshift warlord (Ralph Richardson). Menzies, who had already racked up an impressive list of credits as a production designer (and would win an honorary Oscar for *Gone With the Wind* [1939]), directs with an eye toward spectacle, as Wells packs the dialogue with his technocratic and socialist agendas. The result is a somewhat preachy but visually stunning work of art, augmented by Arthur Bliss's majestic score.

Fast forward to the year 2036, and the set design becomes truly astounding. Alexander's brother Vincent Korda—with input from cinematographer Georges Périnal and Bauhaus artist László Moholy-Nagy—expanded on 1930s *moderne* architecture to create an underground city that manages to look both retro and futuristic today. Menzies allows

Korda's gleaming art-deco utopia to fill the screen, overwhelming our senses with Wellsian touches like contemporary-looking TV sets, escalators, and personal helicopters. Stylistically, *Things to Come* could almost be a sequel to *Metropolis*, though Wells disliked Fritz Lang's film. At one point, he even sent a memo to the staff advising: "Whatever Lang did in *Metropolis* is the exact opposite of what we want done here." But the two films are linked by their dreamlike vistas of massive future cityscapes, and by the sheer audacity of their existence. Though the warm, human element is lacking in *Things to Come*, noble intentions prevail as Oswald Cabal, great-grandson of John (also played by Massey), exerts his level-headed control and, in the end, arranges for his daughter and her boyfriend to be sent to the moon.

The film's tone of sleek confidence belies a great deal of behind-the-scenes tension between Korda, Menzies, and Wells, who fought for total control of the production, though he had no practical filmmaking experience. When *Things to Come* failed to make the desired impact, its writer and director each blamed the other. Wells privately considered Menzies "an incompetent director . . . a sort of

Cecil B. DeMille without his imagination," while Menzies wrote of the collaboration, "Damn that old fool Wells." None of the film's creative forces was entirely happy with the finished product, and it performed poorly at the box office. The Depression-battered public wasn't ready for such a far-reaching vision—nor was it prepared for the dreary Wellsian future of an advanced but sterile civilization.

As much as Wells tried to avoid it, his film cannot escape comparisons to *Metropolis*. Yet *Things to Come* is prescient in many ways that *Metropolis*, for all its beauty, is not. Though it may not have predicted the future of society, the combined vision of Wells, the Kordas, and Menzies—with its plague of walking dead, giant flat-screen TVs, and post-apocalyptic anarchy straight out of a *Mad Max* movie—uncannily forecasted the future of entertainment.

KEEP WATCHING

LOST HORIZON (1937)
SKY CAPTAIN AND THE WORLD OF TOMORROW (2004)

FAR-OUT FACTS

The first cut of the film totaled 130 minutes before being edited down to 110 minutes for its London premiere. Subsequent cuts were made until the film reached 97 minutes. Much of the trimmed footage has been lost.

The *Things to Come* score by Arthur Bliss was recorded by the London Symphony Orchestra and released by Decca Records in 1936, making it the first commercially available movie soundtrack.

MIND-BLOWING MOMENT

In 1970, when Everytown has regressed to riding horses, Wings Over the World pilot John Cabal arrives in his advanced aircraft and space-age helmet. This exhilarating moment effectively contrasts the ravages of war with the hope of technological progress.

1951

DIRECTOR: CHRISTIAN NYBY PRODUCER: HOWARD HAWKS SCREENPLAY: CHARLES LEDERER, BASED ON A STORY BY JOHN W. CAMPBELL (AS DON A. STUART) STARRING: MARGARET SHERIDAN (NIKKI NICHOLSON), KENNETH TOBEY (CAPTAIN PATRICK HENDRY), ROBERT CORNTHWAITE (DR. ARTHUR CARRINGTON), DOUGLAS SPENCER (NED "SCOTTY" SCOTT), JAMES YOUNG (LIEUTENANT EDDIE DYKES), DEWEY MARTIN (CREW CHIEF BOB), ROBERT NICHOLS (LIEUTENANT KEN MACPHERSON), JAMES ARNESS ("THE THING")

The Thing from Another World

WINCHESTER PICTURES/RKO • BLACK & WHITE, 87 MINUTES

When a bloodthirsty visitor from another planet crash-lands at the North Pole, a team of scientists and military officers fight to avoid becoming dinner for "the thing."

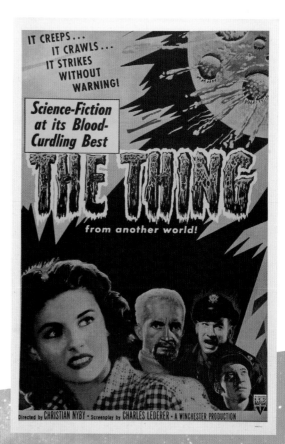

James Arness as
The Thing

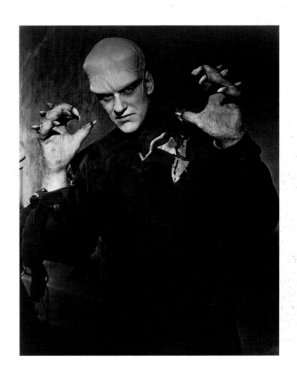

Though its title may smack of grade-B exploitation, *The Thing from Another World* is one of the smartest, subtlest, and wittiest films of its kind, and among the most influential. Many—including author/filmmaker Michael Crichton and *Time* magazine—have called it the greatest science-fiction movie ever made. It not only spawned a hugely popular 1982 remake and a big-budget 2011 prequel (both simply titled *The Thing*), it laid the groundwork for the entire *Alien* franchise by merging sci-fi and horror in an isolated location. Even the 1960 cult favorite *The Little Shop of Horrors* took a leaf from *The Thing*'s book with the concept of a killer plant that thrives on human blood.

Today, John Carpenter's 1982 version remains one of the most celebrated reworkings in science-fiction cinema. Like the alien in John Campbell's original 1938 novella *Who Goes There?*, Carpenter's monster adapts itself physically to imitate its prey, thanks to Rob Bottin's authentically gory special effects. Though the original 1951 film's budget was over a million dollars, limitations in the era's technology and makeup prevented a believable-looking shape-shifter, so the visitor was changed to a highly evolved, humanoid

plant. While Carpenter's later version follows the source material more faithfully, *The Thing from Another World* broke new ground by placing an alien life form within a realistic context in contemporary society.

In the hands of master director/producer Howard Hawks, who closely supervised the direction of his protégé Christian Nyby, the tale of a space monster crashing to Earth becomes a sort of sci-fi *His Girl Friday* (1940), a character-driven combination of horror and otherworldly phenomena that deftly mixes in elements of comedy and romance. Unlike Carpenter's all-male version, there are women in *The Thing from Another World*. Margaret Sheridan plays Nikki, a typical Hawksian female. A smart professional in sensible slacks, she may serve the men

Top: The men blast the flying saucer from the Arctic ice.

Bottom left: Kenneth Tobey and Margaret Sheridan

Bottom right: Robert Cornthwaite, Dewey Martin, Kenneth Tobey, James R. Young, John Dierkes, and Paul Frees

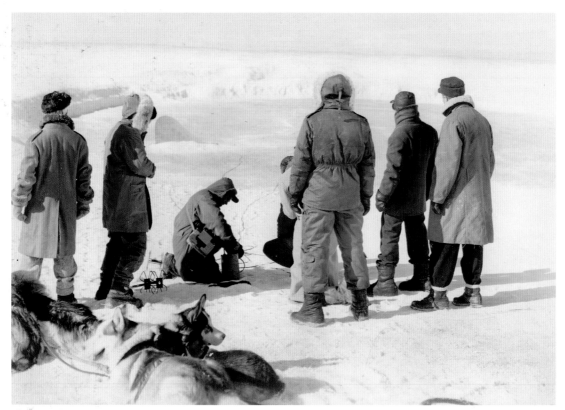

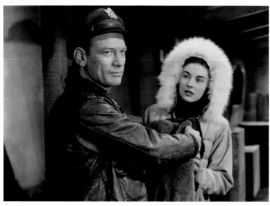

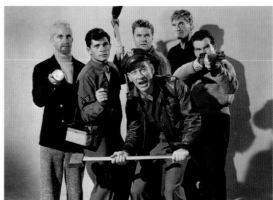

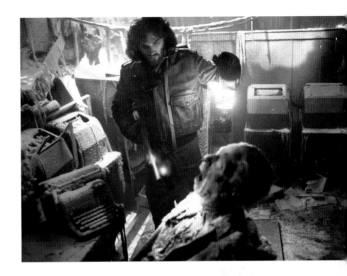

Kurt Russell in John Carpenter's 1982 remake *The Thing*

coffee, but she's nobody's fool; she even ties crew-leader Captain Hendry's (Kenneth Tobey) hands behind his back to teach him a lesson about how to treat women in a scene often cut from TV broadcasts of the film. She also saves the day by suggesting a method for destroying the violent vegetable: "Boil it, stew it, bake it, fry it."

Shot in forty-five days at the RKO Ranch in Encino, *The Thing from Another World* endures as a joy to watch well over half a century since its release. Its natural overlapping dialogue beat Robert Altman to the punch by about twenty years, and its droll wisecracks—courtesy of Charles Lederer, with a hand from Hawks's buddies Ben Hecht and William Faulkner—set it apart from other '50s space-man thrillers that followed. For all its levity, the film remains powerful because of its ability to frighten, and to do so without elaborate makeup or special effects. Seen only fleetingly, and always from a distance, "the thing" (played by an unrecognizable James Arness) is surrounded by mystery and paranoia.

The ominous mood is aided by the claustrophobic atmosphere of the Arctic research outpost; the eerie, Theremin-enhanced Dimitri Tiomkin score; and the tense whispers of the crew as they discuss "that thing" and its victims. Because the audience never sees the men "hanging upside down, their throats cut open" in the greenhouse, the imagination runs rampant; descriptions are far more chilling than any visual depiction could be.

Despite its no-star cast, the movie was a smash hit, though some in the sci-fi community criticized it for being more anti-science than science fiction. The military men are the heroes, while the scientists are practically on the monster's side—especially Robert Cornthwaite's eccentric Dr. Carrington, who reveres the thing as a "more advanced" species. Raising questions about the value of cold scientific logic and touching on themes like communism versus capitalism, *The Thing* packs an astounding array of ideas, laughs, and chills into its compact eighty-seven minutes. It even sparked a controversy that still rages to this day over who really directed the film: Nyby or Hawks? Kenneth

FAR-OUT FACTS

The famous scene where the men circle the Arctic crash site was filmed in the San Fernando Valley on a blisteringly hot day in late 1950. Fans of John Carpenter's *Halloween* (1978) will recognize this as the scene Lindsey Wallace watches on TV on Halloween night.

To get the lead role of Captain Hendry, actor Kenneth Tobey had to be personally approved by then RKO chief Howard Hughes. Tobey recalled, "I walked in his office and he stared at me, looked me up and down, and said, 'Okay.' That was my Howard Hughes experience."

In order to make the actors' breath visible for the sequence in which the temperature drops suddenly, Hawks had the entire set built inside a twenty-five-degree ice-storage warehouse in Los Angeles.

MIND-BLOWING MOMENT

In a scene that predicts *Invasion of the Body Snatchers* (1956), Dr. Carrington grows seedling plants from the alien's severed arm. The blood-drinking pods emit faint squeals like hungry infants.

Tobey claimed Hawks did most of the directing, while Robert Cornthwaite remembered Nyby helming the scenes with Hawks standing by as a consultant.

A major influence on the work of John Frankenheimer, Ridley Scott, Tobe Hooper, and John Carpenter, *The Thing from Another World* single-handedly ushered in the era of serious science fiction when it was released in April of 1951. As the first "flying saucer" picture by a respected A-level producer, it legitimized the fledgling, often-derided genre of sci-fi cinema.

In the end, Douglas Spencer delivers the film's often-repeated final line that, in retrospect, sounds a little like a gauntlet thrown down to early 1950s Hollywood: "Watch the skies—everywhere. Keep looking. Keep watching the skies." Heeding these words, filmmakers and audiences would turn their attention toward unidentified flying objects overhead for the remainder of the decade.

KEEP WATCHING

IT! THE TERROR FROM BEYOND SPACE (1958)
PREDATOR (1987)

DIRECTOR: **ROBERT WISE** PRODUCER: **JULIAN BLAUSTEIN** SCREENPLAY: **EDMUND H. NORTH, BASED ON A STORY BY HARRY BATES** STARRING: **MICHAEL RENNIE (KLAATU), PATRICIA NEAL (HELEN BENSON), HUGH MARLOWE (TOM STEVENS), SAM JAFFE (DR. JACOB BARNHARDT), BILLY GRAY (BOBBY BENSON), FRANCES BAVIER (MRS. BARLEY), LOCK MARTIN (GORT)**

The Day the Earth Stood Still

TWENTIETH CENTURY-FOX • BLACK & WHITE, 92 MINUTES

A peaceful visitor
from another planet
lands in Washington, D.C.,
where a young widow
helps him deliver
an important message
to the world.

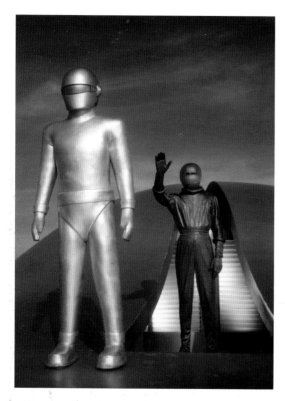

Afraid he might be a danger to Earth—or a Communist—the army panics and shoots Klaatu, only to have their weapons reduced to ashes by Klaatu's towering metal robot, Gort. Calling himself Mr. Carpenter, the spaceman escapes from the hospital and blends into the city while waiting for Earth's leaders to gather and hear the message he has traveled 250 million miles to deliver. The silent Gort, meanwhile, stands ready to annihilate at the first sign of aggression. Wise keeps the pace brisk, the camera work unobtrusive, and the special effects to a minimum as Klaatu's strange journey unfolds with startling realism.

"Farewell to the Master," a 1940 short story by Harry Bates, provided the basis for Twentieth Century-Fox's first sci-fi outing. Screenwriter Edmund North took the premise (space visitor Klaatu lands on Earth with a robot named Gnut) and fashioned a strikingly original and intelligent story, renaming the robot Gort and adding countless embellishments, like the characters of war widow Helen Benson (Patricia Neal) and her son, Bobby (Billy Gray), who befriend Klaatu. North even managed to weave in biblical and moral themes without mounting a soapbox. In fact, Robert Wise was unaware of the Christian

The Day the Earth Stood Still is not only one of the best science-fiction films in history, but a must-see masterpiece of American cinema. Chock-full of wisdom, wit, emotional resonance, and sheer entertainment value, The Day the Earth Stood Still is a moral message neatly disguised as a sci-fi thriller. Robert Wise directs with characteristic efficiency, allowing the compelling story to drive the action forward. "I like to grab an audience right at the very beginning," Wise once said, "and never let them go."

True to his word, Wise grips us right from the opening shot. Washington, D.C., is alarmed when a flying saucer whirrs to a halt on the Ellipse and a man named Klaatu emerges.

Top: Robert Wise
and crew on the set with
Michael Rennie

Bottom left: Michael
Rennie is outfitted with a
helmet by the Fox costume
department.

Bottom right: Patricia
Neal inside the spaceship
with Gort, played by
Lock Martin

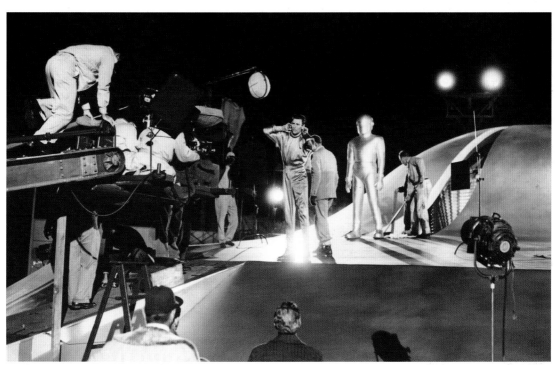

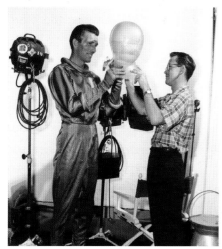

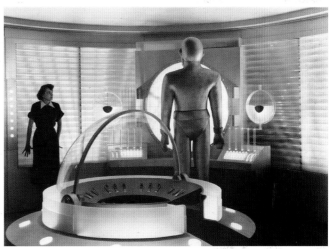

parallels—the gentle messenger called Carpenter who is shot, then resurrected—while shooting the film.

Casting the role of the Christ-like spaceman posed a challenge. Fox head Darryl F. Zanuck originally favored Spencer Tracy, Robert Wise envisioned Claude Rains, and producer Julian Blaustein wanted an unknown. The problem was solved when Zanuck spotted a tall British actor named Michael Rennie in a London play. Wise "lucked out," as he said, because Rennie was ideal for the part. He was also new to American films, which meant Klaatu carried no movie-star baggage when he stepped off the spaceship, adding to the story's believability. Michael Rennie was proud of his distinctive role, but initially approached the character of Klaatu with some uncertainty.

"How do you play a man from Mars?" Rennie said. "I had my doubts but Robert Wise, my director, was a terrific help. He told me to play him with dignity but without superiority—and that I did."

Patricia Neal brings a rich internal depth to Helen Benson, one of the few earthlings Klaatu can trust. In one sequence, Helen and Klaatu are trapped in an elevator when the power goes off. The only light source, emanating from a ventilator shaft, projects a claustrophobic grid of shadows as the two beings from different planets share a private talk about the fate of the world. Here, Wise—who edited *Citizen Kane* (1941) and worked with horror producer Val Lewton at RKO—uses darkness to superb effect. Bernard Herrmann's innovative score heightens the urgency and suspense without overshadowing the drama.

The film's climax is, quite literally, its message. Before soaring back to his planet, Klaatu finally delivers his warning: "The threat of aggression by any group anywhere can no longer be tolerated. . . . If you threaten to extend your violence, this Earth of yours will be reduced to a burned-out cinder." Its antiwar ideology earned the film a special Golden

Globe for Best Film Promoting International Understanding. Judging by the fact that it was remade as recently as 2008 (starring Keanu Reeves and Jennifer Connelly), the message resonates into this century.

Robert Wise went on to direct acclaimed classics in other genres—*West Side Story* (1961), *The Haunting* (1963), *The Sound of Music* (1965)—but would return to sci-fi with *The Andromeda Strain* (1971) and *Star Trek: The Motion Picture* (1979). Today, *The Day the Earth Stood Still* stands as one of his seminal works. As Wise himself observed in a 1988 interview, "By and large, it holds up damn well after all these years."

KEEP WATCHING

THE MAN FROM PLANET X (1951)
STARMAN (1984)

FAR-OUT FACTS

Gort was played by Lock Martin, who stood over seven feet tall—eight feet in his foam-rubber costume. Martin was not an actor but a doorman at Grauman's Chinese Theatre in Hollywood.

Klaatu's streamlined spaceship was designed by Lyle Wheeler to resemble liquid metal and to be operated completely by light rays. The practical model was constructed of wood and plaster over a wire frame and measured nearly one hundred feet in diameter.

The Day the Earth Stood Still is the first of eleven sci-fi movies referenced in the song "Science Fiction/Double Feature," the opening theme to *The Rocky Horror Picture Show* (1975).

MIND-BLOWING MOMENT

In the dead of night, Helen must deliver a message to Gort. Paralyzed with fear, she utters three little words that save her life, and the lives of everyone on Earth: "Klaatu barada nikto." Edmund North told Wise the meaningless phrase was something he "cooked up" because he "thought it sounded good."

DIRECTOR: JACK ARNOLD PRODUCER: WILLIAM ALLAND SCREENPLAY: HARRY ESSEX, BASED ON A STORY BY RAY BRADBURY STARRING: RICHARD CARLSON (JOHN PUTNAM), BARBARA RUSH (ELLEN FIELDS), CHARLES DRAKE (SHERIFF MATT WARREN), JOE SAWYER (FRANK DAYLON), RUSSELL JOHNSON (GEORGE), KATHLEEN HUGHES (JANE)

It Came from Outer Space

UNIVERSAL • BLACK & WHITE, 81 MINUTES

After witnessing a spacecraft crashing in the desert, a writer tries to convince his small community that benign aliens have landed.

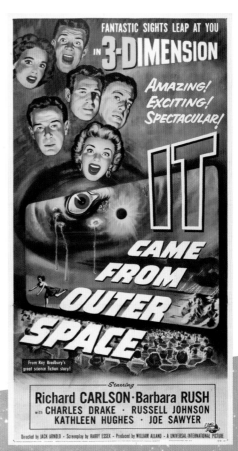

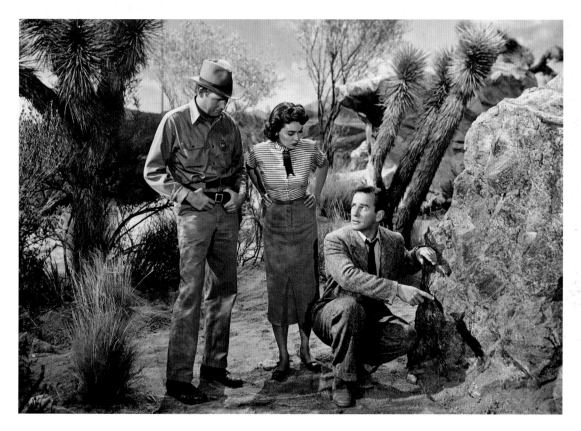

"**E**xcitement that can almost touch you!" This was one of Universal's taglines for the first 3-D science-fiction movie, *It Came from Outer Space*. Besides eye-popping 3-D thrills, the film boasts Clifford Stine and David Horsley's deep-focus cinematography, an atmospheric desert setting, a thought-provoking message of tolerance by fantasy author Ray Bradbury and director Jack Arnold, and a monster with his own point-of-view shots. It may have started as a gimmicky B movie, but *It Came from Outer Space* has come to be regarded as a classic.

Writer and stargazer John Putnam, played by stalwart 1950s sci-fi hero Richard Carlson, is the only citizen of Sand Rock, Arizona, who realizes the "meteor" that falls is actually a spaceship. Once he convinces others, it's too late. The aliens have already abducted and duplicated several people, including John's girlfriend, Ellen (a role that earned Barbara Rush a Golden Globe as Most Promising Female Newcomer). John discovers that the monstrous-looking xenomorphs are simply cloning people to help repair their ship so they can leave; they mean no harm. Or do they? It's difficult to trust them when his friends begin to disappear, and then reappear as emotionless clones, a plot twist that predicts the storyline of *Invasion of the Body Snatchers* (1956).

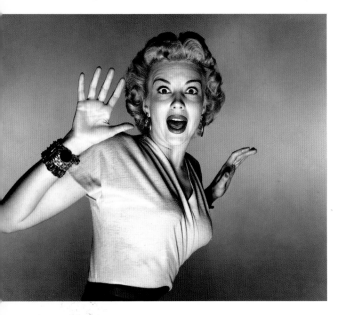

Though Ray Bradbury's attempt at a script was rejected by the studio, the bulk of his original story—and some of his poetic dialogue—made it into Harry Essex's final screenplay. As opposed to the malevolent Martians in the H. G. Wells classic *The War of the Worlds* (which was being adapted for the screen at Paramount while this film was shot and released), the aliens in *It Came from Outer Space* crash into Earth by accident, with neither good nor bad intentions. Instead of battles, Bradbury focuses on the townspeople's reactions to the creatures, raising questions about the way humans behave toward strange or different cultures. "They don't trust us," our hero says of the aliens, "because what we don't understand we want to destroy."

This was a lesson for the Cold War era, a time of fear and hostility beneath the placid surface. The United States was on high alert against a Communist takeover, and racial segregation was still the norm. "We are all prone—all of us," said director Jack Arnold, "to fear something that's different than we are, whether it be in philosophy, the color of our skins, or even one block against another." This same underlying message would also find its way into Arnold's later works of science fiction, including *The Creature from the Black Lagoon* (1954) and *The Incredible Shrinking Man* (1957). John Baxter, author of *Science Fiction in the Cinema*, characterizes Jack Arnold as "the great genius of American fantasy film," and compares his clarity of vision and craftsmanship to those of Alfred Hitchcock.

Keeping the 3-D effects natural and restrained, Arnold opts to use desert settings (shot in the Mojave Desert and the Universal back lot) to set a tone of quiet menace. Aside from the aliens that have landed there, the desert poses its own threats: the beating sun, the harsh landscape, the landslide that buries the spacecraft and almost kills John. Some of the most memorable dialogue is about the power of the desert. "It's alive and waiting for you," John warns Ellen, "ready to kill you if you go too far." A striking shot of Ellen's clone

Top: The alien, or as the crew called it, "the fried egg"

Bottom: The film's premiere at the Pantages Theatre in Hollywood

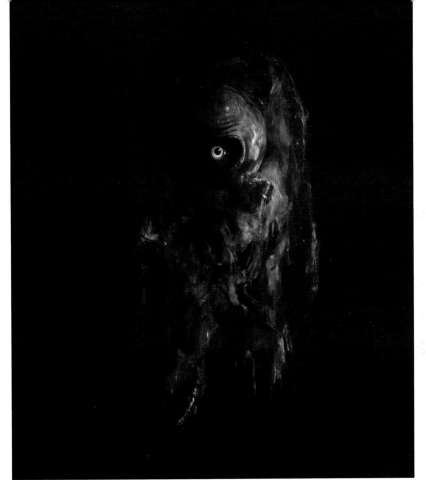

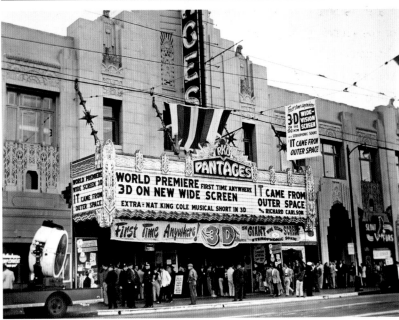

FAR-OUT FACTS

Producer William Alland had worked with Orson Welles's Mercury Theatre group in the 1930s and '40s, and played reporter Jerry Thompson in *Citizen Kane* (1941).

Stereoscopic three-dimensional film was so new in 1953 that the technology was still in the experimental stage. Effects photographer David Horsley worked for months to devise a 3-D system that basically consisted of two cameras side by side, one turned upside down.

When *It Came from Outer Space* was originally screened, the bosom of actress Kathleen Hughes was 3-D-enhanced in one scene. *Variety* noted that this use of the 3-D process showed "that sticks and stones are not the only things that can be projected into the auditorium."

MIND-BLOWING MOMENT

When John asks the xenomorph to show itself, he recoils in disgust as the hideous beast emerges from a cave. The creature was reportedly built, filmed, and destroyed in a single day to prevent word from leaking out about its appearance.

draped in a black evening gown atop a craggy hill is beautifully unsettling.

The xenomorphs were originally shot only from their point of view, accompanied by an eerie Theremin trill and a globular visual effect. None of the film's creative forces ever intended the creatures to be seen, but Universal panicked and decided to construct a monster at the last minute. Their creation resembles an amorphous fried egg with one eyeball in the center, and leaves a trail of sparkly space dust in its wake, like an intergalactic slug. Ray Bradbury, for one, felt the aliens were better left to the viewer's imagination. "I told the studio in my treatment that the suggestion of terror would be better than showing the monsters," Bradbury said. "But they insisted on showing the monster and, sure enough, there it is."

KEEP WATCHING

THE FLYING SAUCER (1950)
THE SPACE CHILDREN (1958)

DIRECTOR: BYRON HASKIN PRODUCER: GEORGE PAL SCREENPLAY: BARRÉ LYNDON, BASED ON THE NOVEL BY H. G. WELLS STARRING: GENE BARRY (DR. CLAYTON FORRESTER), ANN ROBINSON (SYLVIA VAN BUREN), LES TREMAYNE (GENERAL MANN), ROBERT CORNTHWAITE (DR. PRYOR), SANDRO GIGLIO (DR. BILDERBECK), LEWIS MARTIN (PASTOR MATTHEW COLLINS), HOUSELEY STEVENSON JR. (AIDE TO GENERAL MANN), PAUL FREES (RADIO ANNOUNCER)

The War of the Worlds

PARAMOUNT • COLOR, 85 MINUTES

A scientist and a teacher join forces to fight a race of killer Martians invading Earth.

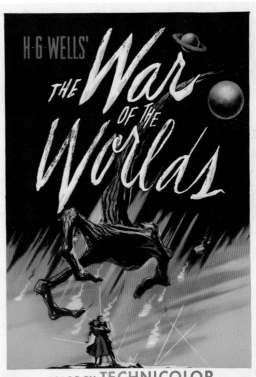

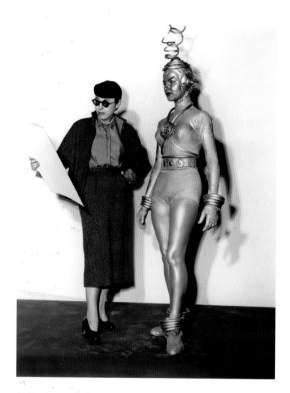

World War I and World War II, director Byron Haskin grounds the fantastic tale in the gritty realism of a newsreel before transitioning to color. Sir Cedric Hardwicke's godlike narration commands us to believe that Martians have decided to invade and colonize Earth— and the war is on. In the spirit of the novel, the movie focuses on regular people rather than presidents and generals: scientist Clayton Forrester and library-science teacher Sylvia Van Buren, played by Gene Barry and Ann Robinson, get to know each other better during the course of the invasion. Richly saturated in the rainbow of Technicolor, the film makes extensive use of paintings, models, and indoor sets (it was shot almost entirely on Stage 18 at Paramount), giving it a comic-book quality, an intriguing combination of reality and fantasy.

The fantasy element was courtesy of producer George Pal, who had ushered in the 1950s sci-fi craze with his low-budget lunar escapade *Destination Moon* (1950) and his follow-up, *When Worlds Collide* (1951). With the flying-saucer trend heating up, Pal knew the time was right to turn the 1898 H. G. Wells novel *The War of the Worlds* into a feature film. Orson Welles had panicked the

By 1953, extraterrestrial life was cropping up on movie screens across the nation, but the world had yet to witness a full-scale alien invasion. Enter *The War of the Worlds*, a blockbuster that launched itself on the unsuspecting public like a nuclear bomb. In this film, the aliens come not to strike bargains or issue warnings, but with one single mission: to annihilate life on Earth. It was World War III in full color, a bloodcurdling prospect for the Cold War crowd. "Viewers," *Variety*'s early review predicted, "will walk out of theatres relieved to find the world still as it was."

Without rushing, *The War of the Worlds* packs a lot into its swift eighty-five minutes. Opening with black-and-white footage of

Top: The Martian, created by Charles Gemora

Bottom: Art director Albert Nozaki's Martian machine

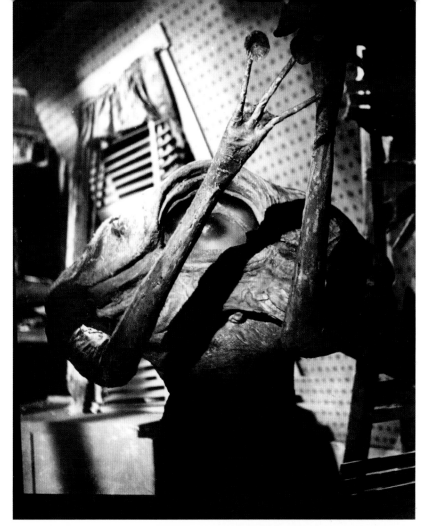

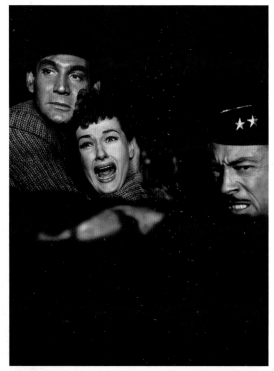

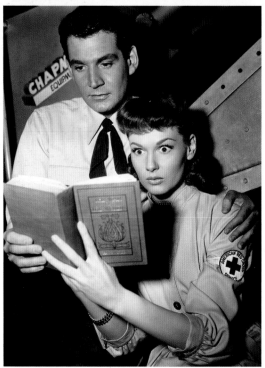

nation with his 1938 radio broadcast of the tale, but special-effects hurdles had always prevented a believable visualization from reaching the screen. As far back as 1926, Paramount announced that Cecil B. DeMille would direct a silent version of *The War of the Worlds*, but the technical obstacles proved impossible to overcome, and the property lay dormant until Pal revived it in 1952.

With only $2 million to dramatize Earth's war with Mars, Pal's team of artists and special-effects wizards had to get very creative. Switching Wells's setting from Victorian-era Sussex to modern-day southern California helped cut costs, but their biggest challenge was conjuring the Martian war machines described by Wells as having "tripod legs." Art director Albert Nozaki designed long, black legs on which the machines could walk, but they almost electrocuted the crew. George Pal recalled, "It was dangerous to generate a million volts on a regular soundstage. . . . It could have killed someone, perhaps set the studio on fire." So the legs were scrapped, and the Martian machines hovered in midair instead, suspended by barely noticeable wires.

The airborne machines are equipped with snakelike heat-rays that destroy everything—

humans, buildings, tanks—with a single blast. In one disturbing sequence, a pastor ventures toward one of the machines with a prayer and a cross, only to be incinerated to ashes in an instant. As the earthling death tolls start to rise, panic sets in, followed by mass hysteria. The undercurrent of paranoia tapped into America's Red Scare mentality, as did the religious motif, supplied not by H. G. Wells but by screenwriter Barré Lyndon. In the end, it is only a miracle "which God in his wisdom had put upon this earth" that can save humanity from the godless invaders.

Though very much a product of its era, *The War of the Worlds* remains a paragon of creative ingenuity and pre-CGI craftsmanship. It also set the standard for subsequent versions to follow, from *Independence Day* (a 1996 loose reworking of the story) to Spielberg's 2005 summer blockbuster, *War of the Worlds*.

KEEP WATCHING

WHEN WORLDS COLLIDE (1951)
INVADERS FROM MARS (1953)

FAR-OUT FACTS

The Martian seen grabbing Sylvia's shoulder and scurrying away was made and operated by sculptor Charles Gemora. Gemora and his daughter, Diana, constructed the monster from papier-mâché, wire, rubber, tape, and plywood the night before the scene was shot.

Gordon Jennings was in charge of the special effects. Sadly, Jennings died of a heart attack before the film was released, unaware that his work would win an Academy Award.

The U.S. War Department declined to provide the filmmakers with battle footage they requested, in part because the film, they said, "shows the military to be inept and incapable of stemming the imaginary attack from Mars."

MIND-BLOWING MOMENT

Moviegoers in the 1950s were horrified when the meteoric spacecraft unscrews and the sinister metallic probe emerges. Albert Nozaki designed the Martian machines in the shape of manta rays, their probes made to resemble cobras.

DIRECTOR: GORDON DOUGLAS PRODUCER: DAVID WEISBART SCREENPLAY: TED SHERDEMAN AND RUSSELL HUGHES, BASED ON A STORY BY GEORGE WORTHING YATES STARRING: JAMES WHITMORE (SERGEANT BEN PETERSON), EDMUND GWENN (DR. HAROLD MEDFORD), JOAN WELDON (DR. PATRICIA MEDFORD), JAMES ARNESS (ROBERT GRAHAM), ONSLOW STEVENS (BRIGADIER GENERAL ROBERT O'BRIEN), SEAN MCCLORY (MAJOR KIBBEE), CHRIS DRAKE (ED BLACKBURN), SANDY DESCHER (LITTLE GIRL), FESS PARKER (ALAN CROTTY)

Them!

WARNER BROS. • BLACK AND WHITE, 94 MINUTES

Martial law is declared in the city of Los Angeles when a police officer, an FBI agent, and two scientists track an invasion of giant mutated killer ants to the LA storm drains.

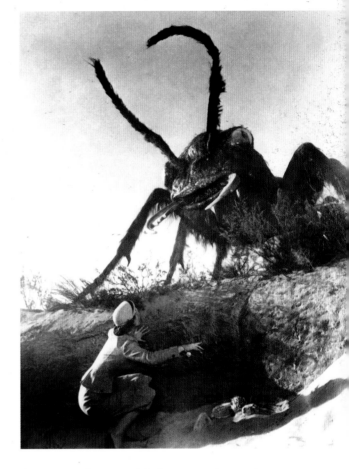

Joan Weldon meets a giant ant.

In 1954, something new was added to the pantheon of science-fiction cinema: the giant insect movie. As the first major entry in this subgenre, *Them!*, established the formula that the others followed. Shot in a straightforward, almost documentary style, the movie treats its subject seriously. The casting of beloved character actor Edmund Gwenn—who had won an Oscar for playing Santa Claus in *Miracle on 34th Street* (1947)—adds credibility to the fantastic concept of ants mutated into human-eating giants by atomic radiation.

No one knew what kind of long-term effects to expect from the first atom-bomb testing in Alamogordo, New Mexico, in 1945. By the 1950s, Hollywood's imagination ran wild. *The Beast from 20,000 Fathoms* (1953) was an example of atomic testing awakening a prehistoric beast, but insects didn't enter the picture until Warner Bros. purchased an original story by George Worthing Yates about mutant ants in the New York subway. It seemed outlandish, but screenwriter Ted Sherdeman instantly saw the cinematic possibilities. "Everyone had seen ants and no one trusted the atomic bomb, so I had Warner buy the story," Sherdeman remembered. The Manhattan locations—as well as the plans for WarnerColor and 3-D—were deemed too costly. The film was shot in black and white, and the settings switched to Los Angeles and New Mexico.

The studio kept the concept and production under tight security. Neither the film's title nor the early publicity materials revealed that the subject was, in fact, giant ants. The monstrous creatures don't even appear until nearly half an hour into the story. The film's first reel ramps up suspense by presenting seemingly unrelated oddities: a dazed young girl is found wandering the New Mexico desert

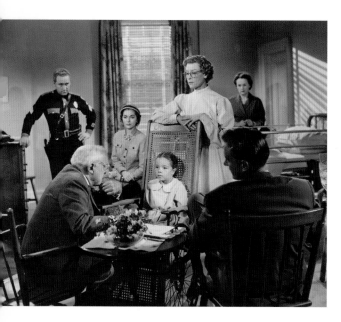

Edmund Gwenn and
Sandy Descher (seated)

alone; nearby, a general store is ransacked, its owner bludgeoned to death. Even after the myrmecologists (ant experts) are flown in to investigate, they don't mention the word "ants" until their hypothesis is confirmed.

The myrmecologists, Drs. Harold and Pat Medford, played by Edmund Gwenn and Joan Weldon, are a father-daughter team. A subtle back-burner romance is sparked between James Arness as FBI man Graham and Pat as they fight the irradiated insects together. For a change, the female love interest is not merely a passive damsel in distress, but a heroic scientist who insists on entering the danger zone right alongside the men in uniform. It was one small step forward for women in monster movies.

Larry Meggs was in charge of designing the mechanized ant-props that worked by a system of wires and pulleys. Though the ants

may not hold up under close scrutiny today, they managed to frighten and inspire a generation of future filmmakers who saw the movie as children, including Steven Spielberg and George Lucas. "I believed the ants in *Them!*," Lucas has said. "These are kind of corny big things, but they were scary enough to where I believed they were what they were." Because only two fully operational ants were made, only two ants at a time are seen moving on screen. The audience's imagination, spurred on by eerie chirping sound effects, provides the rest of the invasion.

If budget restrictions and the absence of technology prohibited a full-scale ant attack, the movie compensates by having terrified onlookers recount their stories. The traumatized little girl finally breaks her silence to scream, "Them! Them!" while another witness is committed to an insane asylum for ranting about huge airborne ants. When the colony's queens grow wings, they fly across the country stealing vast amounts of sugar, as ants are wont to do. In the case of twelve-foot-long ants, calling an exterminator is not enough—tanks, bazookas, machine guns, and flamethrowers courtesy of the U.S. military must be deployed.

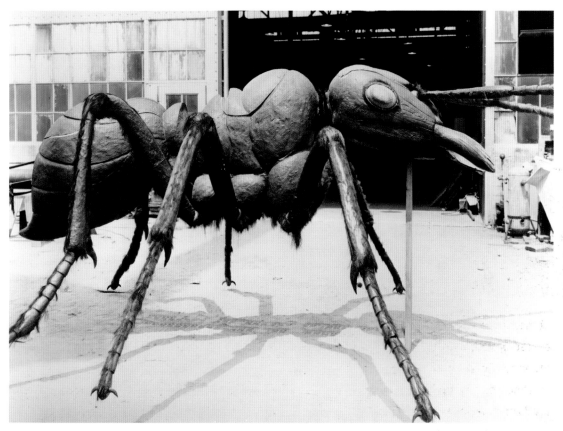

Top: One of two
twelve-foot ants built
for the film

Bottom: Edmund
Gwenn and Chris Drake

FAR-OUT FACTS

Them! was one of the most successful films of 1954, earning over $2.2 million in box-office returns.

Director Gordon Douglas recalled the oversize mechanical ants as "purple, slimy things. Their bodies were wet down with Vaseline. They scared the bejeezus out of you."

When Walt Disney saw Fess Parker as the Texas rancher who sees "flying saucers" shaped like ants, he cast him as the lead in the 1955 TV series *Davy Crockett: King of the Wild Frontier*. That same year, James Arness would find TV fame as Marshall Dillon in the series *Gunsmoke*.

MIND-BLOWING MOMENT

When the first giant ant appears in the desert, Pat Medford is almost caught in the mandibles of the ferocious beast. This was only a partial-body prop consisting of an ant's head and thorax mounted on a camera crane.

In the final scene, Gwenn gives voice to humanity's conscience when he muses, "When man entered the atomic age, he opened the door to a new world. What we will eventually find in that new world, nobody can predict." According to movies that followed *Them!*, that new world would be populated by gargantuan killer spiders, tarantulas, praying mantises, crabs, leeches, moths, mollusks, and even rabbits. These creature features tapped into the collective unconscious of the time, preying on atomic-age paranoia in the 1950s and '60s. In 2002, the genre was revisited with the giant-spider parody *Eight-Legged Freaks*.

KEEP WATCHING

TARANTULA (1955)
THE MONSTER THAT CHALLENGED THE WORLD (1957)

DIRECTOR: ISHIRO HONDA PRODUCER: TOMOYUKI TANAKA SCREENPLAY: TAKEO MURATA AND ISHIRO HONDA, BASED ON A STORY BY SHIGERU KAYAMA STARRING: AKIRA TAKARADA (HIDETO OGATA), MOMOKO KÔCHI (EMIKO YAMANE), AKIHIKO HIRATA (DAISUKE SERIZAWA-HAKASE), TAKASHI SHIMURA (KYOHEI YAMANE-HAKASE), FUYUKI MURAKAMI (PROFESSOR TANABE), SACHIO SAKAI (NEWSPAPER REPORTER HAGIWARA)

Gojira (Godzilla)

TOHO FILM CO. (JAPAN) • BLACK & WHITE, 96 MINUTES

When a giant prehistoric lizard is awakened by atom-bomb testing, a scientist and his fiancée must employ a secret weapon to stop the beast before it destroys Japan.

Haruo Nakajima
in costume as Godzilla

Say the name "Godzilla" to many people in the Western world, and they probably picture an actor in a lizard costume stomping on a miniature city of Tokyo. In fact, the original 1954 Japanese film is an expertly crafted and surprisingly poignant monster movie in which the monster is as much a victim of atomic warfare as the hapless bystanders he crushes.

Producer Tomoyuki Tanaka dreamed up *Gojira*—known to much of the world as *Godzilla*—as an answer to Hollywood's trend of creature features, particularly *The Beast from 20,000 Fathoms*, about a thawed Jurassic-era dinosaur who ravages New York City. Tanaka also took his inspiration from the real-life devastation of the 1945 atomic bombings in Hiroshima and Nagasaki. It had only been nine years since the mass destruction, so imagining a radioactive monster with the power to annihilate cities was all too easy for anyone in postwar Japan. When Tanaka's idea was realized by Toho Motion Picture Company, the *kaiju* (or giant monster) film officially arrived in Japan, and has since become a staple of Japanese cinema.

The director, World War II veteran Ishirô Honda, infused Japan's first monster movie with his pacifist beliefs. Making a film that directly addressed the atom bombings or condemned war in a literal sense would have been unthinkable in the political climate of the 1950s, so Honda, Tanaka, and screenwriter Takeo Murata used a grotesque giant to symbolize the horrors of war. Honda simply "took the characteristics of an atomic bomb," he said, "and applied them to Godzilla." The creature—a dormant prehistoric relic brought to life by radiation from the bomb—indiscriminately lays waste to everything in its path.

Though time and budget for special effects were limited, the filmmakers used the not-entirely-convincing puppets and foam-rubber suits to their best advantage. Rarely has a hand puppet been more effective than in the scene where Godzilla makes his first appearance, roaring over a hillside as villagers flee in a state of sheer panic.

Raymond Burr as reporter Steve Martin in *Godzilla, King of the Monsters!*

Until that moment, we only hear growls and ominous thudding footsteps, and see death and destruction caused by a massive unknown force. These images—along with the sequence showing children in the hospital orphaned by Godzilla's rampages—are among the film's most powerful.

For a monster movie, *Gojira* invests deeply in its human characters. Those who understand and attempt to defeat Godzilla include the respected Dr. Yamane, his daughter, Emiko, military officer Ogata, and the tortured scientist Dr. Serizawa. Serizawa, portrayed by *kaiju* regular Akihiko Hirata, is young and intense, burdened by his accidental discovery of a substance "as powerful as a nuclear bomb." Like Godzilla, he is scarred by radiation (his face is burned and he wears a patch over one eye), and ultimately realizes that only he has the power to destroy the monster.

Unlike most typical American films where Marines are enlisted to fight a towering mutant, the characters in *Gojira* are not action heroes. They represent a cross section of average Japanese society whose heroics "are the moral and ethical choices they make," Godzilla expert Steve Ryfle has noted, "rather than firing a bazooka or flying a fighter-plane."

Though violence abounds, Honda balances the action scenes with tense silences and hushed conversations occasionally broken by Akira Ifukube's striking, less-is-more musical score. The overall tone is at once horrifying, unsettling, and sad.

Gojira was a box-office smash in Japan, but the rest of the world was oblivious until American producer Edmund Goldman got hold of the film in 1955. Sensing that he had a potential moneymaker on his hands, he enlisted director Terry Morse to make the movie palatable to the U.S. market. Character actor Raymond Burr was cast in several newly shot scenes that were carefully edited into the original. Taking a foreign film and inserting new scenes in English was an unusual move for Hollywood—and it makes for an unusual film. The 1956 American-release version, *Godzilla, King of the Monsters!*, is a surreal

Top: Akira Takarada, Momoko Kôchi, and Akihiko Hirata in *Gojira*

Bottom:
The monster's rampage

concoction of Godzilla destroying Japan while Burr's American reporter looks on, narrating the action. The film's poetry and its antiwar message are largely lost in the translation.

A surprise hit in America and Europe, Morse's revamped version launched the world's fascination with Godzilla. Neither audiences nor critics seemed to notice the clever handi-work. *Variety* admitted that the film "more than taxes the imagination," but praised its "striking realism" and "startling special effects." Americans only had access to the Raymond Burr version until 2004, when the Japanese original was finally released around the world, and lauded as an unsung science-fiction classic. Godzilla's legacy of over thirty sequels and remakes has cemented his reputation as King of the Monsters.

KEEP WATCHING

RODAN (1956)
MOTHRA (1961)

FAR-OUT FACTS

Haruo Nakajima was the stunt performer inside the Godzilla costume. The suit was heavy, confining, and hot, but Nakajima endured, playing Godzilla in several sequels as well.

The creature's distinctive roar was achieved by recording the lowest strings of a contrabass and slowing down the playback speed.

Many viewers assumed Raymond Burr had shot *Godzilla, King of the Monsters!* in Japan with the original cast. In reality, he never met his Japanese costars. Burr's scenes were shot in Los Angeles over the course of three days.

MIND-BLOWING MOMENT

Godzilla's attack of the high-voltage barrier reveals the full extent of his atomic power. His radioactive breath melts the metal towers, an effect that was achieved by simply building the towers of wax and heating them.

DIRECTOR: RICHARD FLEISCHER PRODUCER: WALT DISNEY SCREENPLAY: EARL FELTON, BASED ON THE NOVEL BY JULES VERNE STARRING: KIRK DOUGLAS (NED LAND), JAMES MASON (CAPTAIN NEMO), PAUL LUKAS (PROFESSOR PIERRE ARONNAX), PETER LORRE (CONSEIL), ROBERT J. WILKE (FIRST MATE), TED DE CORSIA (COMMANDER FARRAGUT), CARLETON YOUNG (JOHN HOWARD)

20,000 Leagues Under the Sea

WALT DISNEY PRODUCTIONS, • COLOR, 127 MINUTES

A curious professor, his assistant, and a sailor become the first outsiders to board the *Nautilus*, a wondrous undersea vessel helmed by the enigmatic Captain Nemo.

One of Walt Disney's first full live-action features was an adventure tale with a strong undercurrent of science fiction as only Jules Verne could dream it. Using state-of-the-art 1950s technology, Disney revamped Verne's 1870 novel *Vingt mille lieues sous les mers: Tour du monde sous-marin (Twenty Thousand Leagues Under the Sea: An Underwater Tour of the World),* an odyssey about an amazing underwater craft, the *Nautilus.* In the novel, the submarine was merely a cigar-shaped vessel. By the time production designer Harper Goff was finished with it, the *Nautilus* sported a stylized sea-monster design, a large circular window like an eye gazing at the sea, and a souped-up engine running on atomic power. The luxurious inte-

riors described in the book, including a full Victorian-era lounge complete with a pipe organ, were lovingly re-created.

The first science-fiction movie shot in CinemaScope, *20,000 Leagues Under the Sea* made history as one of the costliest and most innovative productions of its time. The project attracted two top-tier stars, James Mason and Kirk Douglas, and spent over one full year on preproduction alone. Walt Disney himself selected Richard Fleischer to direct, knowing that he was the son of Disney's former rival, cartoonist Max Fleischer. The choice was a wise one. Fleischer (with the help of his screenwriter Earl Felton) delivered a piece of thought-provoking entertainment that has endured for generations. The director went on

Page 75: The two-ton mechanical giant squid

Top: James Mason, Peter Lorre, Kirk Douglas, and Paul Lukas

Bottom left: Walt Disney and Kirk Douglas on location in the Bahamas

Bottom right: The *Nautilus*

James Mason as
Captain Nemo

to build an impressive résumé that included two more sci-fi classics, *Fantastic Voyage* (1966) and *Soylent Green* (1973).

One of the film's most memorable scenes is the undersea battle with a giant squid that attacks the *Nautilus*. When Fleischer complained that the original squid looked too artificial, Uncle Walt had his Disneyland geniuses construct a $200,000 mechanized beast of mammoth proportions. Weighing over two tons, with ten arms and a retracting beak, it was a mass of wires, electronics, and hydraulics, and required thirty men to operate it. The squid helped earn the film an Oscar for Best Special Effects.

Groundbreaking visuals aside, *20,000 Leagues Under the Sea* remains a classic primarily because of the characters, and the actors who portray them. In a movie with so many gadgets and striking locations—not to mention a highly entertaining trained seal—it's easy for performers to get swallowed up by their surroundings. The larger-than-life Kirk Douglas as Ned Land adds a tremendous jolt of energy to the comedy and action scenes, effectively playing off the distinctive look and voice of the sad-eyed Peter Lorre. The genuine camaraderie on the set aided the comic chemistry between

the two. "I loved Peter, and we had a great time together," Douglas wrote in his 1988 autobiography. He also "loved the song," according to Fleischer. Douglas learned to play the guitar so he could sing and perform "A Whale of a Tale," one of the few songs the acclaimed actor sang in his sixty-two-year screen career.

James Mason owns the role of the intimidating Captain Nemo, and it's a difficult one. Mason nearly turned down the project because he couldn't find a "key" to unlock the inscrutable character. Nemo (Latin for "no one") is an unusual mixture of a dark Byronic antihero and a postmodern man. He's an environmentalist and antiwar activist before such terms were used; a violent radical fueled by

FAR-OUT FACTS

Richard Fleischer learned how to scuba-dive so he could orchestrate the large-scale scenes right there on the sea floor. The film's underwater shoot in the Bahamas made the cover of *Life* magazine on February 22, 1954.

___/\\/___

After the production wrapped, the giant squid and the *Nautilus* were retired to Disneyland's *20,000 Leagues Under the Sea* exhibit at Tomorrowland, where they remained on display for eleven years.

MIND-BLOWING MOMENT

In the end, Nemo's secret island of Vulcania is destroyed in a violent, bomblike explosion. Though not in the source novel, this was a cinematic choice made by the filmmakers to ensure a dynamic ending, and to make a "comment about the morality of the use of atomic energy," Fleischer said. The island's destruction was inspired by the massive volcanic eruption at the end of Verne's follow-up novel *The Mysterious Island*.

his hatred of violence. Mason, one of the rare conscientious objectors to World War II, had a powerful sensitivity that was tailor-made for Nemo. When contrasted with the extroverted style of Douglas, Mason's internal combustion becomes all the more potent. His depth lends believability to every scene in the film.

Before Disney's definitive version, two silent adaptations of *20,000 Leagues Under the Sea* had been made: one by Georges Méliès, in 1907, and one directed by John Williamson that pioneered underwater photography in 1916. It is a testament to the author's prescience that by the third adaptation in 1954, Jules Verne's science fiction had become science fact. The first atomic-powered submarine, appropriately named the USS *Nautilus*, was launched that same year. But when Verne first imagined them, a motorized submarine with an electrically lit interior and the aqualung that made undersea exploration possible were all just fantasies.

KEEP WATCHING

IT CAME FROM BENEATH THE SEA (1955)
VOYAGE TO THE BOTTOM OF THE SEA (1961)

DIRECTOR: FRED M. WILCOX PRODUCER: NICHOLAS NAYFACK SCREENPLAY: CYRIL HUME, BASED ON A STORY BY IRVING BLOCK AND ALLEN ADLER STARRING: WALTER PIDGEON (DR. EDWARD MORBIUS), ANNE FRANCIS (ALTAIRA MORBIUS), LESLIE NIELSEN (COMMANDER ADAMS), WARREN STEVENS (LIEUTENANT "DOC" OSTROW), JACK KELLY (LIEUTENANT FARMAN), RICHARD ANDERSON (CHIEF QUINN), EARL HOLLIMAN (COOK), MARVIN MILLER (NARRATOR/VOICE OF ROBBY THE ROBOT)

Forbidden Planet

MGM • COLOR, 98 MINUTES

In the twenty-third century, a crew sent to investigate a colonized planet finds only three inhabitants: a reclusive doctor with a dark secret, his beautiful daughter, and their servile robot.

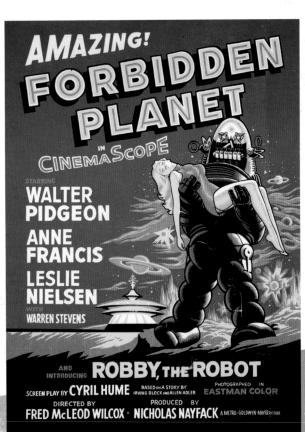

Leslie Nielsen's ray gun is powerless to stop the monster.

"We're all part monsters in our subconscious." This statement, spoken by Leslie Nielsen as Commander J. J. Adams, is the truth behind *Forbidden Planet*'s deadly secret, and the heart of its brilliance. Of all the space monsters in science-fiction cinema, perhaps none is more horrifying than the invisible, nameless force that wreaks havoc in *Forbidden Planet*—the repressed primitive beast buried within each person's mind. MGM took this weighty concept and dressed it in charming, fanciful wrappings. Lavishly designed sets, an otherworldly electronic score, clever comic touches, and a dash of sex appeal are the brightly colored ribbons that make the film a wholly satisfying package.

Metro-Goldwyn-Mayer was never a studio that blindly seized on the latest trends. Proud of its Latin motto *Ars gratia artis* (Art for art's sake), MGM took a careful approach to its first major science-fiction offering, sparing no expense to craft it with the sparkle and sheen the studio was famous for. The use of vivid Eastmancolor and CinemaScope raised the bar for 1950s sci-fi, a genre that consisted of mostly black-and-white B movies before *Forbidden Planet*. The sheer scale of the sets was extraordinary in its day. The scene in which Morbius, the commander, and Dr. Ostrow are shuttled deep within the cavernous Krell underground both recalls the grandeur of *Metropolis* (1927) and anticipates the spectacle of *2001: A Space Odyssey* (1968); the blue neon orbs forming a tunnel of light, the pulsating whirr of synthesized tones, and the mind-boggling system of ventilator shafts generate an almost hypnotic effect.

The script began as *Fatal Planet*, a loose adaptation of Shakespeare's *The Tempest*, set on the planet Mercury. Screenwriter Cyril Hume later decided on a more distant, exotic locale: the fictional world of Altair-4 in the farthest reaches of deep space. There, amid aquamarine skies, two moons, and a desert-oasis landscape resembling an undeveloped Palm Springs resort, the crew of the C-57D space cruiser finds the isolated Dr. Morbius, played to the hilt by Walter

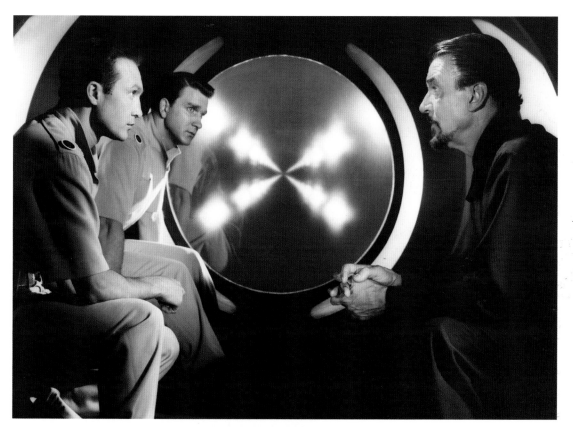

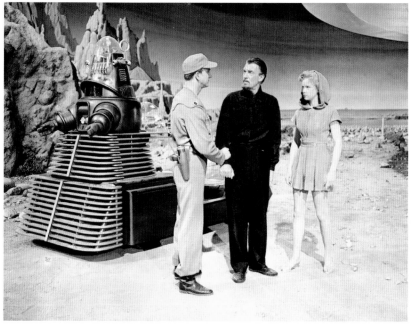

Top: Warren Stevens, Leslie Nielsen, and Walter Pidgeon go underground.

Bottom: Robby the Robot, Leslie Nielsen, Walter Pidgeon, and Anne Francis

Pidgeon, and his innocent daughter, Altaira (Anne Francis in her defining screen role). If Shakespeare provided the scenario, Sigmund Freud—along with a few concepts swiped from Robert Louis Stevenson's *Strange Case of Dr. Jekyll and Mr. Hyde*—inspired the rest of the premise. The Krell, an extinct race of beings on Altair-4 who destroyed themselves with too much knowledge (including the power of 9,200 thermonuclear reactors at their fingertips), serve as a sly comment on humanity's then-new acquisition of the nuclear bomb.

Despite its cerebral themes, *Forbidden Planet* has more fun with science fiction than any other space opera of its time. The film is filled with tongue-in-cheek humor, like Altaira asking "What's a bathing suit?" when Commander Adams finds her swimming in a pond, and Robby the Robot producing a truckload of bourbon on demand. Robby also shoots laser beams at mischievous monkeys and constructs elegant gowns for Altaira in his spare time. These whimsical details enrich the world of Altair-4 and nicely counterbalance the film's dark psychological undertones.

Helen Rose ingeniously designed Anne Francis's wardrobe, including what may have been the first ever mini-dresses. As the forthright and completely guileless Altaira, Francis adds an element of glamour to the often unglamorous world of science fiction. She sizzles with romantic innuendo as the only young woman on a planet surrounded by her choice of attractive men. Barefoot and bare-legged in micro-minis with strings of beads around her neck, Altaira's look truly forecasts the future; a decade after the film was released, this style would go mainstream.

Forbidden Planet's soundtrack also predicted the near future. Instead of music, the entire film is scored by electronic bleeps and gurgles from the homemade synthesizers

of Louis and Bebe Barron. The Barrons were hired to provide sound effects, but MGM made the bold choice to use their "electronic tonalities" as the actual musical score—or more accurately, the first non-musical movie score. Fifteen years before the electronic soundtrack for *A Clockwork Orange* (1971) would inspire a wave of synthesizer-based pop music, the Barrons created what they called "a new art form, completely electronic."

From the score to the set design, *Forbidden Planet* was given a full A-picture treatment. The result is not only a timeless classic, but one that elevated science fiction to a new level, encouraging other major studios to delve into the realm of big-budget sci-fi. The film's influence can be detected in the *Star Wars* franchise, and it served as Gene Roddenberry's inspiration for the original *Star Trek* TV series.

KEEP WATCHING

THIS ISLAND EARTH (1955)
STAR TREK II: THE WRATH OF KHAN (1982)

1956

DIRECTOR: DON SIEGEL PRODUCER: WALTER WANGER SCREENPLAY: DANIEL MAINWARING, BASED ON THE COLLIER'S MAGAZINE SERIAL BY JACK FINNEY STARRING: KEVIN McCARTHY (DR. MILES BENNELL), DANA WYNTER (BECKY DRISCOLL), LARRY GATES (DR. DANNY KAUFFMAN), KING DONOVAN (JACK BELICEC), CAROLYN JONES (THEODORA "TEDDY" BELICEC), JEAN WILLES (NURSE SALLY WITHERS), RALPH DUMKE (POLICE CHIEF NICK GRIVETT), VIRGINIA CHRISTINE (WILMA LENTZ)

Invasion of the Body Snatchers

ALLIED ARTISTS • BLACK AND WHITE, 80 MINUTES

A small-town doctor is reunited with his high-school sweetheart as they fight the emotionless alien clones that are replacing their friends and neighbors.

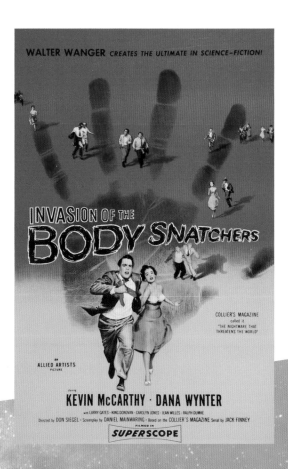

While other 1950s sci-fi pictures were scrambling to outdo each other with increasingly elaborate monsters, spaceships, and robots, Don Siegel's brilliantly streamlined *Invasion of the Body Snatchers* surpassed them all with its encroaching grip of psychological terror. This is science fiction meets film noir, its story told in a flashback, with shadowy lighting and off-kilter angles. The enemy is not a man from space, but plants from space: plants that grow into seedpods with the ability to replicate and replace humans down to the last detail, except the very essence that makes them human.

Plant life surrounds us—the trees in the yard, the flowers in the vase at home, the potted plants in the office—but Jack Finney was the first writer to introduce menacing vegetation into popular fiction. According to author Stephen King, Finney's original tale *The Body Snatchers* "set the mold for what we now call the horror novel." When the first part of Finney's saga appeared in *Collier's* magazine in 1954, Walter Mirisch, head of Allied Artists studio, purchased the screen rights and hired Walter Wanger to produce the adaptation as a quick B picture. Talented theater actors were cast instead of big-name

stars: Kevin McCarthy as Dr. Miles Bennell and Dana Wynter as his love interest, Becky Driscoll. Shot for $350,000 at real California locations on a brisk nineteen-day schedule, the film is a masterpiece of economy.

From the moment Miles arrives in his hometown of Santa Mira, he notices strange goings-on. People are changing, but no one can say exactly how. A tense mood is established using dialogue, editing, and subtly dramatic music. With a bare minimum of special effects, suspicion gradually ramps up to paranoia, then sheer terror. The only effects used were plaster of Paris molds of the actors, prop seedpods, and a few soap bubbles.

Director Siegel's original cut was even shorter than the eighty-minute final version, but the studio "pods" (as Siegel called the men in charge) insisted on bookending the film with scenes of Miles seeking help from

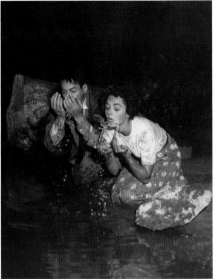

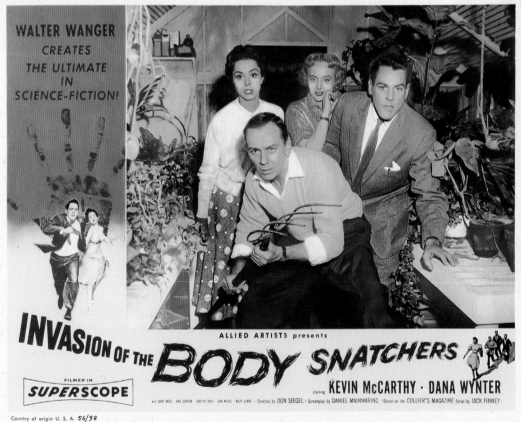

doctors in a nearby town. The authorities are alerted to the alien invasion, ensuring a more hopeful ending. Though Siegel and latter-day fans have criticized the film for these additions, Finney's original story ended even more optimistically, with all four main characters surviving and triumphing over the pods.

Largely dismissed by serious film critics at the time of its release, *Invasion of the Body Snatchers* has thrived, like its unstoppable pods, and firmly implanted itself in our culture. Its impact can be seen across all film genres, from the psychological suspense of *The Stepford Wives* (1975) to the monster that gets you while you sleep in *A Nightmare on Elm Street* (1984) to the musical comedy about a man-eating alien plant, *Little Shop of Horrors* (1986). Hollywood has even remade the film three times.

Updating a sci-fi classic is not easy, but renegade director Philip Kaufman managed to do justice to the original with his paranoid, hyperrealistic 1978 reboot. Kaufman's *Invasion of the Body Snatchers* speculates what would happen if the pods from 1956 found their way

from the small town of Santa Mira to the city of San Francisco, twenty-two years later.

This time, telling the difference between clones and humans is more challenging in the teeming ratrace of modern urban life. Health-department workers Elizabeth (Brooke Adams) and Matthew (Donald Sutherland) and their friends Jack and Nancy—brought to life with endearingly human quirks by Jeff Goldblum and Veronica Cartwright—seem to be the only four people in the city who notice the takeover. Leonard Nimoy as psychiatrist Dr. David Kibner, attempts to explain the phenomenon away with Spock-like analysis, but his logic only serves to make him virtually indistinguishable from his duplicate. Nancy, a freethinker

FAR-OUT FACTS

Dana Wynter begged Walter Wanger to change the film's title. "How can I admit to my parents that I'm doing a picture called *Invasion of the Body Snatchers*, for God's sake?" she said. "They'll think I'm demented!"

Daniel Mainwaring, who adapted Jack Finney's novel into a screenplay, also wrote under the name of Geoffrey Homes. Mainwaring was best known for penning crime novels and films noir, such as *Out of the Past* (1947) and *The Big Steal* (1949). *Invasion of the Body Snatchers* was his first and only foray into science fiction.

MIND-BLOWING MOMENT

When Miles discovers the pods growing in the greenhouse, he must destroy his own duplicate self with a pitchfork. For this crucial scene, Kevin McCarthy was warned by Siegel that he only had one chance to stab the rubber pod-body through the heart, because there was no time or money to have a second one made. The director was heard to instruct, "For God's sake, stab it, don't just pierce it, and don't miss!"

who plays music for her plants, is the unsung hero of the story. Her belief in aliens and conspiracy theories arms her with the skills to fight the pod people until the bitter end—and Kaufman's ending is much more bitter than Siegel's.

Invasion of the Body Snatchers endures because of its underlying message. In fact, the message may be more relevant than ever in today's digital age, when a steady barrage of increasingly sophisticated gadgets makes us feel less than human. A line from Finney's novel, "Sometimes I think we're refining all humanity out of our lives," could apply to a variety of refinements of modern-day existence, from GPS to texting.

KEEP WATCHING

I MARRIED A MONSTER FROM OUTER SPACE (1958)
VILLAGE OF THE DAMNED (1960)

DIRECTOR: JACK ARNOLD PRODUCER: ALBERT ZUGSMITH SCREENPLAY: RICHARD MATHESON, BASED ON HIS NOVEL STARRING: GRANT WILLIAMS (SCOTT CAREY), RANDY STUART (LOUISE CAREY), APRIL KENT (CLARICE BRUCE), PAUL LANGTON (CHARLIE CAREY), RAYMOND BAILEY (DR. THOMAS SILVER), WILLIAM SCHALLERT (DR. ARTHUR BRAMSON)

1957

The Incredible Shrinking Man

UNIVERSAL • BLACK AND WHITE, 81 MINUTES

A man is accidentally exposed to nuclear radiation and pesticide, causing him to shrink at a horrifying rate.

MUST-SEE SCI-FI

At first glance, *The Incredible Shrinking Man* may appear to be just another artifact of atomic-age paranoia. On the surface, it presents a straightforward narrative about a man faced with the nightmare of growing smaller every day until he is barely visible, and how he deals with his predicament. But deeper layers abound, making this one of the most timeless, thought-provoking movies of its kind. Underappreciated when it was released in 1957, *The Incredible Shrinking Man* was later rediscovered and hailed as essential science fiction.

Scott Carey, played by Grant Williams, could be any one of us. He's an average guy with a wife, a job, a house in the suburbs, and a cat. By a freak occurrence, he is exposed to chemicals that alter his body's molecular structure, reversing the growth process. Writer Richard Matheson and director Jack Arnold took a premise that is not only fantastic but bordering on downright ludicrous, and managed to make it utterly believable and compelling. Even in the film's more outlandish moments—such as the revelation that Scott must live in a doll's house and wear tiny doll clothes—we feel the protagonist's anguish more acutely than we feel the desire to laugh.

While movies like *Them!* (1954) tapped into concerns about the atomic bomb, *The Incredible Shrinking Man* hits a much deeper, more sensitive nerve: the innate human fear of being powerless and irrelevant. As Scott loses his physical size and his self-worth, his diminished ego leads him to ruthlessly berate his wife, Louise, as she gradually becomes a giant. "Every day a little smaller," he confides via voiceover, "and every day I became more tyrannical, more monstrous in my domination of Louise." Their scenes together boil over with subtext about physical, sexual, and psychological power struggles, feeding into the overall theme of dominance versus vulnerability. When a man loses his corporeal identity, the movie seems to ask, does he still matter? In Scott's case, he succumbs to bitterness and self-hatred when his personal myth of male superiority is shattered.

Once the shrinking man reaches the size of a mouse, he is attacked by the family cat and pitched into the depths of the basement. The film shifts dramatically at this point as Scott descends into a primitive underworld where size no longer matters—only survival. Microscopically small and clad in toga-like rags, he wields a sewing pin as a makeshift sword and stabs a mammoth spider through the heart like an ancient gladiator to win the spoils: a crumb of cake trapped in the spider's web. By asserting his dwindling physical power, Scott has proven his dominance over his minute corner of the universe.

Director Jack Arnold stays faithful to the spirit of Richard Matheson's harrowing novel *The Shrinking Man* while filtering the tale through his own perspective. Arnold—one of the era's greatest B-movie auteurs—helmed several popular sci-fi titles (*It Came from Outer Space* [1953], *The Creature from the Black Lagoon* [1954], *Tarantula* [1955], *The Space Children* [1958]), but *The Incredible Shrinking Man* remains the jewel in his crown. Universal put pressure on Arnold to end the film happily by having the protagonist return to his normal size. "Over my dead body," the director replied, and insisted on penning the

MUST-SEE SCI-FI

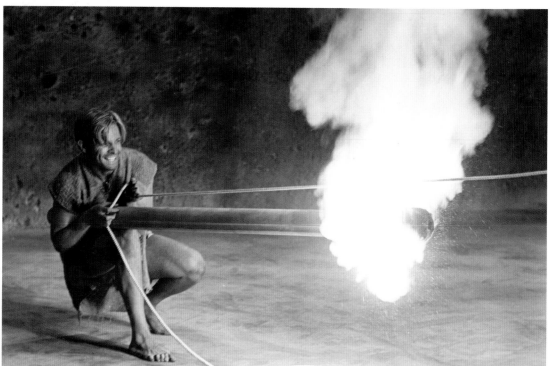

Top: Grant Williams
as Scott Carey takes
on a spider.

Bottom:
Lighting a match

poignant dialogue for the film's final scene himself. "This is not a film suited to a happy ending," Arnold explained to the studio.

At the end of Scott Carey's ever-narrowing road lies an unexpected spiritual epiphany, a level of insight rare for 1950s sci-fi. According to Steven Spielberg, who was impacted by the film as a child, "*The Incredible Shrinking Man* is one of the best science-fiction films ever made, with a very profound message about not outer space, but inner space—about the soul." The shrinking man finally finds acceptance as he escapes his basement prison and gazes up at the night sky. "All this vast majesty of creation," he ponders, "it had to mean something. And then I meant something too. Yes, smaller than the smallest, I meant something too."

KEEP WATCHING

ATTACK OF THE PUPPET PEOPLE (1958)
THE LAST MAN ON EARTH (1964)

FAR-OUT FACTS

Several large-scale replicas were constructed for the film's later scenes, including an enormous spiderweb, a giant windowsill, and a huge match-box. A combination of perspective filming, double exposure, and rear projection was used to create the illusion of a shrinking man.

To cast the role of the spider, Jack Arnold had sixty different tarantulas flown in from Panama. "Domestic ones were too small and we couldn't keep a sharp focus on them," he said.

Orson Welles provided narration for the movie's theatrical trailer while he was on the Universal lot working on *Touch of Evil* (1958).

MIND-BLOWING MOMENT

Scott's cat—who begins as a friendly house pet—eventually turns on its shrunken master in a vicious surprise attack. The cat was portrayed by Orangey, a marmalade tabby best known for her role as Cat in *Breakfast at Tiffany's* (1961).

DIRECTOR AND PRODUCER: KURT NEUMANN **SCREENPLAY:** JAMES CLAVELL, BASED ON A STORY BY GEORGE LANGELAAN **STARRING:** AL HEDISON (ANDRÉ DELAMBRE), PATRICIA OWENS (HÉLÈNE DELAMBRE), VINCENT PRICE (FRANÇOIS DELAMBRE), HERBERT MARSHALL (INSPECTOR CHARAS), KATHLEEN FREEMAN (EMMA), BETTY LOU GERSON (NURSE ANDERSONE), CHARLES HERBERT (PHILLIPE DELAMBRE)

The Fly

TWENTIETH CENTURY-FOX • COLOR, 94 MINUTES

When an inventor is killed by his wife, his brother and a police detective learn the gruesome truth about his failed teleportation experiment.

On the subject of performing in monster movies, horror legend Vincent Price once remarked, "You have to make the unbelievable believable." Perhaps no science-fiction thriller of the 1950s accomplishes that feat better than Kurt Neumann's *The Fly*. At once preposterous and disturbingly credible, the story of a scientist who accidentally turns himself into a monstrous half bug has remained embedded in our culture's collective unconscious since 1958. After generating two sequels (*Return of the Fly* [1959] and *Curse of the Fly* [1965]) and a popular 1980s remake with its own sequel, *The Fly* retains its morbid fascination today.

Neumann, who had been directing in Hollywood since the 1930s (he was Carl Laemmle's first choice to helm *Bride of Frankenstein* in 1935), had never quite distinguished himself until *The Fly*. The German director wisely stays faithful to George Langelaan's 1957 short story and opens with a grisly death: scientist André DeLambre (Al Hedison, later known as David Hedison) is pulverized in a hydraulic press by his loving wife, Hélène, played by Patricia Owens. Vincent Price, cast against type as André's mild-mannered brother, François, plays it straight and subdued as he and Herbert Marshall's police inspector learn the incredible story told by Hélène. Veteran cameraman Karl Struss photographs the shocker like a Douglas Sirk melodrama, a nightmarish soap opera viewed from the perspective of a '50s housewife. Because its setting is a plush upper-class home—not a dim Gothic castle or a barren planet in the depths of space—*The Fly* festers with an undercurrent of sickening abnormality beneath its glossy CinemaScope surface.

Except for a few memorable visual tricks (courtesy of makeup artist Ben Nye and effects photographer L. B. Abbott), psychological horror dominates the film. André's transformation is left up to the viewer's imagination; we never see his ill-fated teleportation excursion, unwittingly made with a housefly inside the "disintegrator-integrator." Over an hour into the film, Hélène learns that her husband's atoms became tangled with the fly's—even the insect's brain has somehow merged with his own. André's typed explanation for wanting himself destroyed is disconcerting, to say the least: "Brain says strange things now." Lines such as this were not in the original story, but furnished by screenwriter James Clavell, who would later pen *The Great Escape* (1963) and the 1975 novel *Shōgun*. Clavell enriched the script with smart, idea-driven dialogue that questions blind technological advancement. "Rockets,

Earth satellites, supersonic flight, and now this," Hélène says of her husband's invention. "Everything's going so fast." André is not frightened by progress, he says, but "filled with a wonder of it." Like most inventors in sci-fi movies, this intoxication with scientific progress becomes his downfall.

One of the most iconic scenes in science-fiction cinema occurs when Hélène whisks the black shroud from André's head to reveal his hideous fly-face. Patricia Owens's shrieks of terror are multiplied into a honeycomb of screams, a fly's eye view created by Abbott's innovative use of a prism lens. Hélène faints at the bone-chilling sight, but soon emboldens herself to carry out André's wishes—she literally squashes the fly. As Jonathan Malcolm Lampley observes in his book *Women in the Horror Films of Vincent Price*, "In a very literal sense, *The Fly* is about a woman who must clean up the mess made by a man." Indeed, in the end, Hélène seems relieved, even happy, to be rid of the filthy abomination her husband had become.

Unlike many of the era's monster movies, *The Fly* was critically praised. The *New York Times* called it "a quiet, uncluttered, and even unpretentious picture, building up almost

Top: Al Hedison as
the Fly

Bottom left:
Patricia Owens, Vincent
Price, and Al Hedison
take a break.

Bottom right: Geena
Davis and Jeff Goldblum in
David Cronenberg's 1986
remake of *The Fly*

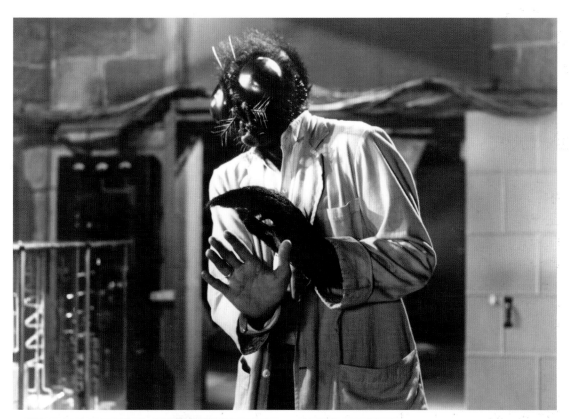

FAR-OUT FACTS

Some of André's laboratory equipment had been used as EMERAC, the computer in the Fox comedy *Desk Set* (1957), with Katharine Hepburn and Spencer Tracy. The rest was recycled from U.S. Army and Air Force surplus.

An early advertising campaign for the 1958 film used the tagline "Don't be afraid of *The Fly* . . . even if it scares the wits out of you!" Ads for the 1986 remake featured a twist on this line, a piece of dialogue from the movie that became a catchphrase: "Be afraid. Be very afraid."

MIND-BLOWING MOMENT

François and Inspector Charas witness proof of Hélène's unbelievable story when they see a human-headed fly trapped in a spiderweb squealing, "Help me!" While filming this scene, Vincent Price and Herbert Marshall had a hard time maintaining their composure. "We couldn't look each other in the face," Price recalled. "Herbert and I kept ruining the takes by breaking up and laughing ourselves sick."

unbearable tension by simple suggestion." Sadly, Kurt Neumann scarcely had a chance to enjoy his magnum opus—he died a month after the film's release.

Nearly thirty years later, David Cronenberg's 1986 version of *The Fly* was a much-buzzed-about hit and an Oscar winner for Best Makeup. Where Neumann's film relied on suggestion, Cronenberg took the opposite approach, illustrating every disgusting detail of Seth's (Jeff Goldblum) gory transformation into a massive insect, as his girlfriend (Geena Davis) watches in abject horror and pity before finally finishing him off with a shotgun.

KEEP WATCHING

DONOVAN'S BRAIN (1953)
THE WASP WOMAN (1959)

DIRECTOR: IRVIN S. YEAWORTH JR. PRODUCER: JACK H. HARRIS SCREENPLAY: THEODORE SIMONSON AND KATE PHILLIPS, FROM AN ORIGINAL IDEA BY IRVINE S. MILLGATE STARRING: STEVE MCQUEEN (STEVE ANDREWS), ANETA CORSAUT (JANE MARTIN), EARL ROWE (LIEUTENANT DAVE), OLIN HOWLIN (OLD MAN), STEVEN CHASE (DR. T. HALLEN), JOHN BENSON (SERGEANT JIM BERT), GEORGE KARAS (OFFICER RITCHIE)

The Blob

PARAMOUNT • COLOR, 86 MINUTES

A group of teenagers tries to convince the police that a deadly glob of intergalactic goo has landed in their small town.

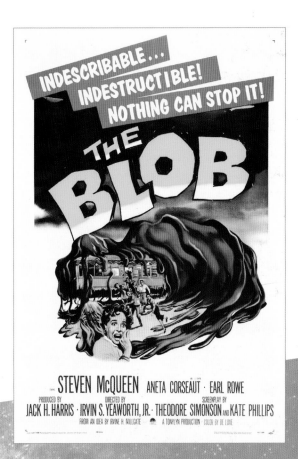

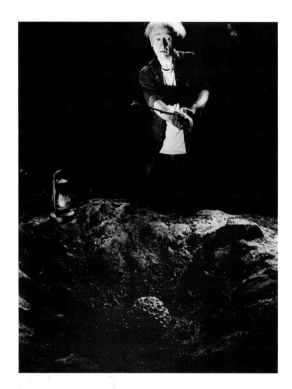

What do you get when you cross the misunderstood teenagers from *Rebel Without a Cause* (1955) with the creeping space fungus from *The Quatermass Xperiment* (1955)? Science fiction's most celebrated slime of all time: *The Blob*. A tour de force of 1950s low-budget filmmaking—complete with a campy concept, a surprisingly sensitive and optimistic script, and a young(ish) Steve McQueen in his first starring role—*The Blob* has slithered its way into the hearts of fans for generations.

The birth of *The Blob* is the stuff of B-movie legend. Its producer, Pennsylvania film distributer Jack H. Harris, had one dream: to combine two hot box-office trends—juvenile delinquency and sci-fi—

in a single movie. Its director, Irvin "Shorty" Yeaworth, was a Methodist minister who couldn't make it to the set on Sundays (he was needed to play the organ in church). Its screenwriter, Ted Simonson (also a minister), had only written educational Christian films until he tackled *The Blob*. Together, they concocted one of the most endearing monster movies in horror history. "We thought it would give an extra layer to the picture to have the bad kids be good kids," Harris said. Instead of being delinquents, the teens of *The Blob* are more heroic than the adults. Rambunctious but well intentioned, they save their suburb from a gelatinous substance that oozes forth from a meteorite, devouring everything in its path. Growing redder and more bloated with the blood of its victims, the jellylike mass threatens to consume the Earth until Steve, Jane, and the gang discover its preference for tropical temperatures.

Twenty-seven-year-old McQueen (credited as "Steven") was working regularly in television but struggling to land film roles at the time. Harris gave him his big-screen break—in DeLuxe color, no less—with *The Blob*, though there was a catch: McQueen had to play a high-school kid. "I'm a Method actor,"

Top: The blob

Bottom left: A lobby card featuring Aneta Corsaut, Steve McQueen, Olin Howlin, and Steven Chase

Bottom right: Teenagers save the world in *The Blob*.

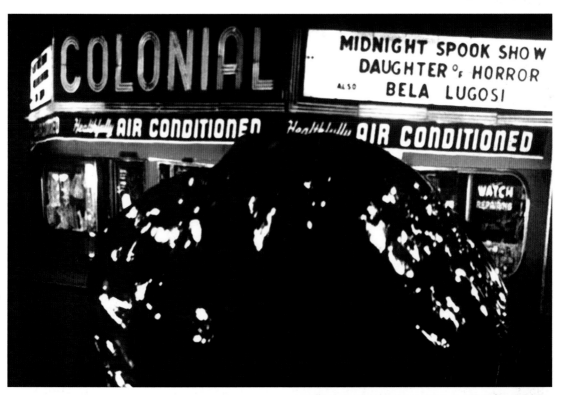

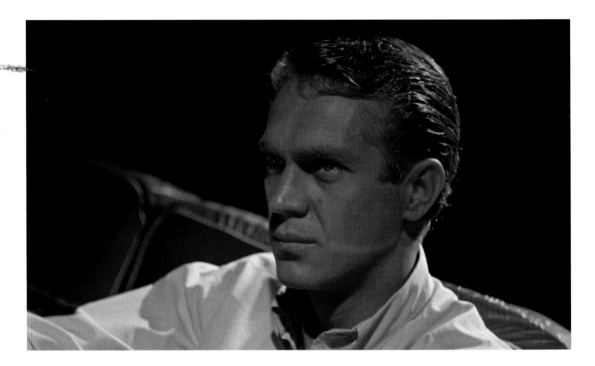

he assured the producer, "and I can do it." Sure enough, the star-to-be pulls it off with characteristic charm. McQueen's burgeoning "icon of cool" persona can even be glimpsed here and there. When the blob threatens Jane in the canned goods section of the grocery store, Steve leaps over the aisle to the rescue as "Cooler King" Virgil Hilts in *The Great Escape* (1963) might do; the backward car-race scene evokes images of a mature McQueen behind the wheel in *Le mans* (1971). His electric energy helps to bring *The Blob*'s squeaky-clean dialogue and naive visual effects to life.

Shot entirely in the Phoenixville, Pennsylvania, area with hundreds of locals in supporting roles, the film was truly a hometown project—and it shows. Only a picture made outside of the Hollywood system could capture midcentury American life with the simplicity and sincerity of *The Blob*. The snappy theme song (by a young Burt Bacharach) and animated credits sequence set the tone for the movie's playful innocence, and its hopeful finale: The teens that nobody would believe ("they're just kids") end up uniting the whole town to fight the viscous alien invader. *The Blob* even gave its filmmakers their own happy ending. Harris—who had mortgaged his home and borrowed against his children's life insurance policies to raise the $130,000 budget—recouped his expenses three times over when, miraculously, Paramount Pictures snatched up the homegrown sci-fi effort and distributed it across the country.

Reviewers didn't think much of the film. *Cue* magazine's critic even accused *The Blob*

of promoting emotional disturbance in children and recommended boycotting it. But the public couldn't get enough. It did tremendous drive-in business, and was reissued to theaters in 1964 before squishing its way onto TV and home video. A 1972 sequel was made (*Beware! The Blob*) followed by a $19 million remake in 1988. The lavish revamp was quickly forgotten, proving that bigger is not always better. Today, the original still prevails. In 2000, director Yeaworth—seemingly unaware of the parallel between his film's longevity and its gooey monster—said earnestly of *The Blob*, "It just won't die, somehow."

KEEP WATCHING

X THE UNKNOWN (1956)
FIEND WITHOUT A FACE (1958)

FAR-OUT FACTS

The blob—which is never referred to as "the blob" in the film—was made of colored silicone manufactured by a Union Carbide plant in Sistersville, West Virginia.

For two weeks, the filmmakers brainstormed titles. *The Meteor Monster*, *The Molten Meteor*, *The Night of the Creeping Dead*, *The Glob That Girdled the Globe*, and *The Glob* were working titles before they finally settled on *The Blob*.

Once he became a big star, Steve McQueen often made disparaging remarks about the film, but came to grudgingly appreciate it later in life. When McQueen died of cancer in 1980, the only piece of decor hanging on his bedroom wall was a framed poster for *The Blob*.

MIND-BLOWING MOMENT

Toward the end of its reign of terror, the giant blob oozes through the projection booth of a movie theater, sending the crowd below into a panic. The famous scene of the audience running out of the Colonial Theatre is ritually reenacted every year at Blobfest, a Phoenixville event that draws thousands of fans.

DIRECTOR AND PRODUCER: GEORGE PAL SCREENPLAY: DAVID DUNCAN, BASED ON THE NOVEL BY H. G. WELLS STARRING: ROD TAYLOR (H. GEORGE WELLS), ALAN YOUNG (DAVID FILBY/JAMES FILBY), YVETTE MIMIEUX (WEENA), SEBASTIAN CABOT (DR. PHILIP HILLYER), TOM HELMORE (ANTHONY BRIDEWELL), WHIT BISSELL (WALTER KEMP)

The Time Machine

MGM • COLOR, 103 MINUTES

An inventor in 1899 London constructs a machine that sends him 800,000 years into the future, where he encounters a strange utopian society.

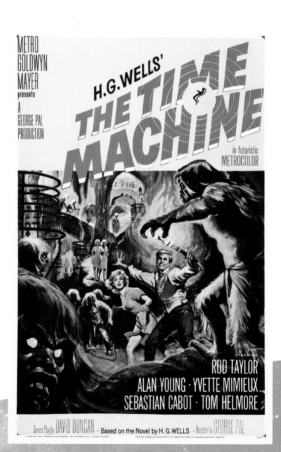

Top: A Morlock captures Yvette Mimieux.

Bottom: George fends off the Morlocks.

Leave it to producer/director George Pal to take a visionary, socially conscious, and often dismal story from the mind of H. G. Wells and transform it into a colorful screen fantasy. After conquering Mars with *The War of the Worlds* (1953) and winning a Best Special Effects Oscar for *Tom Thumb* (1958), the former animator reached the pinnacle of his career with his adaptation of Wells's definitive time-travel chronicle, *The Time Machine*. On a threadbare budget (between $600,000 and $800,000), Pal and his crew fashioned an escapist sci-fi adventure for the ages starring an ornate Victorian time machine that sends its inventor on a wondrous journey across the centuries.

Instead of modernizing the 1895 tale, Pal honored Wells's era by selecting 1899 as a point of departure. "If you start the film at the turn of the century and show this machine working up to the present, then you believe it," Pal explained. The director gave Wells another nod by making his hero, H. George Wells, a stand-in for the author himself. Though Pal initially considered James Mason or Michael Rennie for George, Rod Taylor—who had traveled into the future via a time warp in *World Without End* (1956)—was given his first starring role as the time traveler and inventor of the machine. "I expected

Director and producer
George Pal

something out of *Frankenstein*—electrodes and wires," Taylor said of his first view of the machine, a baroque wood-and-brass contraption patterned after George Pal's childhood sled. "When I saw this wonderful-looking thing that was straight out of the Victorian era, I was ready to really believe that . . . I could indeed travel through time."

As George rides his invention through the fourth dimension, stop-motion details—such as the changing fashions on a department-store mannequin and celestial bodies racing across the sky—indicate the passage of time. These were meticulously photographed frame by frame by Wah Chang and Gene Warren; Tim Baar and Warren received an Oscar for the team's simple yet ingenious pre-CGI effects. With today's technology, Chang speculated, "some things would have been made easier, but other things we did probably as fast, maybe faster than you could do with a computer." Using old-fashioned

craftsmanship, Chang and Warren projected a vivid ride through time, saturated in (according to the film's trailer) "futuristic Metrocolor."

Once George arrives at his final destination—the year 802,701—his adventure takes on elements of romance and horror. The Eloi's idyllic but doomed society, where no one reaches thirty (an idea that would be recycled in the 1967 novel and the 1976 film *Logan's Run*) is disrupted when George appears and falls in love with Weena, a young Eloi woman played by Yvette Mimieux. "We needed a girl of the future," George Pal said of his casting choice, "so beautiful she's almost eerie, and that's Yvette." Though she had no training as an actress, Mimieux learned as she went; *The Time Machine* launched her career as one of MGM's top starlets of the early 1960s. The horror, meanwhile, is supplied by the Morlocks—subterranean cannibals that stand among the most repulsive monsters in science fiction.

Though many of the novella's cautionary tales are diluted or eliminated in the film, the threat of nuclear war is given added weight. Pal tailors the story for a circa-1960 audience, immersing them in the quaint nostalgia of late-Victorian England, jettisoning them into a distant future (one

Top: Rod Taylor is
H. George Wells, inventor
of the time machine.

Bottom: Rod Taylor and
the time machine

FAR-OUT FACTS

Pal consciously chose a clean, non-destructive energy source to power the time machine: crystals. In 2012, MIT professor Frank Wilczek began researching the use of time-space crystals as a source of such energy.

In 1895—the same year *The Time Machine* was published—H. G. Wells and manufacturer Robert Paul applied to patent a time machine device they designed for amusement. The design featured a chamber in which motion pictures would be projected on a screen, providing the illusion of traveling through different eras. It was never manufactured.

MIND-BLOWING MOMENT

When George descends into the cavernous underworld, he lights a match and sees the hideous Morlocks for the first time. Described by Wells as having "pale, chinless faces" and "pinkish-gray eyes," the Morlocks were outfitted with blue-green flesh, gaping mouths, and glowing eyes by pioneering makeup artist William Tuttle.

that oddly resembles the then-impending flower-power era), and making a few wartime pit stops along the way—including an all-too-realistic vision of a possible 1966, complete with Brutalist architecture and fallout shelters on every corner. Because it encompasses so many eras of the past, present, and future, *The Time Machine*—like its lovingly designed contraption—feels simultaneously antiquated and futuristic, and altogether timeless.

When it was released, the movie popularized the concept of time travel by bringing Wells's vision to the moviegoing masses. Through the magic of George Pal's film, Wells sparked a pop-culture phenomenon: a machine that transports its operator to different time periods. Without *The Time Machine*, *Doctor Who*'s TARDIS, Marty McFly's flux capacitor–equipped DeLorean, the *Quantum Leap* accelerator, even Bill and Ted's special phone booth might never have existed.

KEEP WATCHING

WORLD WITHOUT END (1956)
TIME AFTER TIME (1979)

DIRECTOR: **CHRIS MARKER** PRODUCER: **ANATOLE DAUMAN** SCREENPLAY: **CHRIS MARKER** STARRING: **JEAN NÉGRONI** (NARRATOR), **HÉLÈNE CHATELAIN** (THE WOMAN), **DAVOS HANICH** (THE MAN), **JACQUES LEDOUX** (THE EXPERIMENTER)

La jetée

ARGOS FILMS (FRANCE) • BLACK & WHITE, 28 MINUTES

A World War III survivor, sent back in time by a scientist, meets a woman from his childhood memory.

In the aftermath of *The Time Machine* (1960) emerged *La jetée*, a strikingly provocative and unconventional time-travel story. As perhaps the world's only postnuclear, science-fiction, cinéma vérité, short film—and the most celebrated and influential film ever made using still photographs—the twenty-eight-minute masterpiece has inspired countless artists and filmmakers since its 1962 release.

For a film constructed simply of black-and-white images, *La jetée's* scenario is anything but simple. The intricate narrative about an underground prisoner in a future dystopian Paris being sent back "to find a loophole in time" based on the strength of his prewar memories—specifically of a woman whose face he once glimpsed on a pier in childhood—took shape in the mind of avant-garde French filmmaker Chris Marker while he was shooting the documentary *Le joli mai* (1963). "On the crew's day off," Marker recalled in 2003, "I photographed a story I hardly understood. It's in the cutting room that the pieces of the puzzle came together." Those pieces include roughly 380 photographs of Davos Hanich and Hélène Chatelain, two unknown actors playing unnamed characters, a man and a woman forming a unique bond as "time builds itself painlessly around them."

Besides the omniscient narration by Jean Négroni (James Kirk did the English version)

Opposite:
Jacques Ledoux, the experimenter

Top: Davos Hanich travels back in time.

Center: Davos Hanich and Hélène Chatelain

Bottom: Hélène Chatelain as "the woman"

and excerpts of haunting choral music, we hear indiscernible German whispers from the scientists who experiment on the man, shuttling him repeatedly back to the past and, later, into the future. The stark sounds and visuals mesh into a dreamlike effect. The man is never quite certain, the narrator says, "whether he made it up," or "whether he is only dreaming." His time travels, his relationship with the woman—everything, Marker hints, might be taking place within the man's mind. For one brief moment, the still photos seamlessly slip into motion as the woman wakes from a dream and blinks her eyes. Is she a part of his dream, or is he a part of hers?

A strange, touching, and disturbing rumination on time and memory, *La jetée* was strongly influenced by Alfred Hitchcock's *Vertigo* (1958), a film Marker saw nineteen times before making his experimental short. The director might almost have been talking about his hero,

a man who breaks through the barriers of time to find a woman he only saw once, when he described James Stewart's "Scottie" in *Vertigo* as a character who "overcomes the most irreparable damage caused by time and resurrects a love that is dead." In *La jetée*, though, the action unfolds in frozen flashes, like leafing through grainy snapshots in an old scrapbook. The images dissolve, zoom, and fade, but always remain trapped in their stillness, just as the hero is trapped in a time loop, and in a broader sense, imprisoned in the finite circle of his own life. Still photos are the perfect format for this ode to the power of memory, to the ability our memories have to transcend the limits of time and space.

Fittingly, *La jetée* has transcended its own time to become a cultural touchstone. Nearly fifty years after it won the Prix Jean Vigo for France's best short film, *Time* magazine ranked it first on a list of Top Ten Time Travel Movies in 2010. Beyond its accolades, it has proven to be a cinematic wellspring, continually generating fresh works. Among other box-office triumphs, its premise has functioned as an inspirational springboard for *The Terminator* (1984), *Back to the Future* (1985), and *Looper* (2012). Made for a tiny fraction of

their budgets, *La jetée* serves as a reminder that sometimes it's the spontaneous experiments undertaken without much preparation or funding that can have the most profound impact. "It was made like a piece of automatic writing," Marker said of his experiment. "It just happened, that's all."

The most direct reworking of *La jetée* is Terry Gilliam's contemporary sci-fi classic *Twelve Monkeys* (1995). Gilliam and screenwriters David and Janet Peoples took the basic plot of Marker's short film and exploded it into a mutation so wildly original it can barely be called a remake. *Twelve Monkeys* adds a deadly virus, a world overrun by animals, and darkly comic observations on the thin line between madness and sanity to the time-travel loop of *La jetée*, which Gilliam called "a kernel" of his movie. In one scene, the future prisoner (Bruce Willis) and his psychiatrist/love interest (Madeleine Stowe) sit in a dark movie theater watching *Vertigo*—the inspiration for *La jetée*—bringing the loop full circle.

KEEP WATCHING

TWELVE MONKEYS (1995)
LOOPER (2012)

FAR-OUT FACTS

La jetée was shot in underground passageways beneath the Palais de Chaillot, the same location that would later house the film archives of the Cinémathèque Française.

Chris Marker directed mostly documentary films, including *The Train Rolls On* (1973), a history of Russian film trains, and *Sans soleil* (1983), a travel essay. *La jetée* is one of his rare ventures into narrative fiction.

MIND-BLOWING MOMENT

In the end, the man travels back in time to the jetty at Orly Airport where he had witnessed a murder as a child. The haunting scar of his childhood memory is finally revealed in the film's powerful final images.

1962

These Are
the Damned

HAMMER FILMS/COLUMBIA • BLACK & WHITE, 87 MINUTES

In an English coastal town, the leader of a hoodlum gang chases his sister and her American lover into a secret underground encampment of quarantined children.

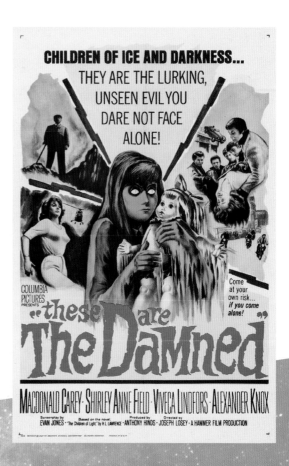

Oliver Reed as gang leader King

In the late 1950s and early '60s, a spate of nuclear paranoia films appeared. *On the Beach* (1959), *The World, the Flesh and the Devil* (1959), *The Day the Earth Caught Fire* (1961), and *Panic in Year Zero!* (1962) presented doomsday scenarios more disturbing than any giant insects. One of the bleakest and most bizarre of this crop is *These Are the Damned*, a remarkable British sci-fi thriller by exiled American director Joseph Losey. Linking common street violence with destruction at the highest government level, Losey's adaptation of H. L. Lawrence's book *The Children of Light* mixes motorcycle gangs, love, and radioactive children to form a peculiar pastiche.

Filmed in the shabby seaside resort of Weymouth in the summer of 1961, one year before the Anthony Burgess novel *A Clockwork Orange* was published, *These Are the Damned* anticipates that book's recreational ultra-violence with its Teddy Boys led by the unhinged King, played by Britain's definitive bad boy Oliver Reed. Gloriously photographed in Hammerscope by Arthur Grant's roving camera, the opening scenes both shock and entertain as King and his thugs savagely beat American tourist Simon to the swinging strains of "Black Leather Rock," composer James Bernard's infectious ode to violence ("Black leather, black leather, kill, kill, kill!"). King's sister, Joan, throws the gang a curve when she hops aboard Simon's boat and they escape to an isolated cliffside cottage inhabited by a sculptress named Freya, who just happens to be the mistress of Bernard, a scientist conducting a dreadful secret experiment nearby.

As the disparate, doomed characters intersect, the landscape becomes more barren, and the unpredictable story winds through Weymouth to the edge of the world. There, beneath perilous cliffs overlooking an endless sea, Bernard and his government officials hold a group of irradiated kids in an underground lair, where they prepare them

for nuclear Armageddon via closed-circuit TV. They are breeding "a new kind of man," Bernard says, to withstand "the conditions which must inevitably exist when the time comes." With chilling efficiency, the government is raising a race to populate the post-apocalyptic world they believe to be unavoidable. When Joan, Simon, and King follow the children into their hideout, they not only seal their own fates but unknowingly damn the young victims as well.

Joseph Losey, who had relocated to England after being blacklisted by Howard Hughes at RKO for alleged Communist sympathies, infused *These Are the Damned* with his anti-establishment sensibilities. His objective in making this "emotional plea against the destruction of the human race," he said, was "to unsettle people, to force them to think." Losey pulls no punches; his vicious street thugs are more human than the men in suits, "because they don't know what they're doing," the director noted, "and they are not responsible for what they are. The others are perfectly conscious, and they have no innocence."

While he may not be innocent, Bernard is apparently a decent man—he treats the children kindly and seems to have their best interests at heart—making his character all the more unsettling. If he's not the bad guy, who is? The only true villains in this tale, Losey implies, are the bomb and the system that produced it. Viveca Lindfors's Freya (named for Freyja, a Norse fertility goddess), is the film's moral core, embodying the pure impulses of art, love, and passion. She, too, is ill-fated once she learns of Bernard's experiments. Her sculptures resembling immolated birds loom ominously in the background, foreshadowing the helicopters that swoop down on the children in the end. Symbols of oblivion hover in virtually every scene of the film.

Hammer Films, a studio known for horror (*The Curse of Frankenstein* [1957]) and later excursions into sci-fi (*Quatermass and the Pit*

Top: Oliver Reed and
Teddy Boys on location
in Weymouth

Center:
Alexander Knox as Bernard,
the keeper of the children

Bottom: The Teddy
Boys attack Macdonald
Carey as Shirley
Anne Field looks on.

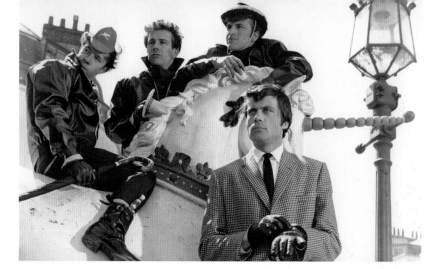

FAR-OUT FACTS

These Are the Damned was awarded the Golden Asteroid (Best Feature Film) at Trieste, Italy's second annual International Science Fiction Festival in 1964.

The British government actually conducted covert experiments off the coast of Portland Bill, where the film's subterranean bunker scenes were shot. In the 1950s and '60s, zinc cadmium sulfide was secretly dropped on the area's population to mimic a chemical warfare attack.

MIND-BLOWING MOMENT

After being sheltered underground their entire lives, nine pale eleven-year-olds finally break free from their secluded darkness in the end. Squinting in the sunshine, they scatter among the dangerous rocks as Bernard watches, horrified.

[1967]), edited nearly twenty minutes from the film and postponed distributing it until 1963 in the United Kingdom, where it was known as *The Damned*. It didn't reach American theaters until 1965, possibly because, as *Variety*'s review speculated, "its subject or its director may have, in 1963, been considered too controversial." Today it has a small but fervent cult following. *These Are the Damned* is a work of art with an agenda—even a grudge—yet it conveys its message so poetically that the result is more profound than preachy. It is a movie steeped in wild abandon, as if every moment might be its last on Earth.

KEEP WATCHING

ON THE BEACH (1959)
CHILDREN OF THE DAMNED (1964)

DIRECTOR: **JEAN-LUC GODARD** PRODUCER: **ANDRÉ MICHELIN** SCREENPLAY: **JEAN-LUC GODARD** STARRING: **EDDIE CONSTANTINE (LEMMY CAUTION), ANNA KARINA (NATACHA VON BRAUN), AKIM TAMIROFF (HENRI DICKSON), HOWARD VERNON (PROFESSOR VON BRAUN), LÁSZLÓ SZABÓ (THE ENGINEER), MICHEL DELAHAYE (ASSISTANT TO PROFESSOR VON BRAUN)**

Alphaville

PATHÉ CONTEMPORARY FILMS (FRANCE) • BLACK & WHITE, 99 MINUTES

A secret agent travels to a distant galaxy to destroy the inventor of a mind-controlling supercomputer.

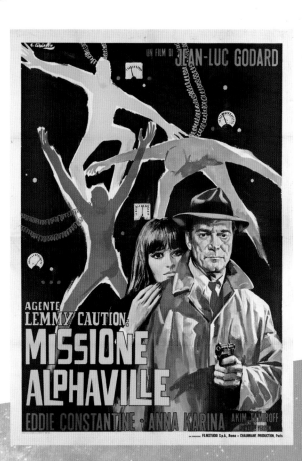

MUST-SEE SCI-FI

Watching *Alphaville* is like traveling to another planet without ever leaving the ground. One of the most unconventional science-fiction movies ever made, *Alphaville* depicts the future as only French New Wave director Jean-Luc Godard could have imagined it: a retro 1940s film noir colliding into a dystopian technocracy—or George Orwell's *1984* meets *Dead Reckoning* (1947) starring Humphrey Bogart. As he had done with the genres of crime (*Breathless* [1960]), musical (*A Woman Is a Woman* [1961]), and war (*Le petit soldat* [1963]), Godard deconstructs the expected science-fiction tropes and scrambles them, creating a new style that has left an indelible mark on cinema.

Alphaville was originally conceived by Godard as *Tarzan versus IBM,* a pulp-fiction mash-up concerning trench-coated, gun-toting secret agent Lemmy Caution (Eddie Constantine). Caution is sent undercover to Alphaville, the capital city of a distant galaxy, to track down a fellow agent, Henri Dickson, and eliminate the evil Professor von Braun. Godard fashions film-noir conventions— night scenes, neon lights—into a dark urban

Opposite: Natacha
von Braun and Lemmy
Caution escape from
Alpha 60's control.

Right: Eddie
Constantine and Anna
Karina

landscape ruled by the cold logic of von Braun's computer, Alpha 60. When Lemmy falls for von Braun's beautiful but brainwashed daughter, Natacha (Anna Karina), he must not only destroy her father and the computer, but rescue her mind from the machine's control. Typical of his off-the-cuff style, Godard shot the film in a few weeks, spinning the story as he went along. "We never had a script," recalled Karina, the director's muse, favorite actress, and wife at the time.

Godard's special-effects budget was nonexistent. His city of the future is a thinly disguised Paris of 1965, a setting that offers a built-in social comment. "I set it in the future, but it's really about the present," Godard told a reporter in 1966. "The menace is already with us." In keeping with the bare-bones effects, Lemmy travels through space simply by driving his Ford Galaxie. Godard apparently couldn't even afford a Galaxie, since the car is actually a Mustang posing as a Galaxie—but that's beside the point. The director weaves a certain magic spell that makes *Alphaville* compelling, a neon-throbbing ambience heightened by the melodramatic strings of Paul Misraki's original score. As Raoul

Coutard's camera roams the corridors of modern buildings, it captures an array of circles, wheels, and spirals, while Alpha 60—depicted as a halogen orb—bellows cryptic philosophies in a croaking mechanical voice: "Time is like a circle which turns endlessly." Godard's postmodern nightmare was a statement "against the destruction of thought and emotion by machines," he said, and was strongly influenced by the Orson Welles drama *The Trial* (1962).

Godard pioneered a language of communicating ideas through pop-culture touchstones, inspiring a generation of directors (Quentin Tarantino, Paul Thomas Anderson) to follow suit. Like most of the auteur's early films, *Alphaville* is brimming with pop references: Caution reads Raymond Chandler's *The Big Sleep*; von Braun's real name is "Nosferatu," as in F. W. Murnau's

MUST-SEE SCI-FI

Top: Jean-Luc Godard
directs his wife,
Anna Karina.

Bottom: Akim Tamiroff
and Eddie Constantine

1922 vampire film; Professors Eckel and Jeckel recall the cartoon magpies Heckle and Jeckle. Even *Alphaville*'s hero, Lemmy Caution, is plucked from a series of detective novels by British author Peter Cheyney, which had been adapted into several French movies with titles like *This Man Is Dangerous* (1953) and *Women Are Like That* (1960).

Caution, a throwback to the past, carries his old-fashioned flashbulb camera and vintage cigarette lighter into the dismal future like beacons of hope. Memory and nostalgia, Godard seems to say, are powerful tools to fight a system that outlaws the words "love" and "conscience," and publicly executes anyone who displays emotion. Young women—under the male-dominated rule of Professor von Braun and his computer—have become passive, robotic sex objects. To break her dependence on the computer, Lemmy reads Natacha surrealist poems and tells her to "think of the word *love*." This is Godard at his most idealistic.

In 1965, *Alphaville* opened the New York Film Festival and won top prize at the Berlin International Film Festival. As a comic-book concoction of action, noir, and sci-fi woven together with a thin thread of winking satire,

it had quite an impact. Though *Alphaville*'s most obvious descendant is Ridley Scott's sci-fi-noir *Blade Runner* (1982), its surreal dystopian atmosphere and undercurrent of irony laid the groundwork for a slew of other movies, including *2001: A Space Odyssey* (1968) and *Brazil* (1985). Ultimately, Jean-Luc Godard would embrace the technology he once opposed. In 2010, Godard released *Film socialisme*, a feature he shot using digital video and a cell phone, edited with content pulled from the Internet.

KEEP WATCHING

FAHRENHEIT 451 (1966)
SECONDS (1966)

FAR-OUT FACTS

Upon its release in France, Godard's sci-fi was accompanied by Chris Marker's 1962 time-travel short *La jetée*, making for an ideal science-fiction double feature.

Twenty-six years after *Alphaville*, Eddie Constantine reprised his role as Lemmy Caution in Godard's *Germany Year 90 Nine Zero* (1991).

MIND-BLOWING MOMENT

When Lemmy Caution learns of Alpha 60's nefarious plans, he feeds the computer a riddle to cause it to self-destruct: "Something which never changes, day or night. The past represents its future, it advances in a straight line, yet it ends by coming full circle."

1966

DIRECTOR: RICHARD FLEISCHER PRODUCER: SAUL DAVID SCREENPLAY: HARRY KLEINER, BASED ON A STORY BY JEROME BIXBY AND OTTO KLEMENT; ADAPTATION BY DAVID DUNCAN STARRING: STEPHEN BOYD (GRANT), RAQUEL WELCH (CORA), EDMOND O'BRIEN (GENERAL CARTER), DONALD PLEASENCE (DR. MICHAELS), ARTHUR O'CONNELL (COLONEL DONALD REID), WILLIAM REDFIELD (CAPTAIN BILL OWENS), ARTHUR KENNEDY (DR. DUVAL), JEAN DEL VAL (JAN BENES)

Fantastic Voyage

TWENTIETH CENTURY-FOX • COLOR, 100 MINUTES

A crew of medical experts is shrunk and injected into the body of an injured scientist to remove a blood clot.

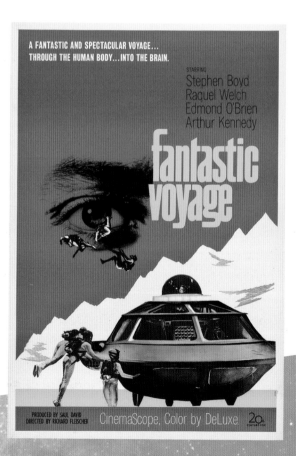

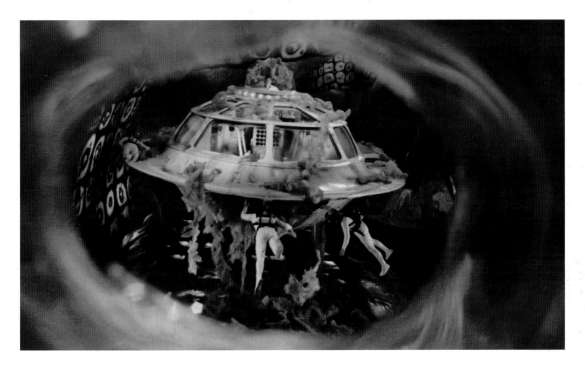

When Twentieth Century-Fox poured $6.5 million into *Fantastic Voyage* in 1965, the studio took a great leap into the unknown. At that time, Hollywood no longer considered science fiction a marketable genre. Strides made toward intelligent sci-fi in the 1950s had degenerated into titles like *Santa Claus Conquers the Martians* (1964) and *Frankenstein Meets the Space Monster* (1965), B movies tailored for kid-friendly matinees. Instead of an outer-space outing, Fox gambled on a new type of adventure: an exploration of inner space—inside the human body. The story of a miniaturized submarine and crew on a journey through the bloodstream to the brain, *Fantastic Voyage* was the most expensive and intricate sci-fi movie ever produced in its day.

Having helmed *20,000 Leagues Under the Sea* (1954), Richard Fleischer was the ideal director to take the movies where they had never gone before: drifting in a sea of plasma through arteries and veins. "When I directed *20,000 Leagues Under the Sea* I thought I was traveling, but the human body contains 100,000 miles of blood vessels," Fleischer told a reporter while shooting *Fantastic Voyage*. "Though this is a work of complete imagination, it's based on reality. . . . We know what we run into in the human body: red blood cells, white corpuscles, antibodies." These microscopic molecules appear immense when viewed from the inside. Lava-lamp globules of pink, blue, and sea-green are shown to resemble, in the words of Fleischer, "abstract art." Artistically rendering the wonders of

Page 125: The *Proteus* and
its crew inside the body

Top: Arthur O'Connell
examines Jean Del Val

Bottom left:
An Italian lobby card
featuring Donald
Pleasence

Bottom right:
Stephen Boyd

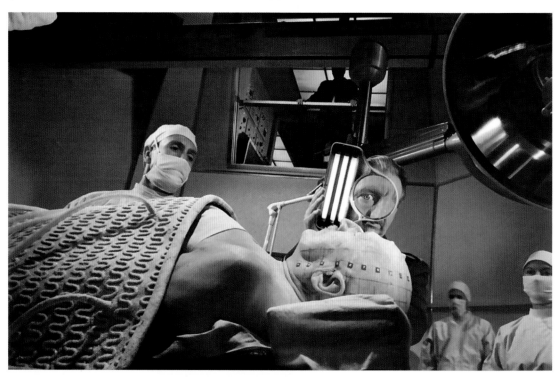

the human body was the primary goal of the filmmakers. They even hired surrealist icon Salvador Dalí to conceive the film's poster art.

Harper Goff, designer of the *Nautilus* in *20,000 Leagues*, surpassed his previous effort with the *Proteus*, the submarine-like craft that is shrunk and injected into the body of a wounded Czech scientist played by Jean Del Val. Sleekly designed with futuristic lines (the film is set in 1995), the *Proteus* was constructed as a practical, life-size vessel with fully appointed interiors. The ensemble cast—led by Stephen Boyd as the awed CIA agent and Donald Pleasence as the suspiciously panicky circulatory specialist—actually filmed their scenes inside the sub. In her first major film role, Raquel Welch is appropriately subdued as Cora the medical assistant. Welch, who later admitted that her part "amounted to little more than eye candy in a team of male researchers," wears her wetsuit well and provides damsel-in-distress suspense when she is viciously attacked by swarming antibodies.

Just outside the operating room, tense CMDF (Combined Miniature Deterrent Forces) officers, played by familiar screen faces Edmond O'Brien and Arthur O'Connell, puff cigars and consume gallons of sugary coffee as everything that can go wrong does go wrong. An undetected fistula sends the *Proteus* in the wrong direction; the crew is forced to take a detour through the heart; they must refuel their oxygen supply from the lungs. The mission is even sabotaged from within, all while the clock is ticking. They have exactly sixty minutes to laser a blood clot in the brain before they return to normal size. Though the concept of miniaturization strains suspension of disbelief, the dazzling imagery makes the idea easier to swallow.

Art Cruickshank earned an Academy Award for the ingenious visual effects, all created using traditional techniques. Arteries, lungs, heart valves, and ear canals are transformed into realistic settings, thanks to exquisitely detailed matte paintings, miniature models, and early blue-screen technology. Antibodies,

MUST-SEE SCI-FI

127

FAR-OUT FACTS

Renowned science-fiction author Isaac Asimov was hired to adapt the screenplay into a novel, which was published in 1966 to promote the film's release.

The sound effects heard over the opening credits sequence were originally created by Ralph B. Hickey for the computer in *Desk Set* (1957).

The heart in *Fantastic Voyage* measured approximately thirty feet by forty feet, making it the largest working model of the human heart ever made.

MIND-BLOWING MOMENT

After veering off course and abandoning the wrecked *Proteus*, the crew must exit the body using the only available passageway: through the optic nerve and out the tear ducts of the patient's eye.

fibers, and corpuscles were crafted of plastic, spun fiberglass, and Vaseline in water. Actors were suspended from wires and filmed in slow-motion to provide the illusion of floating through fluid. Heightening the illusion is the dissonant, unsettling score by cutting-edge composer Leonard Rosenman. The overall effect is an astonishing illumination of the human anatomy.

Made in the waning days of the classic studio-system era, *Fantastic Voyage* was a successful experiment that—along with the 1966 debut of the TV series *Star Trek*—rekindled Hollywood's interest in science fiction, paving the way for the next wave of big-budget sci-fi blockbusters like *Planet of the Apes* and *2001: A Space Odyssey*, both released two years later. It also inspired *Innerspace*, a 1987 comedy with the similar premise of an aviator (Dennis Quaid) who is miniaturized and accidentally injected into a supermarket cashier (Martin Short). In 2016, director Guillermo del Toro and producer James Cameron announced plans for a multimillion-dollar *Fantastic Voyage* remake.

KEEP WATCHING

THE ANDROMEDA STRAIN (1971)
INNERSPACE (1987)

DIRECTOR: FRANKLIN J. SCHAFFNER PRODUCER: ARTHUR P. JACOBS SCREENPLAY: MICHAEL WILSON AND ROD SERLING, BASED ON THE NOVEL BY PIERRE BOULLE STARRING: CHARLTON HESTON (GEORGE TAYLOR), RODDY MCDOWALL (CORNELIUS), KIM HUNTER (ZIRA), MAURICE EVANS (DR. ZAIUS), JAMES WHITMORE (PRESIDENT OF THE ASSEMBLY), JAMES DALY (HONORIOUS), LINDA HARRISON (NOVA), LOU WAGNER (LUCIUS)

Planet of the Apes

TWENTIETH CENTURY-FOX, 1968 • COLOR, 112 MINUTES

An astronaut travels two thousand years through time and space, crash-landing on a strange planet where apes are the dominant species and humans are treated like animals.

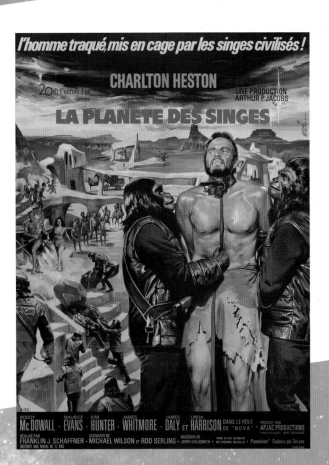

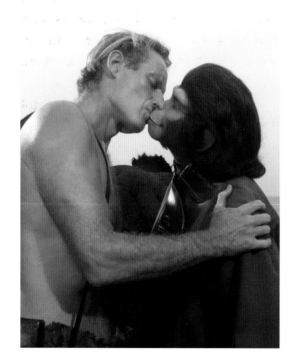

America in 1968 was a world turned upside down. Youth revolted against the age-old establishment, peaceful protest movements ended in violence, and humans first orbited the moon. It was the perfect time for a movie about a planet where apes evolved from men. The original *Planet of the Apes* was a smash hit in this turbulent era, grossing over $26 million and commencing one the most successful franchises in movie history. It was followed by four sequels and more than one twenty-first-century reboot.

No one foresaw such a pop-culture phenomenon, not even Pierre Boulle, who dreamed up the concept. Boulle (author of *The Bridge on the River Kwai*) had little faith in his 1963 novel *La planète des singes* (*Monkey Planet*), believing it had no potential as a movie. Publicist-turned-producer Arthur P. Jacobs disagreed. He had been trying to make a film of Boulle's novel since 1964, despite resistance from Hollywood. Armed with a clever script by *Twilight Zone* creator Rod Serling, Jacobs had a difficult time selling the film's unusual premise of an astronaut stuck on a planet run by simians. According to Charlton Heston, who was the first actor to sign on, Jacobs "would go from studio to studio and they would say, 'What

are you talking about? Spaceships? Talking monkeys? You're out of your mind.'"

Finally, Richard Zanuck, son of former Twentieth Century-Fox head Darryl F. Zanuck and heir to the Fox studio, saw the idea's potential and took a chance on *Planet of the Apes*. When filming began in the spring of 1967, the studio kept the production top secret; all sets were closed, any photos of the apes strictly forbidden. This generated a buzz, and kept the film's shock value intact. For first-time viewers, the surprise was undiluted when, thirty-two minutes into the film, gorillas in military uniforms appear on horseback, shooting rifles at humans as Jerry Goldsmith's spine-tingling musical score punctuates the action. Master makeup artist John Chambers created the ape looks, while veteran performers Roddy McDowall, Kim Hunter, and Maurice Evans brought the latex to life with their distinct vocalizations and body language. As the sensitive, intelligent chimps Cornelius and Zira, McDowall and Hunter represent the only salvation for our hero, Taylor.

When the movie was released, the world saw a whole new type of sci-fi epic, and a very different Charlton Heston. Misanthropic astronaut Taylor was quite a departure from the class of characters Heston was known for playing in films like *Ben-Hur* (1959)—heroic, dignified, and often biblical. In *Planet of the Apes*, he is captured in a net, dragged in the dirt, beaten, shot, caged, stripped naked, repeatedly sprayed with a water hose, and pulled around by a collar and leash. Though the film's bleak ending played on "ban the bomb"–era fears, the story's hope lies in the character arc of Heston's Taylor, who emerges from the ordeal with a greater respect for humanity than when he started. He also speaks some memorable lines that typify the movie's perverse humor: "Get your stinking paws off me, you damn dirty ape!"

A world in which humans are the lowest order of species allows for some pointed social satire. The apes in charge not only enforce a strict class hierarchy—orangutans at the top, chimpanzees in the middle, gorillas at the bottom—but they adhere blindly to religious doctrines in the face of opposing scientific fact. Co-producer Mort Abrahams recalled, "Without ever saying it, we were doing a political film. . . . The country was having very serious problems." *Planet of the Apes* is a perfect example of science fiction

Top left: Robert Gunner, Dianne Stanley, Charlton Heston, and Jeff Burton as the original four astronauts

Top right: Taylor on the run

Bottom Left: Kim Hunter is transformed into Zira.

Bottom right: Roddy McDowall as Cornelius

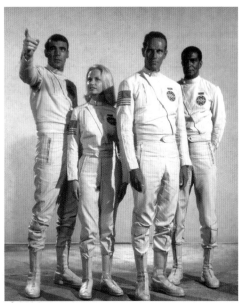

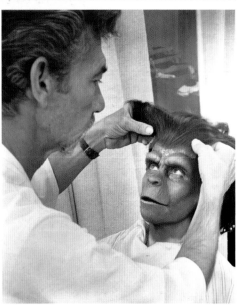

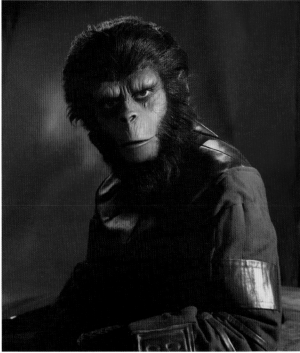

using an alternate world to address topics normally too sacred to touch.

The string of sequels was popular, but none ever reached the caliber of the first film until Fox rebooted the franchise in 2011 with an acclaimed series of latter-day sequels concerning chimpanzee Caesar (Andy Serkis), the son of Cornelius. Starting it all was the 1968 original, a case in which every element came together—acting, writing, direction, makeup, set design, and music—to exemplify, as *Los Angeles Times* critic Kevin Thomas wrote in 1968, "the collaborative art of Hollywood at its best."

KEEP WATCHING

SOYLENT GREEN (1973)
RISE OF THE PLANET OF THE APES (2011)

FAR-OUT FACTS

John Chambers received a special Academy Award for his groundbreaking ape makeup. The movable latex masks, hairpieces, and body paint took two-and-a-half hours to apply to the actors and set the studio back $1 million.

Roddy McDowall based Cornelius's physical movements on the walk and mannerisms of Groucho Marx.

Taylor's iconic last line "God damn you all to hell" almost didn't make it past the censors. "I kept arguing that it wasn't swearing," Heston said. "Taylor was specifically appealing to God to damn all those people that ended the world. It was literal. . . . I said, 'What do want me to say, 'Shucks, darn you?'"

MIND-BLOWING MOMENT

The final scene where Taylor discovers the Statue of Liberty embedded in the sand was a shocking twist conceived by Rod Serling. Serling borrowed the idea from a 1960 *Twilight Zone* episode titled "I Shot an Arrow into the Air," in which a trio of stranded astronauts realizes the planet they landed on is actually Earth.

1968

DIRECTOR AND PRODUCER: **STANLEY KUBRICK** SCREENPLAY: **STANLEY KUBRICK, BASED ON A STORY BY ARTHUR C. CLARKE** STARRING: **KEIR DULLEA (DR. DAVID BOWMAN), GARY LOCKWOOD (DR. FRANK POOLE), WILLIAM SYLVESTER (DR. HEYWOOD FLOYD), DANIEL RICHTER (MOON-WATCHER), LEONARD ROSSITER (SMYSLOV), MARGARET TYZACK (ELENA), ROBERT BEATTY (DR. RALPH HALVORSEN), DOUGLAS RAIN (VOICE OF HAL 9000)**

2001: A Space Odyssey

MGM • COLOR, 148 MINUTES

In the near future, the United States sends a manned spacecraft run by a sentient computer to Jupiter in search of intelligent life.

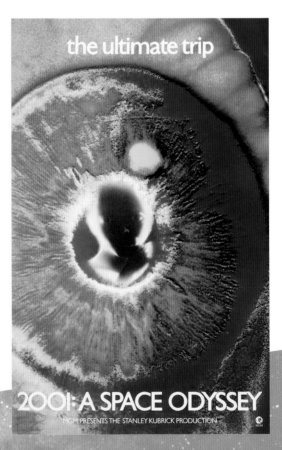

Keir Dullea
and Gary Lockwood

Once in a while a movie comes along that redefines the cinematic experience. *2001: A Space Odyssey* is a prime example of such a movie. Light-years more ambitious and sophisticated than anything that had come before it, Stanley Kubrick's meticulously crafted journey into deep space is revered even by today's standards for its technical brilliance and unforgettable imagery. Much has been made of its importance, but the landmark film remains a classic primarily because it is so enjoyable to watch. *2001* is a feast for the eyes and ears, a work of idea-driven art that retains its power to shock, mystify, and entertain generations of viewers.

After touching on science-fiction themes in his 1964 nuclear-disaster satire *Dr. Strangelove*, director Stanley Kubrick turned his attention to outer space. "I became interested in extraterrestrial life forms in the universe, and was convinced that the universe was full of intelligent life," he said. "And so it seemed time to make a film." When Kubrick decided to tackle science fiction, he envisioned a movie the likes of which had never been attempted, an epic "about man's relation to the universe." Spanning the early days of human-ape evolution to our first awareness of extraterrestrial life in the year 2001, the epic would feature a mysterious black monolith planted on the moon by an advanced race of aliens. The genesis of *2001* was the 1950 short story "The Sentinel" by Arthur C. Clarke, who spent a full year collaborating with Kubrick on the script.

During that year, Kubrick exhaustively researched his subject. He worked with NASA engineers to develop realistic-looking spacecraft and consulted with IBM, DuPont, Eastman Kodak, and General Mills to determine what their products might look like in thirty-five years. He even researched a zero-gravity space toilet, a subject the

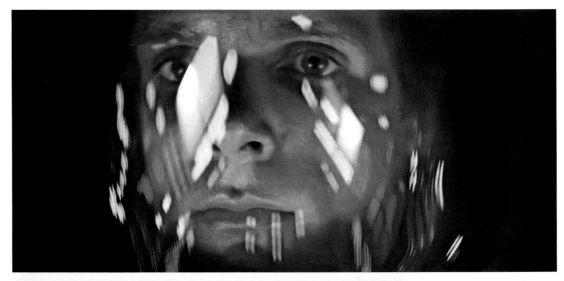

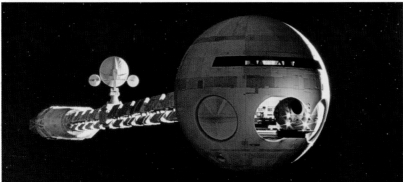

Top: Keir Dullea as astronaut Dave Bowman

Left: The spaceship Discovery

Bottom: Edwina Carroll as an outer-space stewardess

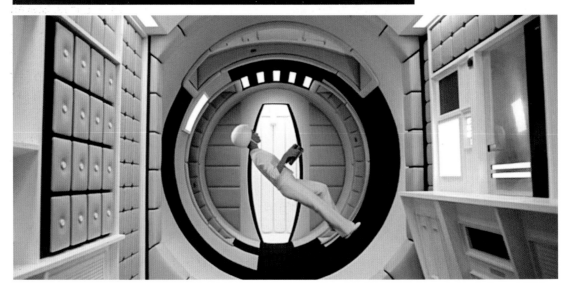

movies had never dared to broach. For his astronauts, Dave Bowman and Frank Poole, the director handpicked actors Keir Dullea and Gary Lockwood because, as Kubrick told Lockwood, they could "do a lot without doing a lot." Kubrick saw the man of the future as stoic and emotionally detached, almost more so than the computers surrounding him. The HAL 9000, vocalized by Douglas Rain, is a darkly prophetic emblem of our society's increasing dependence on technology. HAL runs the spaceship *Discovery* better than any human could, his seemingly affable personality making him all the more dangerous.

Kubrick spent four years (and went $4 million over budget) on what would be his magnum opus: a majestic space symphony set to classical music. From the bold "three-million-year jump cut"—in which an ape-man tosses a bone in the air and Kubrick cuts to a spacecraft—to the iconic image of a space station orbiting to Strauss's "The Blue Danube" waltz, *2001* broke ground as an advanced form of silent film—primarily visual, with minimal dialogue. The Star Gate sequence is pure mind-melting psychedelia; planes of color blast across the screen like a fluid kaleidoscope of lights. To realize that the special effects (supervised by

Douglas Trumbull) were created without computers truly boggles the mind.

When *2001* premiered, it made all the flying-saucer movies that preceded it look like amateur theatrics. This was science fiction's coming of age, or as George Lucas observed, "It was the first time people really took science fiction seriously." Lucas, Steven Spielberg, William Friedkin, Sydney Pollack, Ridley Scott, and Robert Zemeckis are among the legion of young filmmakers who saw the movie and were inspired to explore the outer limits of cinematic craft.

Now recognized as a masterpiece, *2001: A Space Odyssey* was judged by many in 1968 as slow, self-indulgent, and impossible to comprehend. Kubrick has also been criticized for ignoring the civil rights and feminism movements; every character in his vision of the future is Caucasian, and the astronauts are

FAR-OUT FACTS

On February 3, 1966, while *2001* was in production, the Luna 9 became the first spacecraft to photograph the surface of the moon. "Too late to help the art department," Clarke lamented. "All our lunar scenes had already been shot."

The artificial intelligence on board the *Discovery* was originally conceived as a humanoid robot named Socrates. Kubrick and Clarke next toyed with the idea of a female computer called Athena before settling on the male HAL 9000.

Kubrick and his special-effects team always planned to show an extra-terrestrial character at the end, but ran out of time and money to create the effect.

MIND-BLOWING MOMENT

In complete silence, astronaut Frank Poole is sent spiraling through the depths of space, starved of oxygen and doomed to perish when his air hose is severed in what appears to be a "computer malfunction."

all men (the only women in space are serving refreshments). But almost everyone agreed that, whatever they were seeing, it was a spectacular cinematic achievement. The film won the Special Visual Effects Academy Award, and was nominated in the fields of directing, art direction, and writing. According to Arthur C. Clarke, the reason *2001* wasn't recognized for Best Makeup was "because judges may not have realized the apes were actors."

The film's enigmatic finale—in which a progressively aging Dave Bowman inhabits a Louis XVI–appointed region of his mind, then becomes an embryonic infant floating in space—left audiences dumbfounded. Movie critic Charles Champlin deemed the ending "a kind of Cinerama inkblot test, in which there are no right answers to be deciphered but only ourselves to be revealed by our speculations." As a sublime evocation of the wonders of space, *2001* can be enjoyed without being completely understood.

KEEP WATCHING

2010: THE YEAR WE MAKE CONTACT (1984)
MOON (2009)

DIRECTOR: ROGER VADIM **PRODUCER:** DINO DE LAURENTIIS **SCREENPLAY:** TERRY SOUTHERN, ROGER VADIM, VITTORIO BONICELLI, CLEMENT BIDDLE WOOD, BRIAN DEGAS, CLAUDE BRULÉ, AND TUDOR GATES, BASED ON THE COMIC STRIP BY JEAN-CLAUDE FOREST **STARRING:** JANE FONDA (BARBARELLA), JOHN PHILLIP LAW (PYGAR), ANITA PALLENBERG (THE BLACK QUEEN AKA THE GREAT TYRANT), MILO O'SHEA (DURAND-DURAND/THE CONCIERGE), DAVID HEMMINGS (DILDANO), MARCEL MARCEAU (PROFESSOR PING), UGO TOGNAZZI (MARK HAND), CLAUDE DAUPHIN (PRESIDENT OF EARTH)

Barbarella

DINO DE LAURENTIIS CINEMATOGRAFICA/PARAMOUNT • COLOR, 98 MINUTES

In the year 40,000, Earth sends a sexy female agent to a sinister planet in search of a missing astronaut.

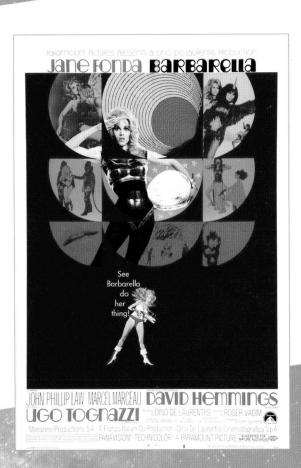

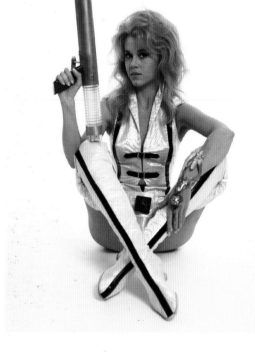

Jane Fonda as
Barbarella

"It makes science fiction . . . something else." So proclaimed the advertising campaign for *Barbarella*, a pop-art space fantasy starring Jane Fonda as Earth's most alluring "astronavigatrix" of the year 40,000. At twenty-nine, Fonda had carved out a promising career as a dramatic and comedic talent in films such as Edward Dmytryk's *Walk on the Wild Side* (1962) and the Oscar-winning *Cat Ballou* (1965) when she put on a spacesuit—and promptly took it off—in the first sci-fi to bring sex into outer space. Barbarella's famous zero-gravity striptease that kicks off the movie captures an illustrious performer at her most wildly uninhibited.

When Italian producer Dino De Laurentiis offered Fonda *Barbarella*, an adaptation of the racy 1964 French comic strip by Jean-Claude Forest, the actress threw his letter in the trash. The role was originally intended for France's leading sex symbol, Brigitte Bardot—who happened to be the ex-wife of Fonda's then-husband, director Roger Vadim. Bardot and Sophia Loren had both turned it down, but Vadim convinced his wife to play Barbarella and to let him direct the spoof. "I explained to Jane," Vadim later wrote, "that the time was approaching when science fiction and galactic-style comedies like *Barbarella* would be important." Jane consented, rejecting lead roles in *Bonnie and Clyde* (1967) and *Rosemary's Baby* (1968) to bring a comic-book vixen to the screen.

Dr. Strangelove (1964) co-screenwriter Terry Southern helped shape the comic into the "something totally original" Vadim hoped to create. The wafer-thin plot concerns Barbarella's mission to the planet Lythion in her mod pink spaceship to locate astronaut Durand-Durand, played with maniacal glee by Milo O'Shea. En route, Barbarella crashes her ship (twice), is attacked by cannibalistic dolls, nearly pecked to death by lovebirds, and is subjected to the rigors of a machine that kills by pleasure. With each scrape,

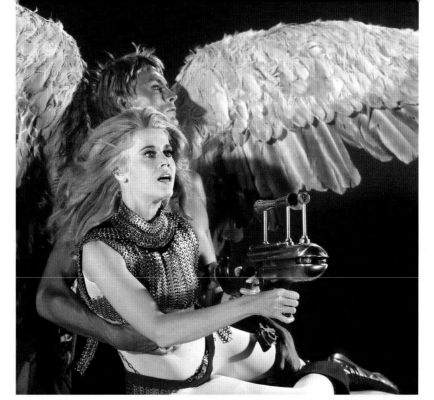

Top: Jane Fonda
and John Phillip Law

Bottom: Roger Vadim
directs Jane Fonda and
John Phillip Law

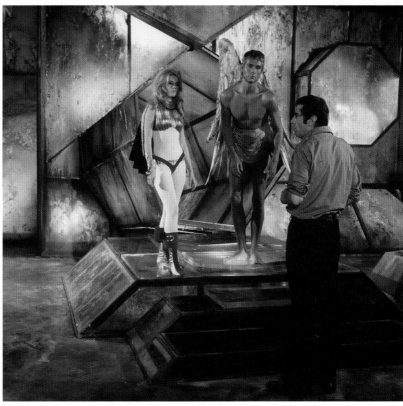

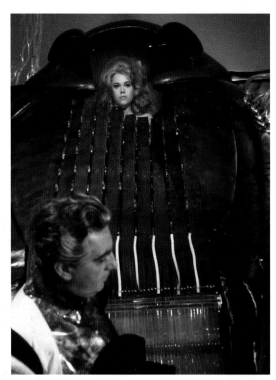

Top: Milo O'Shea and
Jane Fonda

Bottom: Anita Pallenberg
as the Great Tyrant

she loses more of her outré mini-costumes designed by Jacques Fonteray and Paco Rabanne, prompting critic Charles Champlin to observe, "She is both comical and stripped most of the time, which is about all you can ask of a comic strip."

Among Barbarella's rescuers, lovers, and tormentors are John Phillip Law as the winged, angelic Pygar; Anita Pallenberg as the sultry Black Queen, tyrant of the sinful city of SoGo; and David Hemmings in a lively comic turn as a revolutionary leader fixated on the word "secret." But it is Jane Fonda's tousle-haired, false-eyelash-batting performance that makes the movie. Fonda later admitted suffering from bulimia and feeling plagued by insecurities during shooting. "Every morning," she wrote in her autobiography, "I was sure that Vadim would wake up and realize he had made a terrible mistake—'Oh my god! She's not Bardot!'" Remarkably, none of her self-doubt appears on the screen. She is equal parts silly, sexy, and sincere.

The film's poster touts Barbarella's "sexploits" as "the most bizarre ever seen," yet her escapades are actually quite tame. There are no sex scenes; Barbarella never even shares a kiss with her conquests. All sensuality is

implied with a wink and a double entendre. Though, as *New York Times* critic Renata Adler pointed out, the jokes are "mainly at the expense of Barbarella, and of women," our heroine gets the last laugh by triumphing over her aggressors. In the end, the liquid subterranean monster known as the Matmos spits out Barbarella, its evil defeated by her innocence. This movie heroine is allowed to be a paragon of purity without being virginal, and that's a small triumph in itself.

Barbarella managed to shrug off its lackluster reviews to become a bona fide cult classic. Jane Fonda, who later divorced Vadim and rebelled against her sex-kitten image, eventually came to appreciate the film's kitschy appeal, saying, "I think the jerry-built quality of the effects and the offbeat, camp humor give it a unique charm." The actress has even volunteered to step back into her spaceship. "I have a dream: to do a sequel to *Barbarella*," Fonda told the *Los Angeles Times* in 2011. "I think it could be funny—and feminist."

KEEP WATCHING

THE ROCKY HORROR PICTURE SHOW (1975)
FLASH GORDON (1980)

FAR-OUT FACTS

Roger Vadim offered the role of the President of Earth to Jane's father, screen legend Henry Fonda. Fonda, who was just wrapping up the comedy *Yours, Mine, and Ours* (1968) with Lucille Ball and preparing to costar with Tony Curtis in *The Boston Strangler* (1968), politely declined.

For the scenes of Barbarella flying with Pygar, both actors were fastened into metal corsets and hooked to a large rotating steel pole while a sky was front-projected on a screen behind them. "It was sheer, utter agony," Fonda recalled.

A decade after the film's release, a new band in Birmingham, England, saw *Barbarella* televised on the BBC and appropriated the name Durand-Durand, becoming known as Duran Duran.

MIND-BLOWING MOMENT

The opening shot of an astronaut weightless in space quickly defies expectations when she pulls off her helmet, tosses her curls in the air, and begins seductively removing her spacesuit. Claude Renoir, cinematographer and nephew of film director Jean Renoir, devised the effect by having Fonda writhe on a plank of Plexiglas while filming her from above.

DIRECTOR: GEORGE LUCAS PRODUCER: LAWRENCE STURHAHN SCREENPLAY: GEORGE LUCAS AND WALTER MURCH
STARRING: ROBERT DUVALL (THX), DONALD PLEASENCE (SEN), DON PEDRO COLLEY (SRT), MAGGIE MCOMIE (LUH), IAN
WOLFE (PTO), MARSHALL EFRON (TWA), SID HAIG (NCH)

THX 1138

AMERICAN ZOETROPE/WARNER BROS. • COLOR, 86 MINUTES

A factory worker
in a dystopian future illegally
falls in love and tries
to escape his
totalitarian society.

Visit the future where love
is the ultimate crime.
THX 1I38

Warner Bros. presents THX 1138 · An American Zoetrope Production · Starring
Robert Duvall and Donald Pleasence · with Don Pedro Colley, Maggie McOmie
and Ian Wolfe · Technicolor® · Techniscope® · Executive Producer, Francis Ford
Coppola · Screenplay by George Lucas and Walter Murch · Story by George Lucas
Produced by Lawrence Sturhahn · Directed by George Lucas · Music by Lalo Schifrin

MUST-SEE SCI-FI

George Lucas directs
his first feature.

"**A** film *from* the future rather than *about* the future" is cowriter Walter Murch's description of *THX 1138*, the dystopian drama that marked the directorial debut of George Lucas. Though Lucas intended the film as more of a metaphor for the present than a prediction of things to come, it could easily be released to theaters today, nearly fifty years later, and still feel cutting-edge. From its rapid-fire editing to its vision of a technology-driven society where life is captured on video, *THX 1138* is a prescient look ahead, and essential sci-fi viewing.

The movie's first incarnation was *Electronic Labyrinth: THX 1138 4EB* (1967), a fifteen-minute film Lucas made while studying cinema at the University of Southern California. In 1969, up-and-coming director Francis Ford Coppola formed his American Zoetrope studio and secured a deal with Warner Bros. to produce a feature version of Lucas's student film. Lucas (who had directed several short documentaries) gives his first Hollywood effort something of a documentary feel, with minimal camera

movement and a found-footage aesthetic. The quick, disjointed editing style was borrowed from the French New Wave.

After opening with a clip from an old *Buck Rogers in the 25th Century* serial, Lucas cuts to his version of the twenty-fifth century—grim, sterile, and homogenized. This is our first glimpse of the "used future" that would later appear in the *Star Wars* series. Machines and robots are well worn, and often dirty or broken. This advanced yet run-down world not only feels more realistic but, in this case, symbolizes a society that doesn't function as smoothly as it should. How could it? Everyone is bald and dressed in the same shapeless white clothing. They have license-plate codes instead of

Top: THX escapes his
underground world.

Bottom left: Robotic law
enforcement of the future

Bottom right:
Robert Duvall as THX

Robert Duvall

names. Love is outlawed and sexual activity (except with mechanical devices) is forbidden. Sedated, observed by video cameras, and conditioned to conform, people trudge through life working, watching mindless television, and purchasing meaningless objects. "Buy more. Buy now. Buy and be happy," instructs an automated voice.

In his first starring film role, Robert Duvall gives a lesson in powerfully understated screen acting as THX. With very little dialogue to establish his character, Duvall relies on pantomime and subtle facial expressions to create a passive, almost reluctant hero. His female roommate, LUH 3417 (Maggie McOmie), sets the adventure in motion by tampering with his regular dose of sedatives, causing THX to feel emotions, fall in love with LUH, and have a meltdown at the robot factory. Donald Pleasence is edgy and shifty as SEN, THX's new roommate, who talks incessantly but says nothing. (SEN's dialogue is "total nonsense," Lucas has said, and was culled from speeches given by Richard Nixon.) The vast white expanse that confines THX and SEN feels more like a prison of the mind than a literal one; like Dorothy in Oz, THX has the power to escape at any time—all he needs is

the will to do so. When hologram SRT (played by Don Pedro Colley) appears, he leads THX to freedom via a high-speed car chase—the film's only action-sequence—in which steel-faced robo-cops pursue the hero through the newly constructed Bay Area Rapid Transit tunnels beneath San Francisco.

Lucas spoon-feeds nothing to the audience. He allows the story to unfold in its own unique way, through an abstract montage of images and sounds. Instead of music, the film is "scored" with a chorus of distorted voices masterfully engineered by Walter Murch, who also acted as sound designer. At one point, a woman pronounces a series of words over a public loudspeaker: "Fluctuate . . . Undulate . . . Alternate . . . Plastic." Like the confessional machines that ask, "What's wrong?" these automated vocalizations sound alarmingly similar to the helpful voices that greet us from cell phones and laptops today.

MUST-SEE SCI-FI

FAR-OUT FACTS

Many of the extras in the film were members of Synanon, a West Coast drug rehabilitation program that required all its members to shave their heads.

During the car chase, a voice over the radio says, "I think I ran over a Wook-iee back there on the expressway." Actor Terry McGovern improvised the dialogue, unaware that he was coining a term for Chewbacca's species in the *Star Wars* series.

MIND-BLOWING MOMENT

When the robots track THX to the edge of the city and up a steep shaft that leads to the outside world, he knows there will be no going back—he must either submit or leave his reality behind forever. Appearing to climb vertically, Robert Duvall was actually crawling along the floor of a tunnel horizontally with the camera flipped upside down.

An ahead-of-its-time visual and aural experience more than a traditional movie, *THX 1138* portrays a technological world-within-a-world that only the courageous try to escape. In this respect, it is the seed that later sprouted *The Matrix* (1999). In its day, the film was neither a hit with the public nor with Warner Bros. executives, who nixed their deal with Coppola after screening it. Critics, however, sensed they were watching something significant. *Variety*'s 1971 review nailed the film's legacy: "Likely not to be an artistic or commercial success in its own time, the American Zoetrope production just might in time become a classic of stylistic, abstract cinema. . . . We'll know for sure in about a generation."

KEEP WATCHING

THE TERMINAL MAN (1974)
EQUILIBRIUM (2002)

DIRECTOR AND PRODUCER: STANLEY KUBRICK SCREENPLAY: STANLEY KUBRICK, BASED ON THE NOVEL BY ANTHONY BURGESS STARRING: MALCOLM MCDOWELL (ALEX), PATRICK MAGEE (MR. ALEXANDER), ADRIENNE CORRI (MRS. ALEXANDER), MIRIAM KARLIN (CATLADY), AUBREY MORRIS (DELTOID), JAMES MARCUS (GEORGIE), WARREN CLARKE (DIM), GODFREY QUIGLEY (PRISON CHAPLAIN)

A Clockwork Orange

POLARIS PRODUCTIONS/WARNER BROS. • COLOR, 137 MINUTES

In a lawless London of tomorrow, a young thug is imprisoned for murder, then reformed to become physically revolted by violence.

Being the adventures of a young man whose principal interests are rape, ultra-violence and Beethoven.

STANLEY KUBRICK'S

CLOCKWORK ORANGE

A Stanley Kubrick Production "A CLOCKWORK ORANGE" Starring Malcolm McDowell • Patrick Magee • Adrienne Corri and Miriam Karlin • Screenplay by Stanley Kubrick • Based on the novel by Anthony Burgess • Produced and Directed by Stanley Kubrick • Executive Producers Max L. Raab and Si Litvinoff • From Warner Bros., A Kinney Company

Exciting original soundtrack available on Warner Bros. Records

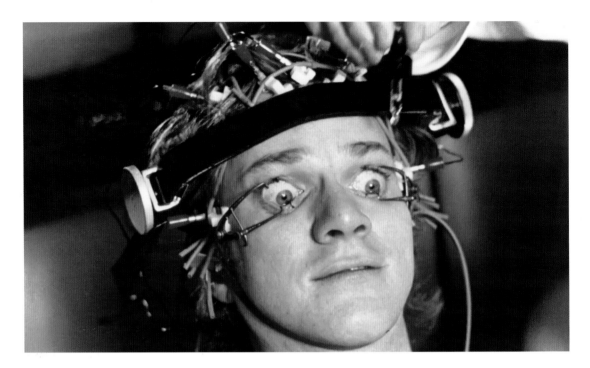

Not content to stun the world with his 1968 masterpiece *2001: A Space Odyssey*, maverick filmmaker Stanley Kubrick followed it with a futuristic fable so singularly and memorably shocking that it was originally given an X rating in the United States and withdrawn from distribution in the United Kingdom for twenty-five years. A social satire that pushes the boundaries of onscreen violence, sex, and pitch-black comedy to the outer limits, *A Clockwork Orange* may be the most subversive film ever released by a major Hollywood studio.

After exceeding his *2001* budget by millions, Kubrick (allotted only $2 million from Warner Bros.) was eager to prove that he could make an impactful movie on a low budget. According to actress Adrienne Corri, who plays a victim of brutal rape in the film, Kubrick

crafted *A Clockwork Orange* as a dark alternative to the bright *2001* future. "That was what we might have got; this is what we were going to get," said Corri. And what we get is a nightmarish journey through author Anthony Burgess's near-future Britain where juvenile delinquency has run rampant, a dystopian horror show with a deep undercurrent of science-fiction running through its subtext. Instead of writing a screenplay, Kubrick filmed scenarios straight from the pages of the 1962 novel.

Kicking off the journey is a seemingly simple shot of Alex—our antihero and "humble narrator," audaciously played by Malcolm McDowell—and his "droogs" lounging in their Korova Milkbar hangout, one of the few sets constructed for the film. Kubrick's one-and-a-half-minute zoom-out as the camera

dollies back to reveal the Korova's outlandish decor is among the most unsettling and unforgettable openings in movie history. Alex's narration establishes the Nadsat slang (a clever Cockney mix of Russian and English invented by Burgess) and his penchant for "a bit of the old ultraviolence." With the hint of a smirk, Alex raises his glass of hallucinogen-spiked milk directly to the camera, as McDowell told Kubrick, to "let [the audience] know they're in for one hell of a ride."

After the Milkbar, Alex and his gang spend the evening attacking and terrorizing innocent victims merely for sport. The use of authentic locations in and around London and the sound captured by mini-microphones pinned to lapels give the movie a vividly real—yet surreal—feel, like the most stylized and perverse documentary ever made. Taking inspiration from a line in the novel about "purple and green and orange wigs" on young women being "the heighth (sic) of fashion," Kubrick and production designer John Barry fashioned a wild world of purple hair, erotic art, and Moog synthesizer versions of Beethoven symphonies, performed by composer Wendy Carlos.

Of his leading man, Kubrick said, "If Malcolm hadn't been available, I probably wouldn't have made the film." Indeed, McDowell brings an uncommon blend of menace, charm, and physical comedy to Alex. While rehearsing the disturbing rape scene, McDowell improvised "Singin' in the Rain" in the style of Gene Kelly, which Kubrick liked so much he immediately called MGM to secure the song rights. Choreographed like a grotesque musical number, the sequence becomes all the more horrifying. For McDowell, the role did not come without a price: the actor suffered a blood clot after an on-camera kick and scratched his cornea when Alex is given the Ludovico Technique, an aversion therapy that leaves him nauseated at the thought of violence. The experimental treatment, an extreme sci-fi twist on Pavlovian conditioning, involves drugs to induce terror, nausea, and paralysis—the results of which are later reversed by brain surgeons who tinker with Alex's "gulliver" (an Anglicization of the Russian word *golova*, meaning "head").

Kubrick's dark satire polarized viewers and critics. Some thought *A Clockwork Orange* deplorable and labeled it pornography, while others hailed it as a thought-provoking work of genius. Amid a firestorm of controversy— including a rash of copycat crimes in England that led Kubrick to pull it from theaters—the

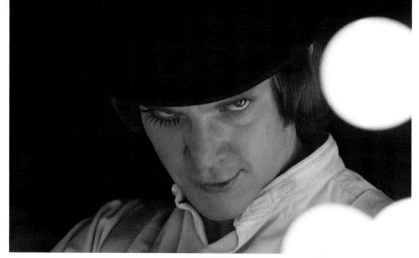

Top: Malcolm McDowell as Alex in the film's opening scene

Center: Adrienne Corri on the set with Stanley Kubrick

Bottom: Paul Farrell, Malcolm McDowell, Warren Clarke, James Marcus, and Michael Tarn

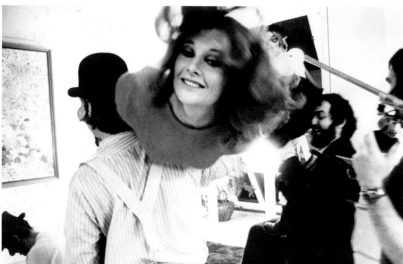

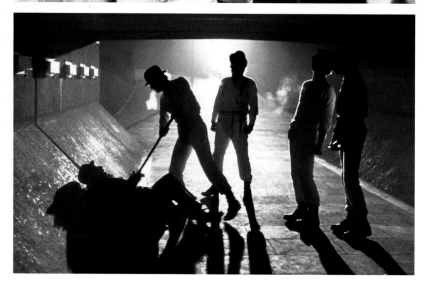

film managed to earn four Oscar nominations, including Best Picture (it won none), and to endure as a pop-culture legend. It impacted cinema as a prototype for edgy dark comedies like Oliver Stone's *Natural Born Killers* (1994), and informed the punk-rock movement in the United Kingdom. Its electronic soundtrack even sparked the trend of synthesizer-driven pop music that would follow in the wake of punk.

To Kubrick, the movie's message was obvious. "It is necessary for a man to have a choice to be good or evil," he said. "To deprive him of this choice is to make him something less than human—a clockwork orange." (Burgess took his title from the obscure Cockney phrase "queer as a clockwork orange," meaning odd or unnatural.) Though acknowledging Alex as "evil," the director maintained that *A Clockwork Orange* only outraged those who could not face the savagery inside themselves. "You can regard Alex as a creature of the id," Kubrick said in 1972. "He is within all of us."

KEEP WATCHING

MAD MAX (1979)
LIQUID SKY (1982)

FAR-OUT FACTS

A few years after the film's release, Malcolm McDowell was introduced to Gene Kelly at a Hollywood party. "He looked at me and quickly turned away and walked off," said McDowell. "I think he was disgusted."

David Prowse is featured in a small role as Julian, the caregiver of a wheelchair-bound writer played by Patrick Magee. Prowse is best known to *Star Wars* fans as the man behind the Darth Vader helmet.

MIND-BLOWING MOMENT

To "cure" their patient of his violent tendencies, doctors inject Alex with a serum to induce nausea. They then bind him in a straitjacket, strap him into a theater seat, clamp his eyelids open, and force him to watch violent films. "It was really horrific," McDowell said of the eye injury he received from the metal eyelid clamps. "I had to have a shot of morphine."

DIRECTOR: DOUGLAS TRUMBULL PRODUCER: MICHAEL GRUSKOFF SCREENPLAY: DERIC WASHBURN, MIKE CIMINO, AND STEVE BOCHCO STARRING: BRUCE DERN (FREEMAN LOWELL), CLIFF POTTS (JOHN WOLF), RON RIFKIN (MARTY BARKER), JESSE VINT (ANDY KEENAN), MARK PERSONS (DRONE), STEVEN BROWN (DRONE), CHERYL SPARKS (DRONE), LARRY WHISENHUNT (DRONE)

Silent Running

UNIVERSAL • COLOR, 89 MINUTES

The caretaker for a galactic greenhouse containing Earth's last remaining plant life goes to extreme measures to keep his forest alive.

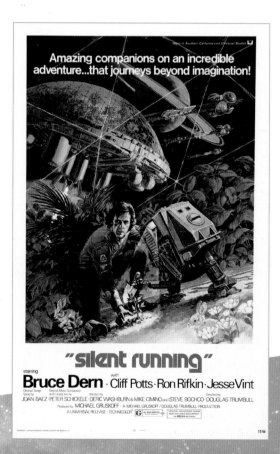

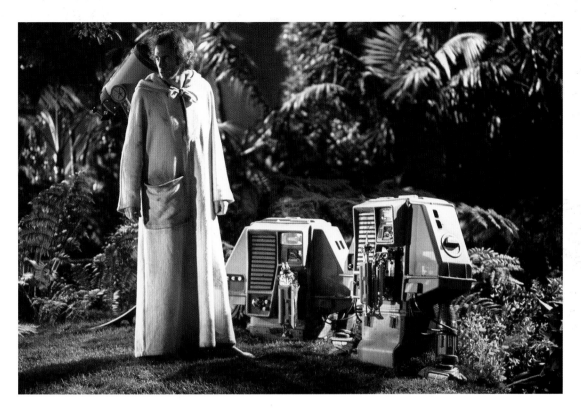

For a low-budget movie made by a first-time director, *Silent Running* has endured far longer than might have been expected. The film's future setting—the year 2008—has come and gone, and still the simple story of one man risking his life for a tiny scrap of natural beauty remains relevant. Because it is that rare science-fiction film with not only a social conscience but a heart, *Silent Running* carries an emotional resonance that lingers nearly half a century later, especially given our planet's environmental challenges.

After creating the famous "slit-scan" process for the Star Gate sequence in *2001: A Space Odyssey* (1968) and supervising the visual tricks in *The Andromeda Strain* (1971), special-effects wizard Douglas Trumbull directed his own space odyssey, one with a positive message. "It's really a story about morality," Trumbull said of *Silent Running*, "about a man who makes a moral decision as to whether or not nature is more important than man." In a radical move, Trumbull (with the aid of screenwriters Deric Washburn, Mike Cimino, and Steve Bochco) has his hero, Freeman Lowell, decide that nature is, in fact, more important than human life.

Lowell, the green-thumbed caretaker aboard the space station *Valley Forge*, is responsible for maintaining the last of the polluted planet's greenery, housed in geodesic domes blooming with flora and fauna. Bruce Dern had built a career on playing

imagination" for one simple reason: "Nobody cares." Dern brings an uneasy balance of heartfelt sincerity and deranged lunacy to the long-haired nature-lover.

Once his shipmates are gone, Lowell is not utterly alone in space. Trumbull recruited young bilateral amputees from southern California hospitals to play the small, boxlike drones, Huey, Dewey, and the ill-fated Louie (named for the animated nephews of Donald Duck). Lowell reprograms the friendly but silent robots to play poker, tend his gardens, and keep him company. Trumbull hoped the drones would show that "machines aren't malevolent factors in our society," he said. "[Technology] is just whatever you make it....You can control a nuclear bomb with it or make it wash the dishes." *Silent Running*'s charming, helpful robot characters spurred George Lucas to create R2-D2, and served as Joel Hodgson's inspiration for Tom Servo and Crow, the two robots in the long-running comedy series *Mystery Science Theater 3000*.

Though Trumbull conceived the ideas, he was "never planning on directing," he said. "On the other hand . . . nobody could think of anybody to handle this crazy picture." So

offbeat villains in films like Roger Corman's *The Trip* (1967) and *Bloody Mama* (1970) "until finally somebody had guts enough to put me in a part they knew I could do," Dern said of his first heroic role. Lowell feels so passionately about preserving the ecology that he disobeys orders to destroy the greenhouses, hijacks the space station, and even murders to save his forests—but only with good intentions. He kills because he cares. Lowell poignantly confronts the problem of apathy when he says, "There's no more beauty and there's no more

Top: Bruce Dern as
Freeman Lowell

Bottom left:
Bruce Dern and director
Douglas Trumbull

Bottom right:
Bilateral amputee Steven
Brown as a drone

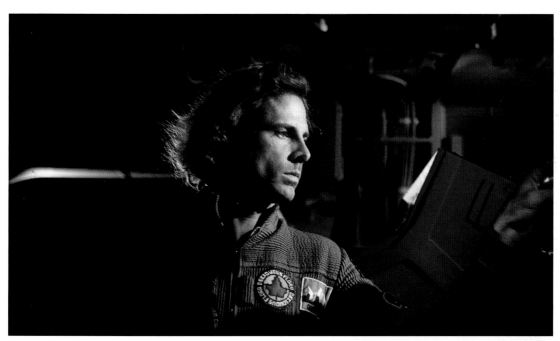

FAR-OUT FACTS

The space station *Valley Forge* was converted from the USS *Valley Forge*, a retired naval aircraft carrier commissioned in the Korean and Vietnam Wars. After filming wrapped, the *Valley Forge* was torn apart and sold for scrap.

According to Trumbull, the title *Silent Running* refers to "a submarine warfare term that means turning off your engines so the enemy can't detect you." The term was also featured in the title of the Robert Wise picture *Run Silent, Run Deep* (1958), starring Clark Gable and Burt Lancaster.

British band Mike + The Mechanics adopted the title for their futuristic 1985 song "Silent Running (on Dangerous Ground)," though the lyrics have no relation to the movie.

MIND-BLOWING MOMENT

Among the film's most impressive imagery is the unforgettable first full view of the *Valley Forge*. As Lowell stands at a sink washing vegetables, the camera pans out to reveal he is aboard a vast American Airlines structure orbiting majestically in deep space.

he stepped into the role of director while also supervising the effects. The results produced by Trumbull and his team equal or surpass anything seen in sci-fi up to that time; their twenty-five-foot model of the space station is a mini marvel patterned on the Landmark Tower from the 1970 World's Fair in Osaka, Japan.

Made for a mere $1 million, *Silent Running*'s understated but stunning space effects, coupled with its mindful themes, elevate it to the rank of classic. While the hippie vibe and Joan Baez ballads lock the film into its early 1970s time period, its message of ecological preservation makes it timeless, and more appropriate now than ever. Since the film was released in 1972, the earth's forests and wildlife have grown even more endangered. Where is Freeman Lowell when we need him?

KEEP WATCHING

MAROONED (1969)
SUNSHINE (2007)

DIRECTOR: ANDREI TARKOVSKY PRODUCER: VIACHESLAV TARASOV SCREENPLAY: FRIDRIKH GORENSHTEIN AND ANDREI TARKOVSKY, BASED ON A NOVEL BY STANISLAW LEM STARRING: NATALYA BONDARCHUK (HARI), DONATAS BANIONIS (KRIS KELVIN), JÜRI JÄRVET (DOKTOR SNAUT), VLADISLAV DVORZHETSKY (ANRI BERTON), NIKOLAY GRINKO (NIK KELVIN), ANATOLIY SOLONITSYN (DOKTOR SARTORIUS)

Solaris

MOSFILM (RUSSIA) • COLOR/BLACK & WHITE, 166 MINUTES

A psychologist encounters a past love when he is sent to investigate reports of unusual phenomena aboard a space station.

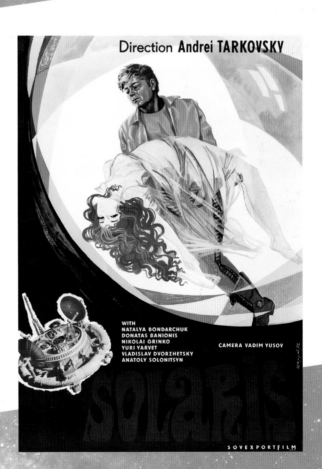

Direction Andrei **TARKOVSKY**

WITH
NATALYA BONDARCHUK
DONATAS BANIONIS
NIKOLAI GRINKO
YURI YARVET
VLADISLAV DVORZHETSKY
ANATOLY SOLONITSYN

CAMERA VADIM YUSOV

SOVEXPORTFILM

Russian director Andrei Tarkovsky once observed that cinema artists can be divided into two categories: those who try to re-create the world in which they live, and those who create their own world. "Those who create their own world," the director said, "are usually poets." This is certainly true of Tarkovsky, a visual poet who created a uniquely mesmerizing world in *Solaris*, his third film and first venture into science fiction. Employing slow tracking shots, meditative pauses, and hallucinatory imagery, Tarkovsky transformed Polish author Stanislaw Lem's 1961 outer-space novel *Solaris* into his own deeply internal celluloid dream.

Often considered Russia's answer to *2001: A Space Odyssey* (1968), *Solaris* was more likely intended by Tarkovsky to be the anti-*2001*. He felt the Kubrick epic was "phony" and "sterile," and sought to use the science-fiction genre as a means of exploring the human psyche. To this end, Tarkovsky steered clear of special effects—an artistic decision that was also necessitated by the budgetary constraints imposed by Mosfilm, the Soviet film bureau. Compare Kubrick's dazzling, whirling spacecraft to the dilapidated space station in *Solaris*, its dim, cavernous hallways evoking only emptiness. Instead of the vibrant spacesuits worn by *2001*'s astronauts, Kris Kelvin sports a T-shirt and rumpled leather jacket as he wanders the space-station corridors unshaven. Played to disheveled, disillusioned perfection by Lithuanian star Donatas Banionis, Kris is a reluctant traveler longing for the comforts of Earth.

Aboard the lonely galactic outpost—inhabited only by two other scientists—Kris encounters something more disturbing than aliens: a being conjured by the strange sea on the nearby planet of Solaris. Tarkovsky introduces the beautiful visitor like a heavenly

Opposite: Donatas Banionis
and Natalya Bondarchuk

Top: Donatas Banionis
and Natalya Bondarchuk

Bottom left: Director
Andrei Tarkovsky,
Anatoliy Solonitsyn, and
Donatas Banionis

Bottom right: Donatas
Banionis as Kris Kelvin

apparition, using back-lighting and a startling close-up that marks a shift from black-and-white to color. The "guest" is soon revealed to be Kris's dead wife, Hari, who had committed suicide years before. Is she human, a ghost, an extraterrestrial, or a figment of his imagination? No clear answers are offered. She seems to be a manifestation of conscience that grows more real with time.

As the Solaris ocean roils in unearthly hues of purple and orange, Hari develops human emotions and Kris rekindles his love for her. For Tarkovsky, the sci-fi scenario was a tool for pondering the nature of relationships, memories, and desires. In one scene, Kris and Hari float together in a weightless embrace while the space station changes its orbit. This wordless expression of visual poetry—the film's only real special effect—is sharply contrasted by the harrowing (and also word-less) sequence that follows: Hari's suicide by

ingesting liquid oxygen. More phantom than mortal, Hari appears to die but is reborn in a writhing, agonizing process resembling a seizure. Actress Natalya Bondarchuk remem-bered Tarkovsky's words as he directed her resurrection. "She is being reborn through pain," he told her. "She is developing internal organs. The corpse is returning to life through death." Tarkovsky later had to fight to keep this scene when Soviet authorities ordered it cut from the film due to its erotic undertones.

Solaris premiered at the Cannes Film Festival in 1972, where it was awarded the Grand Prix Spécial du Jury. When a poorly dubbed and severely edited version (cut from 166 minutes to 132) finally appeared in the United States in 1976, audiences were non-plussed. "Obviously it is impossible to judge the pace, the rhythms, and the clarity of a film that is cut nearly in half [sic]," wrote the *New York Times*. "It is like a fresco partly

The mysterious Solaris
ocean

eaten away by rising damp." Eventually, the film was seen in its entirety and appreciated as a classic. In 2002, *Solaris* was updated by director Steven Soderbergh in a shorter, more commercially appealing form starring George Clooney and Natascha McElhone. Soderbergh whittled the story down to its emotional core, yet kept the introspective tone of the original film and novel.

As much a heartrending drama, a fantasy, and a study in psychological horror as it is a science-fiction epic, Andrei Tarkovsy's *Solaris* defies classification. It is a challenging film—plodding, ambivalent to the wonders of space, more concerned with atmosphere than action. But once experienced, its haunting world is not easily forgotten. One famous fan, Japanese director Akira Kurosawa, praised *Solaris* for its frightening vision of the future. "Just where is scientific progress leading mankind?" Kurosawa wrote. "This film manages to capture perfectly the sheer fearfulness. Without it, science fiction becomes mere fancy."

KEEP WATCHING

STALKER (1979)
CODE 46 (2003)

FAR-OUT FACTS

The movie was shot on four different film stocks (two black and white and two color) that were sparingly doled out by Mosfilm. This hardship was used to great advantage by Tarkovsky to create a work of varied textures and moods.

Taking a cue from Jean-Luc Godard's *Alphaville* (1965), Tarkovsky used footage of a modern-day city—Tokyo, in this case—to portray a futuristic metropolis.

MIND-BLOWING MOMENT

At the end of the film, Kris returns to Earth and visits the home of his father. Or does he? The surreal quality of their scenes together suggests another Solaris-generated reality.

DIRECTOR: **WOODY ALLEN** PRODUCER: **JACK GROSSBERG** SCREENPLAY: **WOODY ALLEN AND MARSHALL BRICKMAN**
STARRING: **WOODY ALLEN (MILES MONROE), DIANE KEATON (LUNA SCHLOSSER), JOHN BECK (ERNO WINDT), MARY GREGORY (DR. MELIK), DON KEEFER (DR. TRYON), JOHN MCLIAM (DR. AGON), BARTLETT ROBINSON (DR. ORVA)**

Sleeper

UNITED ARTISTS • COLOR, 88 MINUTES

A health-food grocer
is frozen in 1973
and thawed two
hundred years later,
only to be hunted down
as a threat to America's
totalitarian society.

WOODY ALLEN
TAKES A
NOSTALGIC LOOK
AT THE
FUTURE.

Woody Allen and Diane Keaton in "Sleeper"

A JACK ROLLINS–CHARLES H. JOFFE PRODUCTION

Produced by JACK GROSSBERG · Executive Producer CHARLES H. JOFFE
Written by WOODY ALLEN and MARSHALL BRICKMAN · Directed by WOODY ALLEN

United Artists

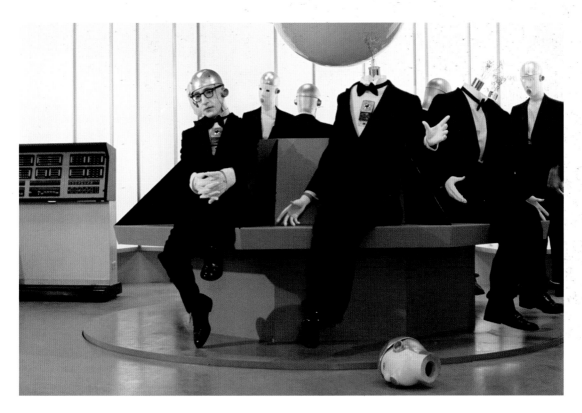

In the 1970s, the science-fiction comedy came into vogue. Germany's Alexander Kluge made the space satire *Der grosse verhau* (*The Big Mess*) in 1971, a young John Carpenter directed the *2001* spoof *Dark Star* in 1974, and Mel Brooks parodied the Universal classics with *Young Frankenstein* that same year. When Woody Allen aimed his talents at sending up the sci-fi genre with *Sleeper*, the result was one of the freshest and funniest films of his career. A pivotal movie in Allen's oeuvre, *Sleeper* marks a transition between nutty comedies such as *Take the Money and Run* (1969) and more sophisticated, complex ones like *Annie Hall* (1977). It also posits an outlandishly imaginative view of the future as seen from a seventies perspective.

Allen got the idea for *Sleeper* while working on a sci-fi segment for his 1972 comedy *Everything You Always Wanted to Know About Sex* But Were Afraid to Ask*. By the time he and Marshall Brickman were finished with the script, Allen had a stellar vehicle for himself and his *Play It Again, Sam* (1972) costar, Diane Keaton. As timid health-food fanatic Miles Monroe, Allen gets what he calls "a cosmic screwing" when he is sealed in foil like a TV dinner and frozen in 1973, then rudely awakened two centuries later. The space-age premise allowed the director to pay tribute to his beloved comics of the past, to lampoon the present, and to poke fun at science fiction.

Page 165: Woody Allen
as Miles Monroe in
a robot factory

Left: Director
Woody Allen on location
in Colorado

Woody Allen's vision of the year 2173 is a fascinating paradox. Though America is run by a totalitarian dictator, partying seems to be the national pastime. They have computerized dogs, sex machines, and over 1,200 TV channels, yet all the cities have been leveled by a nuclear bomb. Everyone lives in circular houses in the middle of nowhere, but they still have freeways and McDonald's. Allen takes a swipe at the '70s health-food craze by making junk food and cigarettes nutritious in his future. When a doctor tells him that after two hundred years all of his friends must be dead, Miles exclaims in shock, "But they all ate organic rice!" Apparently the only thing the future is missing is a sense of humor, which Allen is more than happy to supply using his own brand of sharp-witted buffoonery.

When Miles masquerades as a mute robotic servant for Diane Keaton's pampered poet Luna, Allen slips into stream of sight gags and pratfalls in the style of his silent-era heroes Charlie Chaplin, Buster Keaton, and Harold Lloyd. In a scene where robot-Miles sidesteps through the repair shop with a disarming grin, he's a dead ringer for Lloyd. Later, Allen even dangles from a top-floor window like Lloyd in *Safety Last!* (1923). The Dixieland-jazz soundtrack, like the film, is all up-tempo energy and spontaneity.

Sleeper mixes visual comedy with dialogue that takes jabs at politics, pop culture, sex, religion, and science. "Science is an intellectual dead-end," Miles tells Luna in the final scene. "It's a lot of little guys in tweed suits cutting up frogs on foundation grants." Of course, Allen's high-tech nightmare can't end without a run-in with Bio-central Computer 2100 Series G, a near-twin of Stanley Kubrick's HAL 9000 (and also voiced by Douglas Rain). The stark white sets and avant-garde architecture (in the Denver, Colorado area) set a funky post-apocalyptic mood, while the costumes—designed by filmmaker-to-be Joel Schumacher—charmingly evoke a very 1970s version of the future that includes turtleneck tunics and bell-bottom slacks.

For all its slapstick-sci-fi trappings, the story is essentially a romance. The trailer for

Top left: Diane Keaton
as Luna Schlosser

Top right: Miles
poses as a robot.

Bottom left:
Woody Allen and Diane
Keaton in a car of
the future

Bottom right:
Woody Allen inflates

FAR-OUT FACTS

Allen initially envisioned the film as an epic. "At the start," he said, "I had the insane idea to make it a four-hour movie with an intermission." The first half would have been set in the present, the second half in the future. "I found it hard to write such a big thing," the director said. "I figured, let's just do the second half."

Sleeper won the 1975 Nebula Award for Best Dramatic Presentation from the Science Fiction and Fantasy Writers of America.

MIND-BLOWING MOMENT

Miles disguises himself in an inflatable hydrovac space suit that fills with air, blowing him up like a helium balloon. To evade the authorities, Luna climbs on his back and rides Miles across a lake like a motorized raft.

Sleeper describes it as "a love story about two people who hate each other 200 years in the future," as Luna proves when she repeatedly growls, "I hate you, I hate you!" and "Shut up, shut up!" to Miles. Keaton is equal parts sassy and ditzy as Allen's shallow love interest. "I was portraying her as a Buster Keaton heroine," Allen said of her role. "Chaplin's heroines were just idolized. Keaton's heroines were dummies. . . . I wanted to have more of a Keatonesque Diane Keaton."

With comic-foil Keaton at his side and Marshall Brickman cowriting the script, Allen struck gold; he would collaborate with both of them again on the Oscar-winning *Annie Hall* in 1977 and *Manhattan Murder Mystery* in 1993. But *Sleeper* started it all. Its whimsical take on sci-fi—filtered through Allen's zany yet cerebral lens—made the critics take notice. In his review for the film, Roger Ebert wrote, "*Sleeper* establishes Woody Allen as the best comic director and actor in America."

KEEP WATCHING

THE MAN WITH TWO BRAINS (1983)
GALAXY QUEST (1999)

DIRECTOR: NICOLAS ROEG PRODUCERS: MICHAEL DEELEY AND BARRY SPIKINGS SCREENPLAY: PAUL MAYERSBERG, FROM THE NOVEL BY WALTER TEVIS STARRING: DAVID BOWIE (THOMAS JEROME NEWTON), RIP TORN (NATHAN BRYCE), CANDY CLARK (MARY-LOU), BUCK HENRY (OLIVER FARNSWORTH), BERNIE CASEY (PETERS), JACKSON D. KANE (PROFESSOR CANUTTI)

The Man Who Fell to Earth

BRITISH LION (BRITAIN) • COLOR, 139 MINUTES (UNCUT VERSION)

An alien establishes a corporation on Earth with plans to save his drought-ravaged planet.

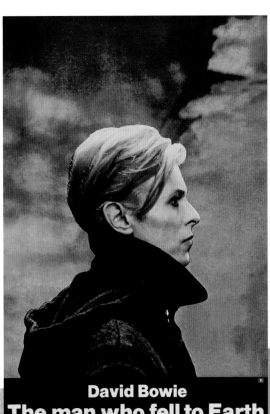

David Bowie
The man who fell to Earth

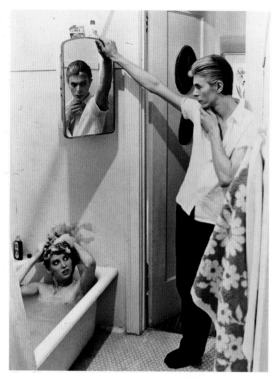

"I think we are all strangers in a strange land," British director Nicolas Roeg has observed. "People from another place are often like aliens." In his brilliantly bizarre sci-fi drama *The Man Who Fell to Earth*, Roeg took the familiar trope of an alien landing on Earth and broadened it into a statement about the alienation all humans feel. Through lush visuals and the inspired casting of David Bowie as the androgynous extraterrestrial, *The Man Who Fell to Earth* expresses the tragic isolation of being an eternal outsider.

Perhaps because Roeg began his career as a cinematographer (working on *Fahrenheit 451* [1966], among other films), striking imagery dominates his films. In *The Man Who Fell to Earth*, according to screenwriter Paul Mayersberg, "We substituted images . . . rather than plot to drive the story forward." Using wide tracking shots, prismatic light, and rich color schemes, Roeg and cinematographer Anthony B. Richmond continually contrast the strange with the common. The vast New Mexico sky, the wall of TV sets, the rippling lake, the luminescent space orb, even a sheet of cookies is transformed by Roeg's camera into an exquisite slow-motion free fall in space. Paintings—particularly

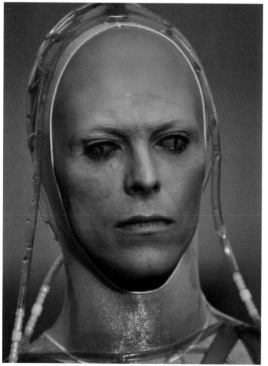

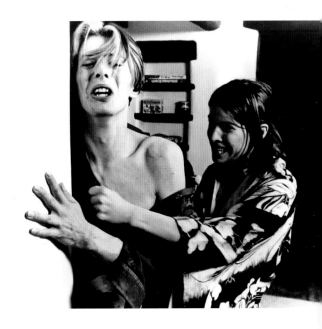

David Bowie and
Candy Clark

Pieter Bruegel's *Landscape with the Fall of Icarus*—are prominent, as is water.

Water is the substance Thomas Jerome Newton (Bowie) travels to Earth to find. Leaving behind his wife and children on the advanced planet of Anthea, Newton becomes a Gatsby-like tycoon in hopes of replenishing his barren world. Keeping his true identity a secret, the alien is soon corrupted by the American society he studied by watching Earth television. Uneducated Mary-Lou (Candy Clark) teaches Newton to filter reality, as she does, through sex and copious amounts of gin, while Mr. Farnsworth and Mr. Bryce help to make their boss—and themselves—wealthy. Only Bryce, played by Rip Torn, suspects the visitor's true origins. But when Newton prompts Bryce to voice the question he's been dying to ask, all he can muster is: "Are you Lithuanian?"

For David Bowie fans, the film captures Ziggy Stardust himself in the prime of his 1970s superstardom. In every frame, Bowie's captivating oddness—the vivid orange hair, the ghostly white skin, the mismatched eyes—is accentuated. Whether struggling through church hymns, playing table tennis, or lounging in seedy New Mexico motel rooms,

he exudes an ethereal otherness that isolates him from his average surroundings. "I was definitely living in two separate worlds at the same time," Bowie said of making the film. "My state of mind was quite fractured and fragmented." The movie is fragmented, too—a puzzle of non sequitur dialogue and imagery that create a confusingly beautiful mosaic.

In the days just before David Lynch came along, *The Man Who Fell to Earth* was as stylishly weird as mainstream cinema got. In certain ways, Roeg anticipates Lynch with his surreal atmosphere and use of 1950s music (Roy Orbison's "Blue Bayou," Louis Armstrong's "Blueberry Hill"). Bowie originally planned to provide the soundtrack—he even recorded some demo tapes—but Roeg ultimately had John Phillips of the Mamas & the Papas handle the music. (Bowie incorporated his recordings into his 1977 album *Low*.) For

Top left: David Bowie
as Thomas Jerome Newton

Bottom: Life on the
planet Anthea

Top right: Rip Torn,
Nicolas Roeg, and David
Bowie on location in
New Mexico

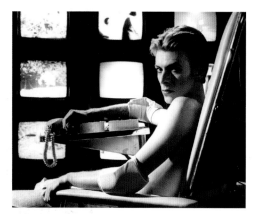
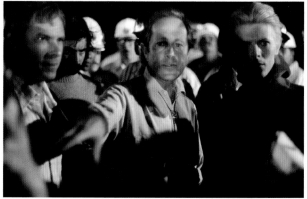
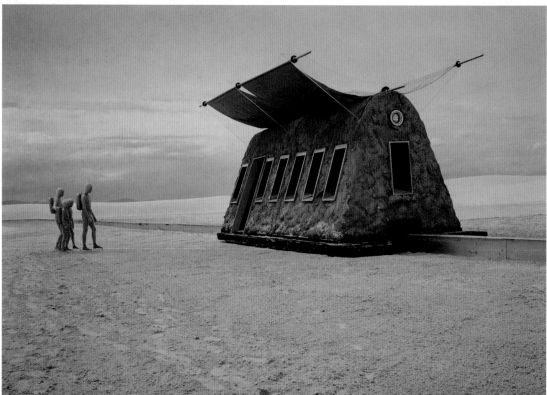

his pitch-perfect portrayal of a spaceman, the musician was awarded a Golden Scroll from the Academy of Science Fiction, Fantasy, and Horror Films. "I actually was feeling as alienated as that character was," Bowie later said. "It was a pretty natural performance. What you see there is David Bowie."

Except for some stunning alien makeup and fleeting glimpses of space travel and time warps, the film contains few traditional sci-fi elements. "This is a science-fiction film with not a lot of science-fiction tools in it," said the director. "It's human science fiction." Critics, most of them unaware that Bowie was a trained actor before he became a rock star, were pleasantly surprised by his characterization, though they felt the film was too long and strange for most audiences. For its American release, distributors cut several key scenes, rendering an already enigmatic film even more puzzling. It was finally restored for its fortieth anniversary in 2016, the same year as David Bowie's death.

KEEP WATCHING

ALTERED STATES (1980)
NAKED LUNCH (1991)

FAR-OUT FACTS

Roeg and Mayersberg shifted the setting from the novel's Kentucky to New Mexico, primarily because of the state's high rate of UFO sightings.

In a 1992 *Movieline* magazine interview, Bowie revealed that he was heavily using cocaine during the film's shooting and could barely remember the experience. "I was totally insecure with about ten grams a day in me," he said. "I was stoned out of my mind from beginning to end."

The blood used in the surgery scene was Anthony Richmond's own. Richmond wanted something more authentic than red makeup, so he requested pig's blood from a butcher. "Bowie heard that and wouldn't entertain it," the cinematographer recalled in 2012. "But he would entertain human blood. We had a nurse on set, and Nic [Roeg] made her take my blood. Can you imagine doing that nowadays?"

MIND-BLOWING MOMENT

Following an emotional confrontation with Mary-Lou, Newton strips away his clothes, his eyebrows, his contact lenses, and other artificial accoutrements to reveal his true self: a hairless, androgynous being with golden catlike eyes.

1976

DIRECTOR: **MICHAEL ANDERSON** PRODUCER: **SAUL DAVID** SCREENPLAY: **DAVID ZELAG GOODMAN, BASED ON THE NOVEL BY WILLIAM F. NOLAN AND GEORGE CLAYTON JOHNSON** STARRING: **MICHAEL YORK (LOGAN), RICHARD JORDAN (FRANCIS), JENNY AGUTTER (JESSICA), ROSCOE LEE BROWNE (BOX), FARRAH FAWCETT (HOLLY), MICHAEL ANDERSON JR. (DOC), PETER USTINOV (OLD MAN)**

Logan's Run

MGM • COLOR, 118 MINUTES

An elite policeman and his girlfriend escape a sealed-off city of the future where no one lives past the age of thirty.

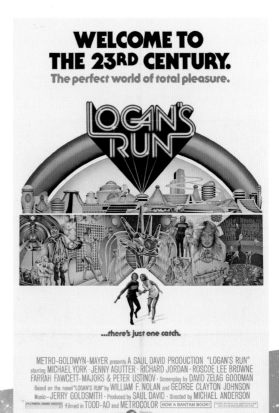

MUST-SEE SCI-FI

ogan's Run is 1970s sci-fi at its flashiest. Released in 1976 (one year before *Star Wars* completely rewired the genre), it was a landmark production, shot with new Todd-AO anamorphic lenses and boasting the first holographic effects ever seen on film. Its $9 million budget made it the costliest movie produced by MGM in the entire decade. During a slump in the sci-fi market, when gritty dramas like *Serpico* (1973) and *One Flew Over the Cuckoo's Nest* (1975) reveled in realism, *Logan's Run* offered pure escapism, recalling the grandeur of Hollywood's golden age.

Michael Anderson, director of the first film version of George Orwell's *1984* in 1956, collaborated with producer Saul David to conjure a twenty-third-century utopia for *Logan's Run*. Rainbow-colored and bursting with pyrotech-nics, this future has everything, even its own vernacular. Michael York stars as Logan, a Sandman whose job is to "terminate" those who try to run from Carrousel, the public execution ritual everyone faces at age thirty. In a giant sealed pleasure dome, Logan and his friends enjoy themselves day and night—until the computer that controls the city orders Logan to run. He brings Jessica (Jenny Agutter) with him, and they escape in search of Sanctuary with Sandman Francis in hot pursuit. Assisted by a team that included cinematographer Ernest Laszlo and production designer Dale Hennesy, Anderson and David affectionately crafted a hedonistic playground of tomorrow. In 1976, David said the utopia in the film "exists in a series of extrapolations on what seem to be pretty obvious tendencies today."

Page 175: The ritual of Carrousel

Top: Michael York and Jenny Agutter

Center: Jenny Agutter, Michael York, and Roscoe Lee Browne as Box

Bottom: Shooting the first meeting of Jessica and Logan

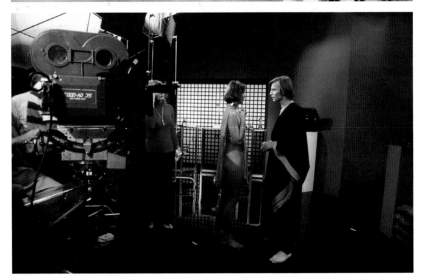

Farrah Fawcett
and Michael York
on the set

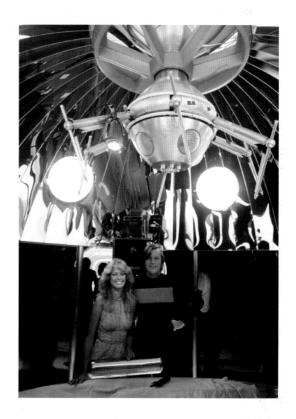

Consequently, *Logan's Run* says more about the Me Generation than it does about the year 2274. The city's attractive young citizens live in what appears to be a disco shopping mall. Their shimmery, diaphanous clothing (described by *Time* magazine as "togas designed by Frederick's of Hollywood") is easily removed for frequent casual liaisons. When Jessica introduces herself to Logan, he replies, "You're beautiful. Let's have sex." Futuristic gadgets—pocket-size communication devices and a computer-dating teleportation circuit—mingle with an array of 1970s artifacts: Jacuzzis, leather sofas, blue eye shadow. Before they reach the outside world, Logan and Jessica must navigate through an orgy with more laser lights and smoke machines than a Pink Floyd concert. This is unpretentious sci-fi at its most enjoyable; a movie that doesn't aspire to answer deep philosophical questions, but simply to entertain.

Shooting on location in ultra-contemporary buildings in the Dallas/Fort Worth area saved the production around $3 million, most of which went into special effects. Veteran effects master L. B. Abbott won a special Oscar for his complex Carrousel effect (created by dangling wire-rigged stuntmen over a flashing, revolving plate built into the floor) and the then-advanced use of holographic technology in Logan's final interrogation scene. Holographic expert Chris Outwater supervised the filming of Michael York's face in a three-dimensional hologram, a process that was shot in black and white but appears red, green, and blue because of the varying bands of wavelengths.

After making their way through an ice realm ruled by the creepy robot Box (Roscoe Lee Browne), Logan and Jessica find not Sanctuary, but a bombed-out wasteland populated by hundreds of cats and one elderly man who speaks in T. S. Eliot poems—a part offered to James Cagney, but ultimately played by Peter Ustinov. *Logan's Run* almost

FAR-OUT FACTS

Producer Saul David had rejected the novel *Logan's Run* when he was an editor at Bantam Books in the early 1960s. "When I bought the project for the movies," David said in 1975, "I changed what I didn't like about it ten years ago."

Roscoe Lee Browne not only voiced Box, but performed inside the unwieldy mechanical costume. The contraption "was top-heavy," recalled Anderson, "and on a number of occasions he started to fall and people had to rush forward to catch him."

Farrah Fawcett would return to science fiction in 1980, then in a leading role as Alex in the outer-space thriller *Saturn 3*. Fawcett was top-billed over costars Kirk Douglas and Harvey Keitel.

MIND-BLOWING MOMENT

After interrogating Logan with a mind probe and finding his information "unacceptable," the computer begins to malfunction. Grabbing a gun, Logan blasts the mainframe and sets off a chain reaction of explosions in the city. Two crew members were injured in the explosion, one requiring hospitalization for third-degree burns on his arms and hands.

starred Lindsay Wagner as Jessica, William Devane as Francis, and Jon Voight as Logan, until York—whose first reaction was to throw the script in his wastebasket—had a change of heart. The Shakespeare-reared actor adds a certain gravitas to Logan, a role that easily could have descended into one-dimensional action-hero.

York also did some talent-scouting for the picture, spotting Farrah Fawcett (billed as Farrah Fawcett-Majors, being married at the time to Lee Majors) "playing tennis on a friend's court one weekend, a vision of blonde perfection," he later wrote, "and suggested her for the role of Holly, the laser cosmetician." Her brief but showy *Logan's Run* cameo—along with a best-selling poster and the popular TV series *Charlie's Angels*—helped Fawcett ascend to superstardom.

KEEP WATCHING

ROLLERBALL (1975)
THE ISLAND (2005)

DIRECTOR: **GEORGE LUCAS** PRODUCER: **GARY KURTZ** SCREENPLAY: **GEORGE LUCAS** STARRING: **MARK HAMILL (LUKE SKYWALKER), HARRISON FORD (HAN SOLO), CARRIE FISHER (PRINCESS LEIA ORGANA), PETER CUSHING (GRAND MOFF TARKIN), ALEC GUINNESS (BEN OBI-WAN KENOBI), ANTHONY DANIELS (C-3PO), KENNY BAKER (R2-D2), PETER MAYHEW (CHEWBACCA), JAMES EARL JONES (VOICE OF DARTH VADER)**

Star Wars

TWENTIETH CENTURY-FOX • COLOR, 121 MINUTES

A young man from a remote planet trains with a master warrior and joins the galactic rebellion against an evil empire.

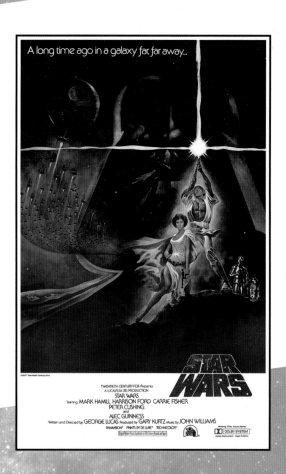

Star Wars not only changed the face of science fiction, it actually changed the world. Today, more than forty years after its debut, the saga's popularity shows no sign of waning. Described as a "space fantasy" (by producer Gary Kurtz) and a "space opera" (by writer/director George Lucas), *Star Wars* is a far-out fusion of mythology, Hollywood Westerns, Errol Flynn swashbucklers, 1930s *Flash Gordon* serials, live-action Disney classics such as *Treasure Island* (1950), Akira Kurosawa films, and a dash of *The Wizard of Oz* (1939). Creator George Lucas drew upon old influences to produce something wholly new—a sci-fi-flavored adventure the *Los Angeles Times* called "the ultimate tribute to the past." Unlike most science-fiction tales, *Star Wars* is set not in the future, but "a long time ago in a galaxy far, far away."

With no opening credits and only an old-fashioned screen crawl to establish the backstory, Lucas drops the audience in the middle of an intergalactic battle. We catch on easily enough, thanks to the engaging characters: comical droids R2-D2 and C-3PO (the Laurel and Hardy of robots) lead us to the spunky Princess Leia, described by actress Carrie Fisher as more of a "distressing damsel" than a damsel in distress. Mark Hamill as Luke Skywalker leaps boldly to Leia's rescue, embarking on the quest of a lifetime with gruff star pilot Han Solo, played by Harrison Ford. The sonorous voice of James Earl Jones (as Darth Vader) and the established British stars Peter Cushing and Sir Alec Guinness (as Jedi Knight Obi-Wan Kenobi) provide enough weight to anchor the space-fairy tale, lending it a mythic quality.

Though it spawned popular sequels, the first film—later retitled *Star Wars Episode IV: A New Hope*—remains an undisputed classic. It is the least self-conscious of the series. Nobody involved in the film expected it to take the world by storm, except maybe Lucas, the man with the vision. "Where are the romance, the adventure, and the fun that used to be in practically every movie ever made?" Lucas asked himself upon completing the cruising comedy *American Graffiti* (1973). After his groundbreaking but somber sci-fi *THX 1138* (1971), the young director learned a lesson with his follow-up: "I discovered that making

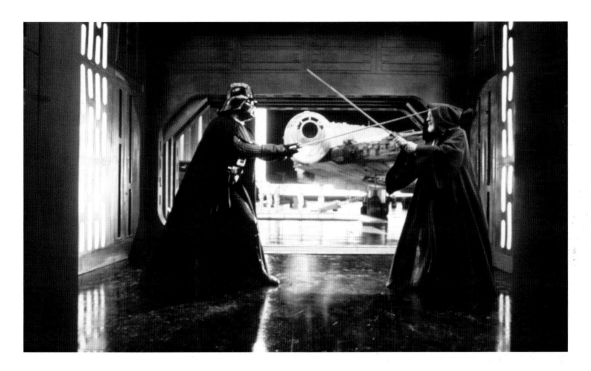

positive films is exhilarating." He poured that exhilaration into *Star Wars*, a happily-ever-after epic without a trace of *THX*'s cynicism.

While the script for *American Graffiti* had taken him three weeks, Lucas labored over the *Star Wars* screenplay for two years, yielding enough material for three films—a trilogy. Despite the director's success with *Graffiti*, the *Star Wars* treatment was rejected by both Universal and United Artists. Finally, Twentieth Century-Fox executive Alan Ladd Jr. agreed to green-light the project for the low figure of $8 million, though he struggled to get the studio to grasp the vision. "How do you do a synopsis of this movie for a board of directors?" Ladd said. "Imagine saying, 'There is a Wookiee named Chewbacca and . . .' The company was going through a bad period anyway.

[They] decided to go with it, and then fortunately didn't ask a lot of questions."

After eighteen grueling months of shooting in England, Tunisia, Guatemala, and Death Valley, Fox threatened to shut the production down when it fell behind schedule and over budget. Working feverishly to save his film—and to perfect the optical effects he and his team at the newly formed Industrial Light & Magic created from scratch—Lucas was rewarded beyond his wildest dreams when *Star Wars* opened in May of 1977. Young and old alike flocked to see the timeless hero's journey with the whimsical details around every corner: the alien band in the cantina, the elegant sabers of light, the ramshackle *Millennium Falcon* speeding through the galaxy, and, of course, the soaring, triumphant John

Top left: Kenny Baker as
R2-D2 and Anthony Daniels
as C-3PO

Bottom left: Mark
Hamill, Carrie Fisher, and
Harrison Ford

Top right: Mark Hamill
promotes *Star Wars* in 1977.

Bottom right: Carrie
Fisher as Princess Leia

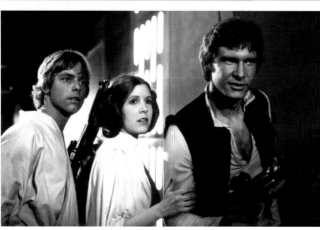

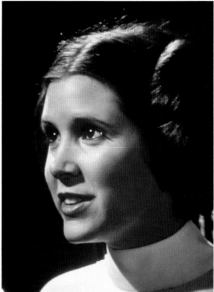

Williams score. The screen had never experienced anything like it before. It collected seven Academy Awards and sold over $400 million in tickets, leading the press to dub it "the most successful film of all time."

As executive producer, Lucas rounded out his trilogy with *The Empire Strikes Back* (1980) and *Return of the Jedi* (1983), and helmed a string of prequels, starting in 1999. Pioneering the modern blockbuster mentality, the *Star Wars* series ushered in the age of repeat screenings and crowds camping out for days to buy tickets. It revolutionized the sci-fi genre, initiated the special-effects industry as we know it, set the stage for the large-scale fantasy franchises (*Lord of the Rings*, *Harry Potter*), and marked the first time T-shirts and toys grossed more revenue than the movie itself. Even the spiritual aspect of *Star Wars* has proven a lasting phenomenon; in a 2001 U.K. census, 390,000 people stated their religion as Jedi, making it the fourth-largest belief system surveyed.

KEEP WATCHING

SUPERMAN (1978)
DUNE (1984)

FAR-OUT FACTS

R2-D2's distinctive tones were patterned after the chatter of toddlers. "As with babies," said sound designer Ben Burtt, "he makes coos and whistles and chirps that have a meaning." Burtt used "a synthesizer and my voice together" to achieve the right blend of sounds.

The movie's impact on world politics could be detected during the 1980s Cold War. U.S. President Ronald Reagan borrowed the name "Star Wars" for his defense system, and used the term "Evil Empire" to describe the Soviet Union.

Despite its overwhelming popularity, Lucas was dissatisfied with the finished product, saying in late 1977 that the film "fell way short of my expectations. It was big and cumbersome to make. . . . I expected more of *Star Wars* than was humanly possible. I had this dream and it's only a shadow of what I dreamt."

MIND-BLOWING MOMENT

After Obi-Wan Kenobi is slain by Darth Vader in a lightsaber duel, his spirit lives on. Luke, on a mission to destroy the Imperial Death Star, is guided by Obi-Wan to "use the Force," a tactic that enables him to obliterate the Death Star with a "one in a million" shot. For this sequence, Lucas took inspiration from aerial fighter-jet battle scenes in World War II movies.

1977

DIRECTOR: STEVEN SPIELBERG PRODUCERS: JULIA PHILLIPS AND MICHAEL PHILLIPS SCREENPLAY: STEVEN SPIELBERG
STARRING: RICHARD DREYFUSS (ROY NEARY), FRANÇOIS TRUFFAUT (CLAUDE LACOMBE), TERI GARR (RONNIE NEARY), MELINDA DILLON (JILLIAN GUILER), CARY GUFFEY (BARRY GUILER), BOB BALABAN (DAVID LAUGHLIN), ROBERTS BLOSSOM (FARMER), MERRILL CONNALLY (TEAM LEADER), GEORGE DICENZO (MAJOR BENCHLEY), LANCE HENRIKSEN (ROBERT)

Close Encounters of the Third Kind

COLUMBIA/EMI • COLOR, 137 MINUTES

A blue-collar worker is inexplicably drawn to a top-secret government rendezvous after a close encounter with a UFO.

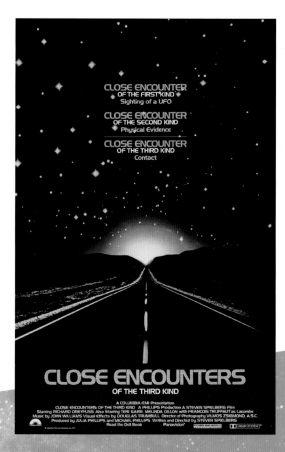

Cary Guffey opens a door to the unknown.

On the heels of *Star Wars* (1977) came *Close Encounters of the Third Kind*, a very different kind of science-fiction epic, and one that broke more new ground. Incredibly, after a quarter-century of flying-saucer movies, this was the first to present a wholly positive view of extraterrestrial life. Even gentlemanly alien Klaatu in *The Day the Earth Stood Still* (1951) was far from harmless, threatening to destroy the Earth if its inhabitants refused to cooperate with his plan. In *Close Encounters*, the aliens seek nothing more than friendship.

Abounding with spectacular visuals that redefined science-fiction cinema, *Close Encounters* favors boundless human curiosity over battles with aliens, focusing on the wonder of the unknown instead of laser beams and robots. In one iconic scene, a three-year-old boy opens his front door. The camera captures him from behind, a tiny, vulnerable silhouette against an orange sky aglow with the otherworldly forces of alien visitors. Perhaps no image better encapsulates the film's theme.

This was a deeply personal project for Steven Spielberg, who had been fascinated by the idea of extraterrestrial life since childhood. When he was seventeen, Spielberg wrote and directed *Firelight* (1964), a low-budget feature about mysterious lights in the sky that turn out to be spaceships. This early film was the basis for *Close Encounters*. Though Spielberg has since become more skeptical of the UFO phenomenon, in his younger days, he was a believer. "I had a real deep-rooted belief that we had been visited," he later said. Only a true believer could have put so much heart into a story about aliens.

With an astronomical final budget of nearly $20 million, the film relied on a team of the best technicians, cinematographers, composers, special-effects artists, and an ensemble cast of actors to create a seamless blend of action, thrills, and touching human drama. After Steve McQueen, Dustin Hoffman, Al Pacino, Jack Nicholson, and Gene Hackman all turned down the lead role, Spielberg cast his friend (and *Jaws* [1975]

Top: Richard Dreyfuss as Roy Neary

Center: Melinda Dillon and Richard Dreyfuss at Devil's Tower

Bottom: Steven Spielberg and François Truffaut on set

Carlo Rambaldi constructs the mechanical alien.

star) Richard Dreyfuss, who ideally embodies working-class underdog Roy Neary. The supporting cast was personally selected by the director: sensitive Melinda Dillon; natural, untrained preschooler Cary Guffey; and, in an inspired casting coup, French filmmaker François Truffaut as the leader of a crew of scientists and military officers in secret communication with interplanetary intelligence. All the major characters have a childlike openness that contrasts effectively with the closed-minded disbelievers like Roy's wife, Ronnie, played by Teri Garr.

From the suburbs of Indiana to the deserts of India, the various characters are obsessively driven to the prearranged UFO landing site at Devil's Tower in Wyoming. Spielberg painstakingly builds anticipation by not showing the audience too much until the finale. The rattling of mailboxes and kitchen appliances, strange flashes in the clouds, and a few orbs whooshing across the night sky are the only evidence of space visitors in the first 100 minutes of the film. Then comes the payoff. Spielberg envisioned the climactic meeting between earthlings and extraterrestrials as a glorious symphony of lights and sounds, a communiqué that would transcend all boundaries through the universal language of music. Composer John Williams tried hundreds of different five-note combinations before settling on the right greeting: G, A, F, F (an octave lower), C, or Re, Mi, Do, Do, So in the solfège scale.

Inside a sweltering airplane hangar in Mobile, Alabama—the largest indoor movie set in history—the ultimate close encounter was staged. Douglas Trumbull, who supervised the effects, encountered the same problem he had faced with *2001: A Space Odyssey* (1968): achieving a realistic-looking alien was practically impossible before advancements in CGI technology. Spielberg's first attempt consisted of dressing an orangutan in a spandex

FAR-OUT FACTS

The title was taken from the writings of astronomer Dr. J. Allen Hynek, who theorized a three-degree hierarchy of alien encounters: the first kind is seeing a UFO, the second is physical evidence of a visitation, and the third is actual contact with an alien.

Columbia executives risked their entire studio to bankroll the film. The company was in dire financial straits and counting on a sci-fi blockbuster to put it back in the black.

The film originally ended with Roy singing "When You Wish upon a Star" until it was laughed off the screen by a preview audience in Dallas. Spielberg reluctantly cut the scene, though it represented the earliest seed of his *Close Encounters* inspiration. "I made this movie because of the Disney song," he said. "That came first, that and the idea of a UFO movie."

MIND-BLOWING MOMENT

When the giant mother ship ascends over Devil's Tower, the world saw a new breed of Hollywood flying saucer. Complex, intimidating, and oddly beautiful, this ship was conceived by Spielberg as a hybrid of an oil refinery in India and the lights of the San Fernando Valley as seen from the Hollywood Hills.

body suit and putting him on roller skates. Unsurprisingly, in the words of the director, "It all went wrong." After several more concepts failed, he settled on a marionette designed by Bob Baker, a group of costumed little girls lit in silhouette, and a complex mechanical puppet created by Carlo Rambaldi. The puppet (nicknamed "Puck" by the director) was a marvel of its time, and would serve as the prototype and inspiration for E.T. in Spielberg's *E.T. the Extra-Terrestrial* (1982).

In 2007, Spielberg recalled of *Close Encounters*, "We made this picture in the spirit of childhood and believing in things that don't make sense." If humans are ever to make contact with a more advanced species, the director tells us here, they must regain their sense of childhood wonder and curiosity.

KEEP WATCHING

THE ABYSS (1989)
CONTACT (1997)

DIRECTOR: RIDLEY SCOTT PRODUCERS: GORDON CARROLL, DAVID GILER, AND WALTER HILL SCREENPLAY: DAN O'BANNON STARRING: TOM SKERRITT (DALLAS), SIGOURNEY WEAVER (RIPLEY), VERONICA CARTWRIGHT (LAMBERT), HARRY DEAN STANTON (BRETT), JOHN HURT (KANE), IAN HOLM (ASH), YAPHET KOTTO (PARKER)

Alien

TWENTIETH CENTURY-FOX • COLOR, 117 MINUTES

The crew of a deep-space towing ship picks up an uninvited passenger when they stop to investigate a distress signal.

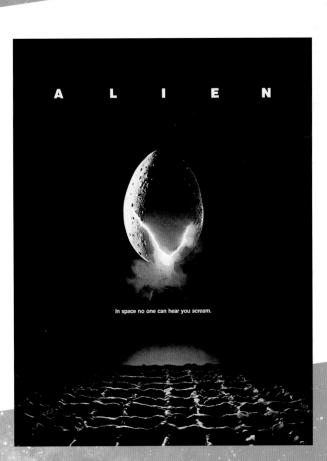

MUST-SEE SCI-FI

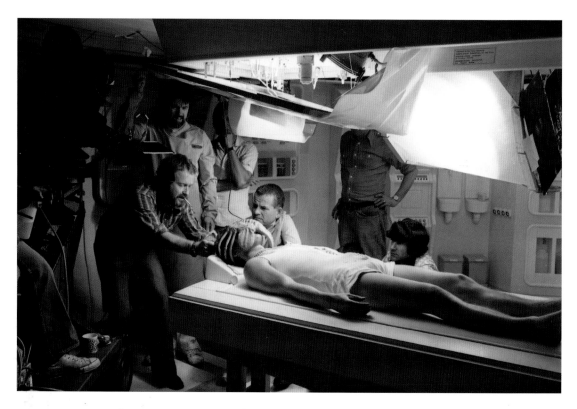

I f *Star Wars* (1977) and *Close Encounters of the Third Kind* (1977) made science fiction exciting again, *Alien* single-handedly made the genre (in the words of the *Hollywood Reporter*) "scary as hell." At once low-key and profoundly shocking, director Ridley Scott's 1979 space thriller is often ranked among *The Exorcist* (1973) and *Jaws* (1975) as one of the most nightmare-inducing films of all time. Like its titular monster, *Alien* slowly coils its slimy tentacles around the audience and never lets go.

Once his gamble on *Star Wars* proved an overwhelming success, Twentieth Century-Fox mogul Alan Ladd Jr. (son of classic movie star Alan Ladd) easily convinced the

studio to bank on another sci-fi screenplay. Dan O'Bannon's script, originally titled *Star Beast*, "was derived from a million science-fiction movies I absorbed while growing up," O'Bannon said. The screenwriter wove together elements from shockers such as *It! The Terror from Beyond Space* (1958), *Planet of the Vampires* (1965), and, most obviously, *The Thing from Another World* (1951)—even down to the crew's overlapping dialogue—to form *Alien*. Visually, the film appropriates the used, grimy look of the spacecraft in *Star Wars* to add a gritty realism. Though it borrows from previous works, *Alien* retains its integrity as a strikingly original story in its own right; its deadly life-form that

Opposite: Ridley Scott directs John Hurt.

Top left: H. R. Giger's alien

Top right: Sigourney Weaver as Ripley with her cat, Jonesy

Bottom left: John Hurt gives birth to a baby alien.

Bottom right: The crew of the *Nostromo* (L to R): John Hurt, Veronica Cartwright, Tom Skerritt, Yaphet Kotto, Sigourney Weaver, Harry Dean Stanton, and Ian Holm

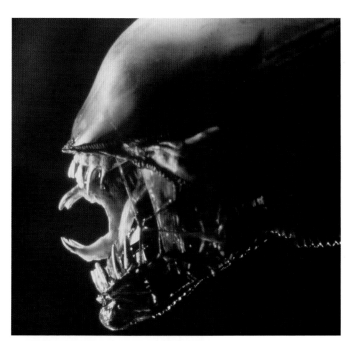

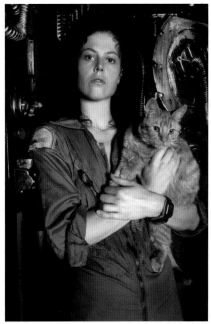

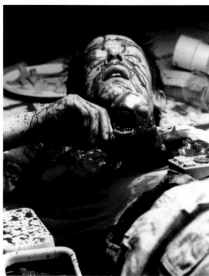

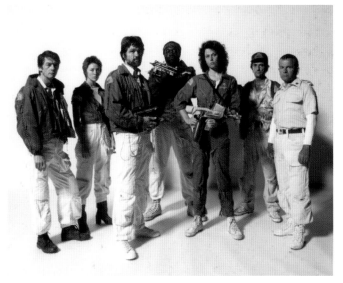

Sigourney Weaver returns as Ripley in James Cameron's 1986 sequel *Aliens*.

gestates inside a human body is one of the most frightening concepts imaginable.

Ridley Scott, who had only TV commercials and one feature (*The Duellists* [1977]) under his belt at the time, fought for the opportunity to direct *Alien*, which he envisioned as "*The Texas Chain Saw Massacre* of science fiction"—in other words, a slasher movie set in outer space. Scott takes his sweet time at the film's start, gradually building a subtle sense of foreboding as he establishes the seven crew members of the *Nostromo*, recently awakened from hypersleep to discover a fossilized alien ship. When certain studio executives saw the movie and complained, "But nothing happens in the first forty-five minutes," Scott replied, "Well, that's the whole point." As critic Roger Ebert once observed, "It isn't the slashing that we enjoy. It's the waiting for the slashing."

When the alien finally appears, it does not disappoint. Young Swiss illustrator H. R. Giger designed the xenomorph he described as "elegant, fast, and terrible," and Carlo Rambaldi (who went straight from *Close Encounters* to *Alien*) created the creature's eyeless, streamlined head. The film's trend-setting production design reflected the sleek new breed of movie monster. Glistening with condensation and billowing with vapor, the dimly lit, steamy corridors of the *Nostromo* would become de rigueur for sci-fi cinema in the 1980s. The whole experience was minimalist and ahead of its time, from Jerry Goldsmith's stark score to the lowercase-only typeface of the screen credits, a style that would later become associated with the Internet era.

Fox's marketing campaign set new standards, too. No clips or photography from the film appeared in the TV ads or theatrical trailers—only the image of an alien egg cracking open and the now-legendary tagline, "In space, no one can hear you scream." In an unusual strategy for an R-rated horror film, Fox had a line of toys and collectible merchandise manufactured, counting on *Alien* to be a blockbuster. When he first saw rushes

of Scott's work, Ladd had upgraded the production from a B picture to a big-budget extravaganza. He also approved the switch of two of the crew members from male to female.

As the smart, self-possessed warrant officer Ripley, Sigourney Weaver was transformed by *Alien* from an unknown stage actress into the first female sci-fi action hero. Her revolutionary role literally made headlines: "The Hero Is a Woman" announced a 1979 *Los Angeles Times* article. "What Lee Marvin and Charles Bronson were to *The Dirty Dozen*, Sigourney Weaver is to *Alien*, a hero as opposed to a heroine (who is usually saved by the hero)," proclaimed the *Times*. In 1986, James Cameron would step in as director and push Ripley even further into action-hero stardom with his acclaimed high-octane sequel *Aliens*. "Just call me Rambolina," Weaver joked of her famed character. With or without Ripley, the *Alien* franchise continues to thrive in the twenty-first century. Ridley Scott returned to direct a sixth installment, *Alien: Covenant*, in 2017.

KEEP WATCHING

PLANET OF THE VAMPIRES (1965)
OUTLAND (1981)

FAR-OUT FACTS

For its close examination by Ash (Ian Holm), the face-hugging creature was constructed of a rubber casing filled with fresh oysters and clams.

To set the mood while shooting the intense final scene in the shuttle, Scott played the 1976 album *The Planets* by electronic music artist Isao Tomita for Weaver at top volume.

In 2003, the hundred-pound, three-foot-tall silver prop egg that hatched the face-hugger was inducted into the Smithsonian National Museum of American History in Washington, D.C.

MIND-BLOWING MOMENT

At the fifty-five-minute mark, *Alien* astounded its original 1979 audience with one of the goriest surprises in film history. Convulsing with stomach cramps, Kane (John Hurt) suddenly "gives birth" to a baby alien that bursts forth from his chest in a blood-splattering eruption. The scene—shot with four different cameras—was done in a single take.

DIRECTOR: STEVEN SPIELBERG PRODUCERS: STEVEN SPIELBERG AND KATHLEEN KENNEDY SCREENPLAY: MELISSA MATHISON STARRING: DEE WALLACE (MARY), HENRY THOMAS (ELLIOTT), PETER COYOTE (KEYS), ROBERT MACNAUGHTON (MICHAEL), DREW BARRYMORE (GERTIE), K. C. MARTEL (GREG), SEAN FRYE (STEVE), C. THOMAS HOWELL (TYLER)

E.T. the Extra-Terrestrial

UNIVERSAL • COLOR, 115 MINUTES

A boy from a broken suburban home befriends a stranded extraterrestrial and helps the creature return to his planet.

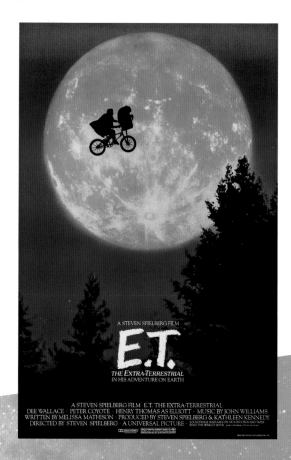

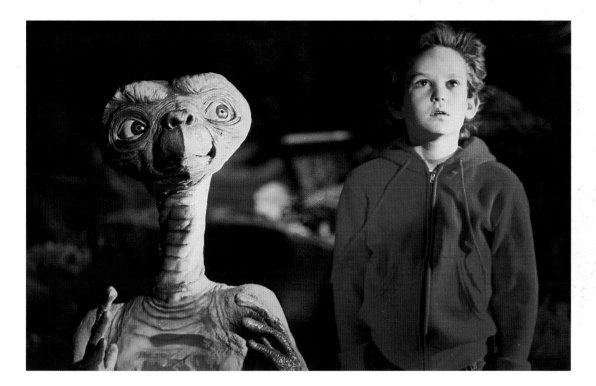

While Steven Spielberg was shooting the spaceship-landing scene in *Close Encounters of the Third Kind* (1977), he got the idea for a sequel. "I had this image that there should be one surviving alien," the director said, "walking away alone and afraid. What I really wanted to do was a movie about that little guy who was left behind." Spielberg also longed to make a small, personal film about children of divorce growing up in the suburbs. When he merged the two concepts into one, the result was perhaps the most endearing science-fiction movie of all time—*E.T. the Extra-Terrestrial*.

The film's story couldn't be simpler. It's essentially a boy-and-his-dog tale in the mold of Disney's *Old Yeller* (1957), but instead of a dog, the boy adopts a stray alien. "We worked out a plot line in five minutes," recalled Melissa Mathison, who wrote the script for Spielberg. "The spaceman gets stranded, he's found by kids who keep him in a closet. Then he gets sick. Then he gets well." But the deceptively simple story accomplished an incredible feat: it injected heart into the often cold universe of science fiction, giving audiences a much-needed dose of warmth.

Through the eyes of ten-year-old Henry Thomas as Elliott, Spielberg conjures a suburban fantasy seen from a child's perspective. Every adult except Elliott's mom (Dee Wallace)—and, later, Peter Coyote's kind government agent Keys—is obscured by shadows or viewed from the waist down. Only Elliott's

Page 195: E.T. and Henry Thomas as Elliott

Top left: Henry Thomas stars in E.T., originally titled *A Boy's Life*.

Top right: E.T. and Drew Barrymore

Bottom left: E.T. boards the spaceship for home.

Bottom right: Peter Coyote and Dee Wallace

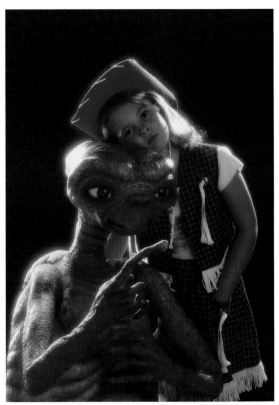

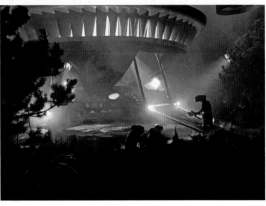

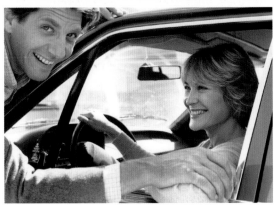

Steven Spielberg
with E.T.

brother and his little sister, Gertie, played by Drew Barrymore, are in on the secret of the "man from the moon" in the closet. At six, Barrymore knew her extraterrestrial costar was not really alive, but saw him as a kind of "guardian angel," she said. At the film's twentieth-anniversary reunion in 2002, the actress remembered E.T. as "one of the first, most important friends of my life." Even grown-up Dee Wallace was consumed by the magic. "I truly never thought of E.T. as a puppet," Wallace said. "He was very real to all of us."

Carlo Rambaldi crafted an engineering miracle with his highly expressive E.T. creation. Spielberg asked Rambaldi to use photos of Albert Einstein, Ernest Hemingway, and Carl Sandburg to design the creature's large, soulful eyes, though Rambaldi claims he modeled the eyes after those of his Himalayan cat. Like a cat, E.T. emits a comforting purr—along with an entire vocabulary of burbles, grunts, and hums—until he picks up a smattering of English. When formulating a plan to contact his home planet, the alien utters one of the most famous lines in movie history: "E.T. phone home."

Cinematographer Allen Daviau enhanced E.T.'s authenticity by using tiny key-lights and foil reflectors, part of an overall mellow,

naturalistic lighting scheme. With golden lamps and sunlit windows, Daviau transformed the kids' bedrooms and walk-in closets into luminous worlds of their own, with enough deep shadows to suggest danger. The story is not all sweetness and light; when the alien's health fades and the government invades Elliott's sanctuary, the fantasy becomes a nightmare. The visible span of darkness and light within each scene mirrors the story's broad range of joy, laughter, thrills, and tears.

In Spielberg's eyes, he had made a small, intimate film. But the fifteen-minute standing ovation it received at its first public screening (at the 1982 Cannes Film Festival) hinted at something much bigger. In fact, his fairy tale about a friendly alien became the phenomenon of the decade, warming the hearts of millions and touching even the most jaded critics. *New Yorker* reviewer Pauline Kael gushed that the tears viewers shed were "tokens of gratitude

FAR-OUT FACTS

The creature was sculpted of fiber-glass, polyurethane, and foam rubber, layered over an aluminum and steel skeleton. Each separate muscle was connected to a control mechanism (operated by Rambaldi and his ten assistants), making E.T. capable of 150 individual, complex movements—even pupils that could dilate on cue.

After playing in theaters for thirty-one weeks, *E.T.* surpassed *Star Wars* (1977) as the biggest-grossing movie of all time. Ironically, *Star Wars* had broken the box-office record previously set by Spielberg's 1975 blockbuster *Jaws*.

The movie was not beloved everywhere. Sweden, Finland, and Norway prohibited children under eleven from seeing the film due to its "threatening and frightening atmosphere."

MIND-BLOWING MOMENT

On Halloween night, Elliot carries E.T. into the forest on his bicycle. When the terrain becomes too rough, E.T. uses his otherworldly powers to raise the bicycle into the sky as he and Elliot soar across the full moon. This scene helped the film win an Oscar for Best Special Effects.

for the spell the picture has put on the audience." *Rolling Stone* hailed it as "the most moving science-fiction movie ever made," and Gene Siskel theorized, "I think the secret of the film's success is that it supplies a quality that has been missing from most American movies of late: the emotion of love."

The box-office triumph was followed by a merchandising frenzy and a wave of copycat movies about adorable aliens or robots, including *Gremlins* (1985), *Short Circuit* (1986), and *Mac and Me* (1988). But beneath all the hype and imitations, a classic film remains. For a motion picture that stars a special effect, *E.T. the Extra-Terrestrial* connects with viewers on a deeply authentic level. It portrays a bond of understanding that transcends barriers of culture, language, and even species. Most of all, it's about the power of believing. Elliott expresses this simply and perfectly when he says good-bye to E.T., assuring him, "I'll believe in you all my life."

KEEP WATCHING

THE GLITTERBALL (1977)
SIGNS (2002)

DIRECTOR: RIDLEY SCOTT PRODUCER: MICHAEL DEELEY SCREENPLAY: HAMPTON FANCHER AND DAVID PEOPLES, BASED ON A NOVEL BY PHILIP K. DICK STARRING: HARRISON FORD (RICK DECKARD), RUTGER HAUER (ROY BATTY), SEAN YOUNG (RACHAEL), EDWARD JAMES OLMOS (GAFF), M. EMMETT WALSH (BRYANT), DARYL HANNAH (PRIS), WILLIAM SANDERSON (J. F. SEBASTIAN), BRION JAMES (LEON KOWALSKI), JOE TURKEL (DR. ELDON TYRELL)

Blade Runner

WARNER BROS. • COLOR, 117 MINUTES (2011 "FINAL CUT")

A detective in 2019 Los Angeles becomes romantically entangled with one of the illegal androids he is assigned to find and destroy.

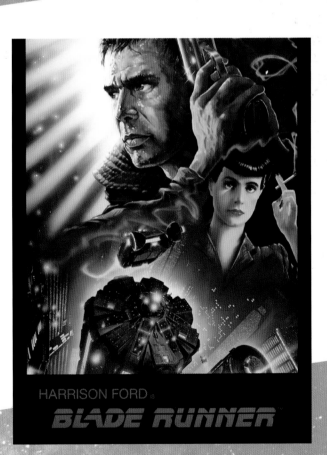

HARRISON FORD is
BLADE RUNNER

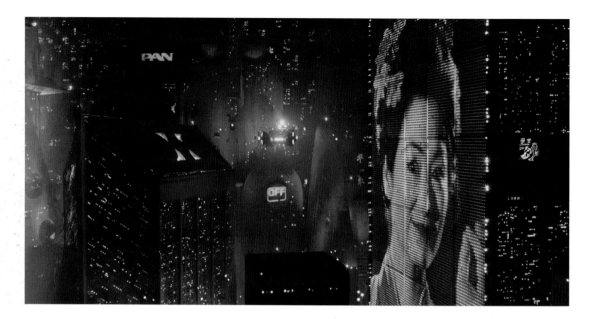

Jean-Luc Godard's *Alphaville* (1965) may have initiated the merging of futuristic science fiction with film noir, but Ridley Scott took the hybrid to breathtaking new heights with *Blade Runner*, arguably the most extraordinary vision of the future captured on film since *Metropolis* (1927). Eclipsed by *E.T.*, *Star Trek II: The Wrath of Khan*, *Rocky III*, and *Poltergeist* on its first release in the summer of 1982, *Blade Runner* spent years as a misunderstood failure before ultimately being recognized as "the *Casablanca* of science fiction."

Originally called *Dangerous Days*, the movie began as Hampton Fancher's loose adaptation of the 1968 novel *Do Androids Dream of Electric Sheep?* by Philip K. Dick. When *Alien* (1979) director Ridley Scott jumped on board, he embarked on his dream project: an optically stunning dystopian film noir. Scott—with the help of director of photography Jordan Cronenweth, "visual futurist" Syd Mead, and effects guru Douglas Trumbull—created a future Los Angeles so distinct it's a vital character in the film. A dense urban wasteland awash with neon and smog, the L.A. of *Blade Runner* is lit up with Asian advertisements and drenched in acid rain, "like Hong Kong on a bad day," as Scott said. Occasionally, sunlight streams in through skyscraper windows like liquid gold as the synth-heavy Vangelis score sets a sensuous, melancholy mood.

The smoke, rain, and darkness—all of which Scott later admitted he used to disguise the inadequacy of the back-lot sets—made for a shooting experience so notoriously miserable that the crew rechristened the film "Blood Runner." To novice actress Sean Young, Scott was a taskmaster, reportedly shooting

Opposite: Director
Ridley Scott's vision of Los
Angeles in 2019

Right: Sean Young as
Rachael

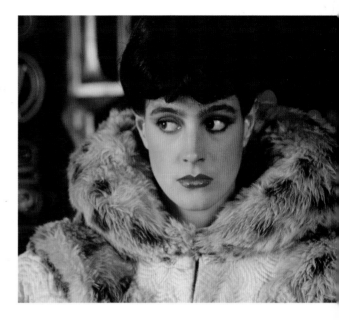

twenty-six takes of her line "Do you like our owl?" because she didn't pronounce "owl" precisely as he wanted. Harrison Ford was equally disgruntled. "It was a bitch working every night, all night long, often in the rain," said Ford. But the oppressive atmosphere not only gives the film an unforgettable aesthetic, it makes an appropriate backdrop for the story's hero. Rick Deckard, like the city, has seen better days. He's a burned-out ex-blade runner forced to hunt down and kill a group of lifelike androids known as replicants. One of them, Young's Rachael (who looks like a synthetic blend of Vivien Leigh and Hedy Lamarr), touches Deckard with her un-replicant-like sensitivity.

"One of the ironies of the film," Ford observed, "is that this dead, dull man is revived by something that he knows is a fraud. But the emotions this fraud incites— the memories it provokes—are sufficient to create a real experience." An understated screen actor, Ford was selected by Scott for his Bogart-like antihero quality. "Harrison Ford possesses some of the laconic dourness of Bogey, but he's more ambivalent, more human," the director said. But is Deckard human or a replicant? The film

implies the question without answering it. Rutger Hauer's smoldering performance as replicant Roy Batty juxtaposes Deckard's icy detachment. Batty is vibrant, poetic, and on fire with emotion, expressing a very human sorrow that all of his memories "will be lost in time, like tears in the rain."

To please the public (and the film's investors), Scott tacked on some voiceover narration by Ford and a happy ending— additions he would soon realize were unnecessary. These were later cut in subsequent versions, but not before the original sharply divided audiences and critics. Of the 1982 premiere, Hauer said, "It was as if the audience had been split with a razor." People either loved *Blade Runner* or loathed it. Yet the film's smoky urban art direction—referred to by the filmmakers as "retro deco" or "trash chic"—would dominate the

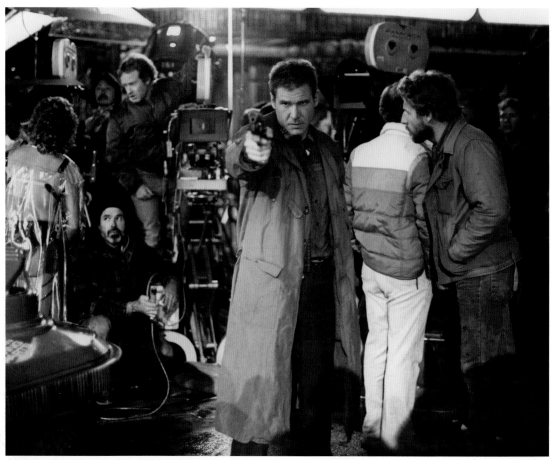

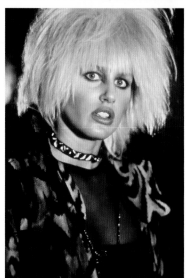

look of the 1980s, from TV commercials to music videos on MTV. Its impact on cinema is immeasurable; movies as varied as *Brazil* (1985), *The Fifth Element* (1997), and *Batman Begins* (2005) owe a debt to Scott's vision.

Co-screenwriter David Peoples believes *Blade Runner* resonates because it poses big questions. "What exactly makes us human beings or not human beings? Are we people because we have memories? That is the underlying question of the film. And it's not answered and not answerable," stated Peoples in 2007. As we inch ever closer to the future depicted in the film, its delayed popularity gains greater momentum. In 2017, Scott's long-dreamed-of sequel finally became a reality with *Blade Runner 2049*, directed by Denis Villeneuve. This time, Ford's Deckard is pursued by a new blade runner (Ryan Gosling) in an even more polluted Los Angeles.

KEEP WATCHING

AKIRA (1988)
DARK CITY (1998)

FAR-OUT FACTS

Scott envisioned his hero sporting a fedora like a 1940s detective, until Ford revealed that he wore a similar hat in the movie he was currently shooting, *Raiders of the Lost Ark* (1981). "I was furious," Scott recalled. "I so wanted him to wear a floppy hat in our film. Instead, we had to settle for that weird haircut."

From the moody cityscape to the soaring "spinners," every shot in the movie was a practical effect achieved by miniature models, matte paintings, and multiple exposures. "There are no computer-generated images in the film," said art director David L. Snyder. "We didn't have all the advantages that people have now, and I'm glad we didn't because there's nothing artificial about it."

MIND-BLOWING MOMENT

His life span running low, a desperate, enraged Roy Batty confronts his maker, Dr. Tyrell (Joe Turkel). When Tyrell denies Batty's plea for longer life, the replicant gives his "father" a good-bye kiss before gouging out his eyes and crushing his skull with his bare hands.

1984

DIRECTOR: JOHN SAYLES PRODUCERS: PEGGY RAJSKI AND MAGGIE RENZI SCREENPLAY: JOHN SAYLES STARRING: JOE MORTON (THE BROTHER), TOM WRIGHT (SAM), STEVE JAMES (ODELL), BILL COBBS (WALTER), CAROLINE AARON (RANDY SUE), JAIME TIRELLI (HECTOR), DEE DEE BRIDGEWATER (MALVERNE), JOHN SAYLES (MAN IN BLACK), DAVID STRATHAIRN (MAN IN BLACK)

The Brother from Another Planet

CINECOM INTERNATIONAL • COLOR, 109 MINUTES

A mute alien escapes slavery on his planet only to find himself among the streetwise citizens of Harlem.

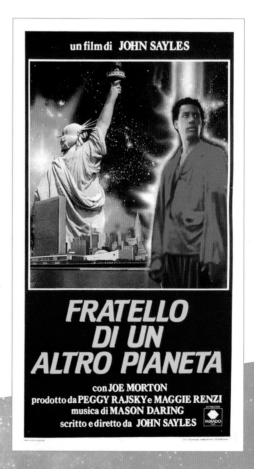

Judging by the sci-fi blockbusters that began dominating the genre in the late 1970s and early '80s, it's easy to forget that cinematic science fiction got its start without bloated budgets or big-name stars. With his quirky, low-budget comedy-drama *The Brother from Another Planet,* independent filmmaker John Sayles not only brought the genre back to its origins, he took sci-fi into the streets. Writing, directing, and acting in a supporting role, Sayles shot his movie on the sidewalks of New York in twenty-three days, for only $340,000. Its sly social commentary lies in its colorful characters, all of whom react to a space visitor with varying degrees of comical nonchalance.

As the three-toed alien who crashes his spaceship in the harbor near Ellis Island, Joe Morton expresses sensitivity and wonder without saying a word. (Sayles "wrote the lead not having any vocal cords purposely," he said, "so we could make the film quickly.") Because he happens to resemble an African American human, he blends right into the Manhattan neighborhood of Harlem, where everyone assumes he's just a quiet "brother" from down the block. Like E.T., the Brother is stuck on a strange planet, able to understand others but not speak, and has a few exceptional abilities up his sleeve. Appropriately enough, in 1980 Steven Spielberg had hired Sayles to write a sequel to *Close Encounters of the Third Kind* (1977), but never used this script; the project would eventually evolve into *E.T. the Extra-Terrestrial* (1982).

Morton's extraterrestrial possesses what Sayles has referred to as "low-budget powers"—he can magically heal and repair just by touching

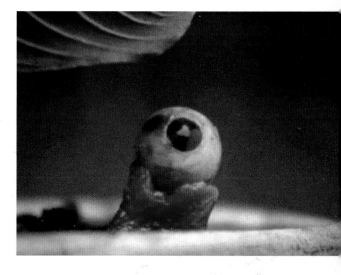

a broken object or injury with his hands. Instead of empowering him with superhero status, this gift merely wins him a low-paying gig repairing video games at an arcade, and endows him with the ability to hotwire a car. On the streets of Harlem, the Brother does what he must to survive.

The Brother from Another Planet is driven by its dialogue—by turns ironic, realistic, surrealistic, and poignant—filtered through Sayles's wry comic lens. The barflies at the local watering hole, the Puerto Rican repairman, the Caucasian single mom from Alabama—they all open up to the Brother in a free-flowing stream of chatter about themselves, the way people tend to do when alone with a good listener. Bar regular Walter (Bill Cobbs) believes outer space is filled with "diseases we ain't even got a name for. Space germs." When someone suggests the brother might be from Haiti, Walter warns, "Haitians got diseases, man. Voodoo germs." Sayles and David Strathairn portray the cinema's first "men in black," alien bounty hunters who follow the Brother's trail to Odell's Bar. Odell asks to see their identification, prompting Sayles to deliver the line "We don't have to show you any badges" as a

hilariously deadpan take on *The Treasure of the Sierra Madre* (1948).

By offering a space alien as a stand-in for an illegal alien, the film redirects the expected sci-fi conventions into some pointed social critique. When the men in black pose as immigration officers and question Randy Sue, played by Caroline Aaron, about taking the Brother in as a boarder, she replies, "We had a kid overdose right downstairs last night, and you're pestering people about whether they've got some piece of paper that says they're legal." Also tackling the drug epidemic, violence, and racism, Sayles casually explores the humor, the cruelty, and the camaraderie that exist between races and within neighborhoods. Neither his dialogue nor his passive camera attempts to moralize, only to observe a variety of behaviors from a nonjudgmental distance.

"Harlem was so hospitable," Sayles told the *Los Angeles Times* of his experience. "We

FAR-OUT FACTS

The film's one major special effect—the exterior of the brother's spaceship—set Sayles back a whopping $12. Doubling for the depths of outer space was a large piece of black construction paper fastened with a pin.

Joe Morton once told the *New York Times* that the Brother was his favorite role in a lengthy acting career. He met his wife of twenty years, artist Nora Chavooshian, on the set when she designed his three-toed feet.

In 1984, the same year that *Brother* was released, John Sayles directed Bruce Springsteen in his iconic "Born in the U.S.A." music video.

MIND-BLOWING MOMENT

During a quiet yet powerful confrontation with a big-time drug dealer, the Brother removes his eyeball from its socket and hands it to the man. The unexpected action is a highly effective literal take on the figure of speech, "Seeing the world through someone else's eyes."

shot all night once, and it was like a block party." To emphasize the vibrant district, cinematographer Ernest Dickerson—who had never shot a 35mm film before—focuses on bright colors and high-contrast lighting, while keeping the overall mood toned down and subtle. *Brother* may be the most natural and gritty sci-fi movie made in the 1980s, proving that big studios and lavish special effects do not define science fiction. By capturing a thought-provoking slice of 1984 street-life, the film broadened the boundaries of sci-fi and has become an underground classic.

KEEP WATCHING

NIGHT OF THE COMET (1984)
MEN IN BLACK (1997)

DIRECTOR: JAMES CAMERON PRODUCER: GALE ANNE HURD SCREENPLAY: JAMES CAMERON WITH GALE ANNE HURD
STARRING: ARNOLD SCHWARZENEGGER (THE TERMINATOR), LINDA HAMILTON (SARAH CONNOR), MICHAEL BIEHN (KYLE
REESE), PAUL WINFIELD (LIEUTENANT TRAXLER), LANCE HENRIKSEN (DETECTIVE VUKOVICH), BESS MOTTA (GINGER)

1984

The Terminator

ORION • COLOR, 107 MINUTES

A post-apocalyptic
cyborg travels into
the past to kill a waitress,
but must also contend
with the soldier
sent back in
time to protect her.

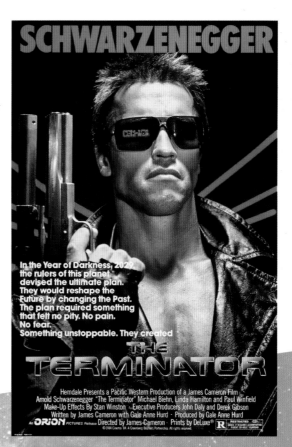

MUST-SEE SCI-FI

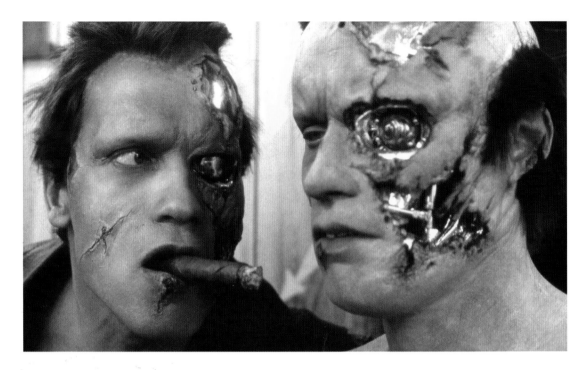

The *Terminator* is one of sci-fi's greatest unexpected triumphs. Shot guerrilla-style on a modest budget, it raked in an enormous profit, earned critical praise, led to one of the biggest sequels in history, and still holds up as essential viewing. The surprise hit not only established Arnold Schwarzenegger as Hollywood's premiere action hero and launched James Cameron as a major filmmaking force, it was considered one of the ten best films of 1984 by *Time* magazine and the "Most Important Film of the '80s" by *Esquire*. Not bad for a B picture made by a neophyte director.

Though expectations for the film were low, the gripping story, relentless pace, and tinges of tongue-in-cheek humor elevated it from other action adventures of its day. Its clever, mind-boggling time-travel loop thrusts a cyber-netic killing-machine from the future into an average young woman's life in present-day Los Angeles, a concept born in James Cameron's fever dream. While sick in bed, the young director of *Piranha II* (1981) envisioned a damaged metal robot dragging itself away from a fire, an image that may have been inspired by a similar scenario in Fritz Lang's *Metropolis* (1927). Encouraged by producer Gale Anne Hurd (who first worked with Cameron on Roger Corman's *Battle Beyond the Stars* [1980]), Cameron fleshed out his battle-scarred robot with a complex backstory about a nuclear war started by defense-network computers that "got smart" and created "a new order of intelligence." Though Cameron invented little from scratch, he began with vaguely familiar science-fiction tropes and built a violent, high-energy thriller around them.

Opposite: Arnold
Schwarzenegger meets
his double.

Top left: Michael Biehn
and Linda Hamilton

Top right: Lance Henriksen
and Paul Winfield

Bottom left: Linda Hamilton
and James Cameron on
the "Tech Noir" set

Bottom right: Kyle Reese
places an explosive inside
the endoskeleton.

Robert Patrick as the T-1000 in *Terminator 2: Judgment Day*

With its every word and deed driving the plot forward, the movie is just as chillingly efficient as Schwarzenegger's Terminator.

In the title role, the Austrian bodybuilder turned actor speaks fewer than seventy words and kills more than twenty-five people. Given his limited range and distinctive accent, the novice *Conan the Barbarian* (1982) performer was savvy enough to recognize *The Terminator* as the ideal vehicle to unleash his unique brand of star quality upon the world. After reading the script and meeting with Cameron, he later recalled, "I knew I was sitting on a goldmine." Aided by the amazing prosthetic effects of makeup expert Stan Winston, Schwarzenegger became the screen's quintessential cyborg and the movie's most impressive special effect. "Somehow, even [the] accent worked," Cameron has noted of his star. "It had a strange synthesized quality, like they hadn't gotten the voice thing quite worked out."

Unjustly overshadowed by Schwarzenegger's epic role are the powerful performances of Linda Hamilton as the Terminator's target, Sarah Connor, and Michael Biehn as her protector, Kyle Reese. Underneath the film's tough hyper-alloy exterior throbs a passionate love story between these two fated souls who have a brief window for romance while escaping the mechanized killer. Biehn—who had to execute many of the same stunts as Schwarzenegger and also deliver pages of exposition—rivals the Terminator for ruggedness, but with a sensitive human heart. As a woman forced to develop courage she didn't know she possessed, Hamilton etches a profound character arc from victim to victor. Every chase scene is fraught with tension because we know the fate of the human race literally depends upon the survival of Sarah, the mother-to-be of a future savior. By the time Reese is seriously injured near the film's conclusion, Sarah has assumed his position as the hero, dragging the fading soldier to his feet and barking commands like a harsh drill sergeant. Cameron's later films, such as *Aliens* (1986), *The Abyss* (1989), and *Avatar* (2009), would reinforce the director's predilection for female characters who prove to be stronger than the men in their lives.

When the movie was released in October 1984, Orion's head of marketing dismissed it as

an "exploitation and action film that will come and go in one week." But, due to audience word of mouth, it topped the box office. On TV and home video, the film's popularity skyrocketed. Eventually, public demand for a sequel grew to such a fever pitch that Cameron, Schwarzenegger, and Hamilton reteamed for *Terminator 2: Judgment Day* (1991), a mega-blockbuster with an incredible $100 million budget (nearly twenty times greater than the original) and the latest in computerized effects by George Lucas's Industrial Light & Magic. In an amusing reversal of their original roles, the Terminator is reprogrammed to be good, while Sarah has become a steely fighting machine, fiercely protective of her young son, John Connor (Edward Furlong).

After starring in two of the four subsequent sequels and planning to come back for more, Schwarzenegger promised a reporter in 2017 that "the *Terminator* franchise is never finished." Cameron agreed, announcing later that year that he would direct Hamilton and Schwarzenegger in a sixth installment.

KEEP WATCHING

WESTWORLD (1973)
TOTAL RECALL (1990)

The metal T-800 endoskeleton that rises from the flames after the tanker-truck explosion was based upon Cameron's dream. For its scenes, a full-size animatronic puppet was combined with a miniature filmed one frame at a time using stop-motion animation.

As *Blade Runner* (1982) had before it, *The Terminator* merges neo-noir with technology-driven sci-fi—a new subgenre Cameron coined that shares the name of a nightclub in the film: Tech Noir.

MIND-BLOWING MOMENT

When his left eye is damaged in a shootout, the Terminator uses a razor to remove his eyeball, revealing a glowing mechanical eye beneath. This scene recalls the optical trick of a woman's eyeball being sliced with a razor blade in Luis Buñuel and Salvador Dalí's surrealist film *Un chien andalou* (1929).

1985

DIRECTOR: **ROBERT ZEMECKIS** PRODUCERS: **BOB GALE AND NEIL CANTON** SCREENPLAY: **ROBERT ZEMECKIS AND BOB GALE** STARRING: **MICHAEL J. FOX (MARTY MCFLY), CHRISTOPHER LLOYD (DR. EMMETT BROWN), LEA THOMPSON (LORRAINE BAINES), CRISPIN GLOVER (GEORGE MCFLY), THOMAS F. WILSON (BIFF TANNEN), CLAUDIA WELLS (JENNIFER PARKER), MARC MCCLURE (DAVE MCFLY), WENDIE JO SPERBER (LINDA MCFLY)**

Back to the Future

UNIVERSAL • COLOR, 116 MINUTES

A teenage boy is sent thirty years back in time, accidentally threatening his own existence by interfering with the meeting of his parents.

Time travel has never been more fun than in *Back to the Future*. In the days when dark, dystopian science-fiction movies were common, Robert Zemeckis (and executive producer Steven Spielberg) brought light and laughter to the genre with an exhilarating exploration of what can go wrong when destiny and the space-time continuum are tampered with. Every line of dialogue in the tightly wound comedy—in addition to often being laugh-out-loud funny—is carefully planned to make repeat viewings rewarding. Even the film's paradoxical title makes complete sense in the context of the narrative. It all fits together like clockwork.

The story is a wonderfully inventive yarn by Zemeckis and Bob Gale that received an Oscar nomination for Best Original Screenplay.

Taking the snappy tone of small-town American comedies, like the ones Frank Capra and Preston Sturges used to make, and adding a swirl of science fiction and a revved-up 1980s sensibility, *Back to the Future* uses time-travel conventions to tell a fresh, character-driven story. The film opens with a variety of clocks ticking on the mantle of our inventor, Dr. Emmett "Doc" Brown, played by Christopher Lloyd. This shot not only pays homage to George Pal's *The Time Machine* (1960) but establishes the most important element in the film: time. When Doc perfects the "flux capacitor," creating the coolest time machine ever—a silver DeLorean DMC-12—Michael J. Fox as teenage slacker Marty McFly ends up at the same high school with the two teens who will someday become

Top: Robert Zemeckis
(far right) directs a scene
with Marc McClure, Wendie
Jo Sperber, and Lea
Thompson.

Bottom left: Crispin Glover
and Michael J. Fox in an
outtake from the film

Bottom right: Lea Thompson
as Lorraine Baines

Michael J. Fox rehearses his performance at the dance.

his parents. Figuratively, the clock is ticking: if Marty doesn't repair history in one week, he will cease to exist.

Reflecting the can-do optimism of the Reagan era, the film takes a positive, empowering view of time travel. In 1985, Marty can't win. His mom and dad are miserable underachievers, he's always late for school, and his rock band isn't allowed to play at the dance on account of being "just too darn loud." But by cruising to 1955 in Doc's plutonium-fueled DeLorean, Marty can be the big man on campus, and can even change the present for the better by bolstering the confidence of his geeky father, George. Because the audience shares Marty's secret, his visit to the past is rich with humor of all varieties, from slapstick to verbal gags. When Marty slips and calls George "Dad," he quickly corrects it to the slang of the era, "daddy-o." Exploiting George's fondness for science-fiction tales to get his attention, Marty decks himself out in a radiation suit and poses as "Darth Vader," "an extraterrestrial from the planet Vulcan."

Zemeckis brings the mid-'50s to life in affectionate detail, complete with corner-drugstore jukeboxes and episodes of *The Honeymooners*. And the film's humor isn't at the expense of the past; jokes about the 1950s are balanced with

jokes about the 1980s. When Marty informs him that Ronald Reagan later becomes the president, Doc retorts, "Who's vice president? Jerry Lewis?" Marty knows a few guitar licks those '50s folks haven't heard yet, but is clueless when it comes to using a bottle opener to pry the cap from his Pepsi. He also discovers that the era was not so innocent. Dad's a peeping tom, and Mom drinks, smokes, and parks in cars with boys—everything she tells her kids she never did "when I was your age." The flirtation between Marty and his teenage mother, Lorraine, played by Lea Thompson, was "always the trickiest part of the story," Zemeckis revealed. "We spent the most time trying to shake that one out." The implications made

FAR-OUT FACTS

In an early draft of the script, the time machine was a refrigerator that derived its power from an atomic bomb testing site in Nevada. Steven Spielberg later borrowed the nuclear fridge idea for *Indiana Jones and the Kingdom of the Crystal Skull* (2008).

Fox was Zemeckis's first choice for Marty. When the actor had trouble breaking free from his steady gig on the sitcom *Family Ties*, Eric Stoltz was cast and several scenes were shot. Finally, Fox convinced the producers to allow him to shoot the movie at night and work on the TV show during the day, and he replaced Stoltz.

The vents on the back of the souped-up DeLorean are for nuclear exhaust—the same principle as cooling towers on a nuclear power plant. "It really needed to look dangerous," said Zemeckis of the modifications to the car, "and look like it was built in somebody's garage."

MIND-BLOWING MOMENT

Doc demonstrates his invention to Marty in a mall parking lot in the middle of the night, promising that when the DeLorean hits eighty-eight miles per hour, "You're gonna see some serious shit." As promised, the car crackles with electric sparks and races into the fourth dimension in an explosive burst of energy, leaving a trail of flames in its wake.

the film too risqué for Disney. They rejected the script for this reason back in 1981.

Supported by a bouncy soundtrack of early rock 'n' roll classics and two original hits from Huey Lewis and the News, *Back to the Future* not only clicked with the public as the highest-grossing movie of 1985, but won a Saturn award for Best Science-Fiction Film of the year, raked in multiple Oscar and Golden Globe nominations, and was added to the National Film Registry in 2007. It crosses an array of genres—sci-fi, adventure, comedy, coming-of-age, period piece—putting it in an unforgettable class by itself.

After shuttling Marty and Doc to the year 2015 in *Back to the Future Part II* (1989) and zapping them into the Old West in *Back to the Future Part III* (1990), Robert Zemeckis would again play with American pop-culture history in the Oscar-winning *Forrest Gump* (1994) before exploring the serious side of science fiction with 1997's *Contact*.

KEEP WATCHING

THE ADVENTURES OF BUCKAROO BANZAI ACROSS THE EIGHTH DIMENSION (1984)

BILL AND TED'S EXCELLENT ADVENTURE (1989)

1985

DIRECTOR: TERRY GILLIAM PRODUCER: ARNON MILCHAN SCREENPLAY: TERRY GILLIAM, TOM STOPPARD, AND CHARLES MCKEOWN STARRING: JONATHAN PRYCE (SAM LOWRY), ROBERT DE NIRO (HARRY TUTTLE), KATHERINE HELMOND (MRS. IDA LOWRY), IAN HOLM (MR. KURTZMANN), BOB HOSKINS (SPOOR), MICHAEL PALIN (JACK LINT), IAN RICHARDSON (MR. WARRENN), KIM GREIST (JILL LAYTON)

Brazil

EMBASSY INTERNATIONAL • COLOR, 132 MINUTES

A civil servant oppressed by a future bureaucracy becomes trapped in a nightmare as he tries to help the woman of his dreams.

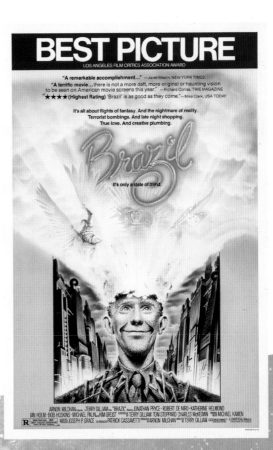

"It's only a state of mind," declared the poster for *Brazil*, as if that explained anything. Iconoclastic director Terry Gilliam's absurdist soufflé of reality, illusion, dream, and nightmare is impossible to describe in a tagline—it must be seen to be believed. Even co-screenwriter Tom Stoppard was hard-pressed to summarize the film when questioned in the 1985 short documentary *What Is Brazil?* "I don't even know why it's called *Brazil*," Stoppard admitted, while Gilliam attempted to encapsulate the film's theme as "the impossibility of escape from reality."

Jonathan Pryce is Sam Lowry, a low-level government clerk stuck in a grim reality: a mechanized society that drains individuals of every last drop of their humanity. Sam can only escape in his Walter Mitty–style daydreams of heroism,

in which he soars through the clouds like an iron eagle to rescue an angelic woman from a monstrous Samurai warrior. When a clerical mix-up makes Sam a wanted man, his fantasies collide disastrously with his worst fears. The film's dark, madcap humor is straight from Stanley Kubrick's *Dr. Strangelove* (1964), and its story is George Orwell meets Franz Kafka. (As a nod to Orwell and surrealist filmmaker Federico Fellini, Gilliam considered titling the film *1984½*.) Yet *Brazil* stands alone as one of the most eccentric flights of fancy ever committed to celluloid.

The idea originated when Gilliam was in Port Talbot, Wales, a seaside mining town with a shore blackened by iron ore. An image popped into his head of a man on the beach listening to the 1939 song "Brazil" on the radio. "Escapist, romantic sounds suggesting that somewhere out there, far

Opposite: The face of
Jonathan Pryce, filtered
through the film's
steampunk style

Right: Kim Greist plays
the woman of Sam's
dreams.

from the conveyor belts and ugly steel towers, is a green and wonderful world," said Gilliam of his vision. "The story that developed from that image really has nothing to do with it, except that everything sprang from it." Later, Gilliam—who was planning his follow-up to the time-travel fantasy *Time Bandits* (1981)—had a chance encounter with producer Arnon Milchan in a Paris restaurant. "After two or three bottles of wine," Milchan recalled, he verbally agreed to produce Gilliam's movie without ever seeing the script.

Nearly two years were devoted to the elaborate production of *Brazil*, yielding what is debatably the bleakest vision of the future ever to disguise itself as a giddy comedy. The offices where Sam and his friend Jack (Michael Palin) work are drab, claustrophobic prisons tangled with ducts, pneumatic tubes, robotic devices, and computers with antique typewriters for keyboards. Norman Garwood's Oscar-nominated art direction evokes a decaying "retro-future," a stylistic innovation that would evolve into steampunk.

The film's black humor is derived from contrasts. Uplifting imagery, such as Sam's arrestingly beautiful daydreams, or Robert De Niro's outlaw heating engineer Harry Tuttle swinging from a rope Spider-Man-style, is counterbalanced with disturbing visions. In one scene, Sam's plastic surgery–addicted mother, Ida Lowry, and her friends are lunching in an upscale restaurant when a terrorist bomb explodes. She asks the waiter to place a screen between their table and the victims, so they won't be bothered by the wretched cries of the wounded. Because of scenes like this, some interpret *Brazil* as a prophetic satire of our modern world, though Gilliam has always insisted the film is not about the future. "I'm dealing with what I think exists now," he said in 1985.

Once the film was in the can, the saga that unfolded behind the scenes was nearly as dramatic as the onscreen entertainment. When MCA-Universal president Sid Sheinberg ordered a complete re-cut of the two-and-a-half-hour film to make it shorter, cheerier, and

Top: Jim Broadbent and
Katherine Helmond

Center: Terry Gilliam,
Kim Greist, and Jonathan
Pryce on the set

Bottom: Jonathan Pryce
in Sam's dream

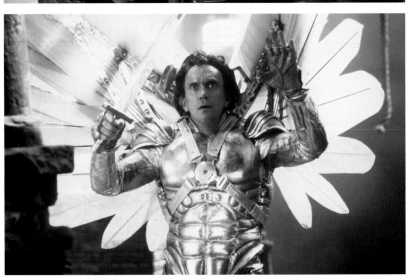

more commercially appealing, Gilliam not only refused, but waged a personal, public battle of wills with Sheinberg over the final edit. Sheinberg responded by turning *Brazil* over to a team of Universal editors who began hacking away. "You're killing my film," the director told them point-blank. "You're destroying it."

In desperation, Gilliam took his original cut to universities and screened it for students and film critics without Universal's authorization. After it won the Los Angeles Film Critics Association Award for Best Picture—an unprecedented honor for an unreleased movie—the studio began to see value in Gilliam's version, and they finally released it with minimal edits. Of *Brazil*, Gilliam once remarked, "If it shows anything profound, which I'm not sure it does, it is that people carry on. . . . The human spirit is not that easily extinguishable." Fittingly, his film about the little guy against the establishment predicts what Gilliam became in his battle with Universal. In this case, the little guy actually won.

KEEP WATCHING

TIME BANDITS (1981)

1984 (1984)

FAR-OUT FACTS

Michael Palin had worked with Gilliam on the 1970s U.K. TV series *Monty Python's Flying Circus*, and later appeared in four of Gilliam's films: *Monty Python and the Holy Grail* (1975), *Jabberwocky* (1977), *Time Bandits*, and *Brazil*.

Gilliam's labyrinthine dolly shot that careens through the office of Sam's boss, Mr. Kurtzmann, was inspired by the lengthy tracking shot that follows Kirk Douglas through the trenches in Stanley Kubrick's *Paths of Glory* (1957).

MIND-BLOWING MOMENT

To make her "look twenty years younger," plastic surgeon Dr. Jaffe (Jim Broadbent) grotesquely stretches the flesh on Ida's face, pulling her cheeks back to her ears and pinning them with metal clips. After filming these scenes, actress Katherine Helmond's skin broke out in blisters from the latex adhesive.

DIRECTOR: PAUL VERHOEVEN PRODUCER: ARNE SCHMIDT SCREENPLAY: EDWARD NEUMEIER AND MICHAEL MINER STARRING: PETER WELLER (OFFICER ALEX J. MURPHY/ROBOCOP), NANCY ALLEN (OFFICER ANNE LEWIS), DAN O'HERLIHY (THE OLD MAN), RONNY COX (DICK JONES), KURTWOOD SMITH (CLARENCE J. BODDICKER), MIGUEL FERRER (BOB MORTON), ROBERT DOQUI (SERGEANT WARREN REED)

RoboCop

ORION • COLOR, 103 MINUTES

A fatally wounded policeman is transformed into a robotic law-enforcement unit to fight rampant crime in future Detroit.

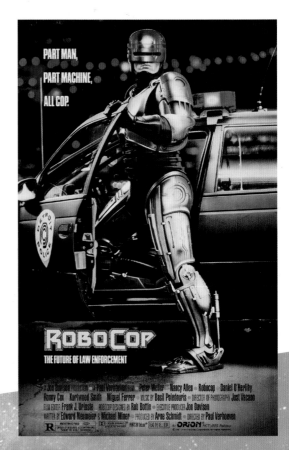

The killer-cyborg concept James Cameron popularized with *The Terminator* (1984) is flipped to the opposite extreme in *RoboCop*, a satire of American culture from Dutch director Paul Verhoeven. As in *The Terminator*, Verhoeven's film posits a threatening embodiment of tomorrow's technology. But instead of a villain, the cyborg is a relatable hero with a surprisingly tender side. Peter Weller as RoboCop incites our sympathy because he is a human victim of corrupt corporate power, a man turned into a machine without his consent. This adds poignancy to the film's dual trajectories of brutal sci-fi thriller and broad comedy.

RoboCop almost didn't get made. Edward Neumeier and Michael Miner's farcical screen-play had been rejected by every major director in Hollywood when Verhoeven read it and was equally unimpressed. "I thought it was a piece of shit," he bluntly stated in the 2001 documentary *Flesh and Steel: The Making of RoboCop*. But Verhoeven's wife, Martine, convinced her husband that the darkly witty script had more layers than he initially saw, from its skewering of corporate culture to its biblical implications. Verhoeven beefed up the story's Christian motifs, fashioning his lead character into a modern American messiah. When Officer Murphy is killed in the line of duty and "resurrected" as a computerized experiment, does he still retain his soul? The movies had never really tackled this area before.

Page 225: Peter Weller
on the set with his costume
and mask

Left: Miguel Ferrer as
RoboCop's creator and Peter
Weller as RoboCop

Humanoid machines have been a science-fiction staple ever since Czech writer Karel Capek coined the term "robot" in his 1921 play *R.U.R.* In the early years of sci-fi, however, android robots tended to be simple mechanized devices resembling men inside cardboard boxes (which they often were). The Maria android in *Metropolis* (1927) and Gort the robot in *The Day the Earth Stood Still* (1951) made strides with the complexity of their appearances, and both were key influences on RoboCop's design: his body armor is a masculine version of Maria's, while his helmet is a modification of Gort's. As a product of Detroit, the Motor City, RoboCop also sports a slightly vehicular style, like a shiny Chrysler just rolling off the assembly line.

Though he made it look natural on the screen, Weller spent agonizing months in his unwieldy wardrobe, a rubber and fiberglass suit that took him several hours to put on every morning. Like *Logan's Run* (1976), the majority of *RoboCop* was shot in Dallas to take advantage of the city's futuristic architecture. Unfortunately, filming in Texas in August and September put temperatures around 120 degrees inside the costume. "Meditation got me through it," said Weller, who was chosen for his acting ability, as well as his strong jawline—it's the only part of his body visible as the cyborg. With his eyes obscured and his movements restricted, Weller somehow exudes a discernible sadness when human memories come flooding back into RoboCop's system.

But the movie is first and foremost a satire. Its near-future setting is a world in which families play nuclear-war-themed board games, a peacekeeping laser misfires from space causing death and destruction on Earth, and the hot new car is a 6000 SUX (it gets eight miles to the gallon). In a none-too-subtle gesture, RoboCop comes equipped with a knife that extends from his fist like a middle finger. Even the violence is so over-the-top it borders on ludicrous. The frequent graphic shootouts earned the film an X rating, which was only changed to R after twenty-two seconds were edited from the release print. To this day, it may be the most

Top: Director Paul
Verhoeven and ED-209

Bottom left:
Nancy Allen and Peter
Weller

Bottom right:
RoboCop apprehends a
suspect played by
Ray Wise.

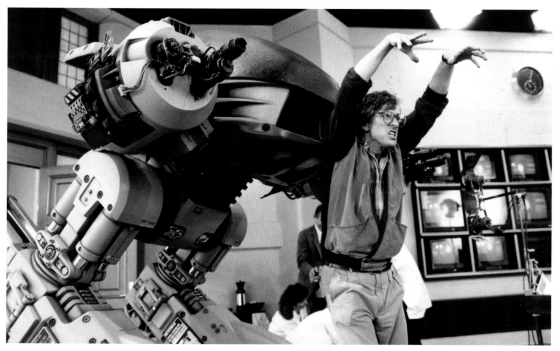

FAR-OUT FACTS

Arnold Schwarzenegger was the first actor suggested to play Robo-Cop, but was never offered the role because the bulky costume required a thinner body type.

Special-effects makeup artist Rob Bottin designed the prosthetics for RoboCop's half-man, half-machine head when his helmet is removed. "It took six-and-a-half hours to put that face on, and we used it for twenty-one days," Weller recalled. "Each face was used for just one time."

In 2015, the City Theatre in downtown Detroit hosted the debut of *RoboCop! The Musical*, an original reimagining of the film as a musical comedy for the stage.

MIND-BLOWING MOMENT

Extreme violence and dark humor unite in the gory demonstration of ED-209, the giant, crude police robot that precedes RoboCop. Lumbering into a boardroom meeting, 209 accidentally machine-guns an executive into a bloody pulp. Stepping over the corpse, corporate weasel Dick Jones (Ronny Cox) responds, "I'm sure it's just a glitch."

violent film ever marketed with a line of toys for children.

Verhoeven's first science-fiction film (he would later helm *Total Recall* in 1990 and *Starship Troopers* in 1997) has aged better than many of its contemporaries. It remains relevant (inspiring a 2014 remake) and is considered one of the most prescient of future-set flicks. For one, it anticipated an increased awareness of gender equality in the workplace; the female cops, including Nancy Allen as Murphy's partner, Officer Lewis, share a coed locker room with the men on the force. Secondly, it predicted the sad economic decline of downtown Detroit, a once-teeming metropolis that experienced its share of setbacks in the years following the film's release. Third, as the advertisements proclaimed, *RoboCop* might truly be "the future of law enforcement." In 2016, Dallas police used a remote-controlled robot to kill a sniper, and in 2017, the world's first fully operational robotic cop joined the Dubai police force.

KEEP WATCHING

STARSHIP TROOPERS (1997)

I, ROBOT (2004)

1993

DIRECTOR: STEVEN SPIELBERG PRODUCERS: KATHLEEN KENNEDY AND GERALD R. MOLEN SCREENPLAY: MICHAEL CRICHTON AND DAVID KOEPP, BASED ON THE NOVEL BY MICHAEL CRICHTON STARRING: SAM NEILL (GRANT), LAURA DERN (ELLIE), JEFF GOLDBLUM (MALCOLM), RICHARD ATTENBOROUGH (JOHN HAMMOND), BOB PECK (MULDOON), MARTIN FERRERO (GENNARO), B. D. WONG (WU), SAMUEL L. JACKSON (ARNOLD), WAYNE KNIGHT (NEDRY)

Jurassic Park

UNIVERSAL • COLOR, 127 MINUTES

A mogul invites three scientists, a lawyer, and his two grandchildren to tour a theme park filled with living dinosaurs cloned from ancient DNA.

MUST-SEE SCI-FI

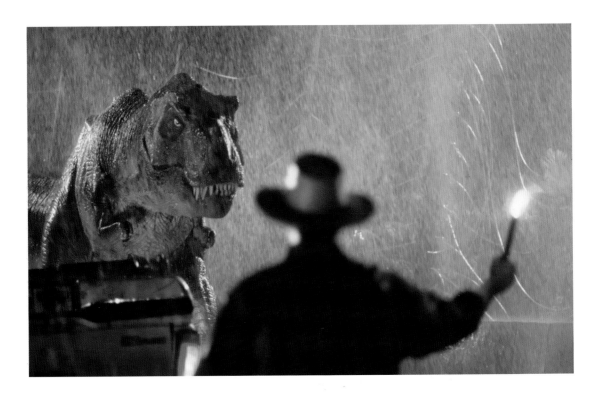

Dinosaurs have fascinated movie audiences since Winsor McCay's animated short *Gertie the Dinosaur* in 1914. Live-action films, however, have always had difficulty bringing the mammoth beasts to life. From *The Lost World* in 1925 to *One Million Years B.C.* in 1969, screen dinosaurs had typically been clay models animated by stop-motion photography, a laborious process that never yielded very lifelike results. But in 1993, Steven Spielberg upped the ante in prehistoric realism with *Jurassic Park*, an enchanting thrill ride that redefined the dinosaur movie and kicked off the age of high-quality computerized effects.

"I had wanted to make a dinosaur picture all my life," Spielberg said in 2007, "but I could never find a realistic way to do dinosaurs until Michael Crichton figured out a science that would make it allowable." In Crichton's ingenious science-fiction novel *Jurassic Park*, prehistoric beasts cloned from the blood of ancient mosquitoes preserved in amber populate a theme park. Spielberg acquired the rights in 1990 (before the book was even published), and planned to film the tale using traditional techniques—computer animation being still too primitive. Seemingly overnight, the technology caught up to the concept. As Crichton told a reporter in 1993, "You couldn't do it three years ago. But by the time they shot the movie, you could."

Thanks to innovations at Industrial Light & Magic, special effects had grown by leaps and bounds in a short period of time.

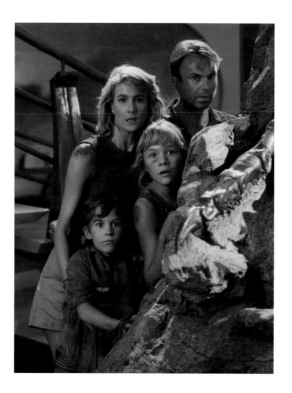

Stan Winston (whose credits include *The Terminator* [1984]), Phil Tippett (whose credits include the *Star Wars* trilogy), and Dennis Muren (of ILM) headed up the trailblazing team hired to combine full-size models with computer-generated imagery. Spielberg knew that the success of the film depended upon the dinosaurs looking realistic and, as Muren said, "they had to move with an attitude"—no miniatures, no stop-motion animation, no herky-jerky claymation jitters of yesterday. With their beady eyes glinting in the moonlight and their dripping, razor-sharp jaws, these CGI-enhanced monsters are so accurately realized that the movie was judged too intense for children under thirteen.

Though it doubles as a family film with cute kids petting benign brachiosaurs, *Jurassic Park* is a horror movie at heart. By nearly being devoured, Laura Dern and Sam Neill as paleontologists Ellie and Grant learn the hard way that their theories are correct—dinosaurs are smarter than we give them credit for. Those wily velociraptors can even open doors. In one scene straight out of a slasher film, young Lex and Tim cower in cabinets as a pack of predatory raptors stalk them through an industrial-size kitchen reminiscent of *The Shining* (1980).

Before Jurassic Park even opens to the public, the beasts are already chomping at the bit to break free. Just as the movie's main voice of reason, Jeff Goldblum's mathematician Dr. Malcolm, warns in the first reel, "If there's one thing that the history of evolution has taught us, it's that life will not be contained." The rest of the film bears out his hypothesis; the primal carnivores cannot be controlled by humans. Stretching suspense to the breaking point and wielding the power of suggestion (we only see about fifteen minutes' worth of actual dinosaurs in the two-hour film), Spielberg does for dinosaurs what he had done for sharks in *Jaws* (1975).

In an unprecedented campaign, Universal spent $65 million to market the $63 million film, slapping its distinctive red, black, and

Top: Jeff Goldblum

Center: Joseph Mazzello hides from two velociraptors.

Bottom: Steven Spielberg and Richard Attenborough on location in Hawaii

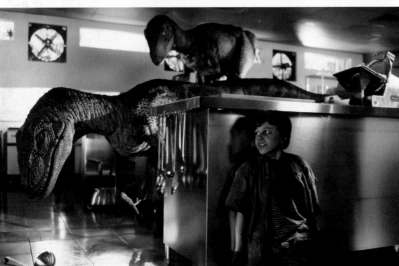

yellow logo on everything from sleeping bags to boxer shorts. Thanks to the market saturation and the screen's most awe-inspiring dino-monsters, *Jurassic Park* became the most successful movie in Universal's history. Like many summer blockbusters, it grew into an institution, later spawning *The Lost World: Jurassic Park* (1997), *Jurassic Park III* (2001), *Jurassic World* (2015), and *Jurassic World: Fallen Kingdom* (2018).

Underneath its hair-raising effects, the original film is a story about evolving. Spielberg—who supervised the post-production remotely while in Poland shooting *Schindler's List* (1993)—was evolving as a filmmaker, too. Before embarking on a new phase of his career as an Oscar-winning director, Spielberg rescued the dinosaur movie from the brink of extinction and ushered cinema into a new era of digital effects. After *Jurassic Park*, virtually anything filmmakers could imagine could be created.

KEEP WATCHING

THE VALLEY OF GWANGI (1969)
KING KONG (2005)

FAR-OUT FACTS

The nine-thousand-pound Tyrannosaurus rex was constructed of a fiberglass skeleton filled with clay and covered in latex skin. To enable it to move, it was mounted on a "dyno-simulator," a hydraulic mechanism based on the traditional six-axis flight simulator used by the military.

More than two hundred new software programs were created to perfect the appearance of the screen dinosaurs.

The film was still being shot when the most powerful hurricane in Hawaii's history, Hurricane Iniki, struck the shooting location of Kauai in 1992. The cast and crew safely evacuated and resumed filming at Universal Studios in Los Angeles.

MIND-BLOWING MOMENT

It's a dark and stormy night when the bloodthirsty T. rex makes its first appearance. Tim and Lex notice plastic cups of water vibrating on the dashboard of the car before T. rex stomps its way into the street. Making ripples appear in the water "was a very difficult thing to do," said special effects supervisor Michael Lantieri, who plucked the string of an electric guitar to achieve the effect.

DIRECTORS: THE WACHOWSKIS PRODUCER: JOEL SILVER SCREENPLAY: THE WACHOWSKIS STARRING: KEANU REEVES (NEO), LAURENCE FISHBURNE (MORPHEUS), CARRIE-ANNE MOSS (TRINITY), HUGO WEAVING (AGENT SMITH), JOE PANTOLIANO (CYPHER), MARCUS CHONG (TANK), JULIAN ARAHANGA (APOC), MATT DORAN (MOUSE)

The Matrix

WARNER BROS. • COLOR, 136 MINUTES

A hacker is informed by a group of rebels that the world he believes to be real is actually an elaborate program run by computers.

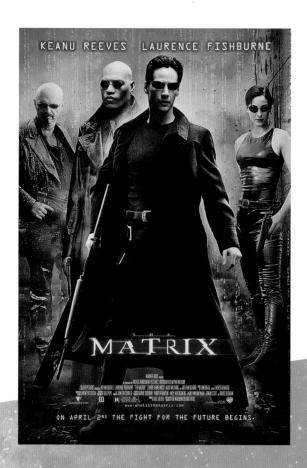

Top: Carrie-Anne Moss
and Keanu Reeves

Bottom: The reality
of the Matrix

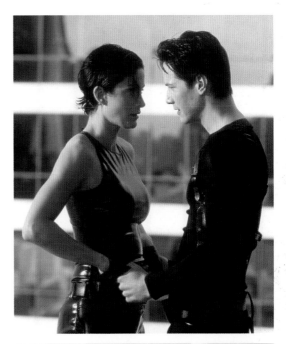

By the tail end of the twentieth century, the genre of science fiction was fast becoming something it had never been before: the epitome of cool. Fueled by advances in digital graphics, a booming Internet community, and the impending millennium, sci-fi had morphed from a niche genre into a mainstream obsession. Arriving right on cue in 1999 was *The Matrix*, a sexy, action-packed comic book of a movie that tapped into the current zeitgeist and established many a cinematic trend. Designer sunglasses, long black trench coats, martial arts, killer special effects, contemporary techno-rock music, and "guns—lots of guns" now factored into the new science fiction.

The Matrix kicks off with a tantalizing, gravity-defying kung fu attack from tough-girl Trinity that reels the audience in, making us want to follow the white rabbit, take the red pill, and discover all the movie's secrets. As with many groundbreaking films, the original story is woven from existing elements. Its dystopian urban landscape fused with a technology-rich underworld is pure cyberpunk, a subgenre that started cinematically with *Blade Runner* (1982) and informed literature, comics, and video games of the 1980s and '90s. More specifically, the film starts with a

Left: Andy and
Larry Wachowski direct
a rooftop scene.

premise in the vein of *Strange Days* (1995) and *Dark City* (1998) and propels it into an imaginative, masterfully orchestrated universe that completely submerges the audience in its own reality . . . or nonreality.

True to their roots as writers of Marvel comics, writers/directors the Wachowskis (then the brother team of Larry and Andy, now Lana and Lilly) first conceived *The Matrix* to be a comic book. In the thought-provoking story, computer geek-turned-hero Neo—the future's answer to Alice in Wonderland—searches for the meaning of life, and is found by the godlike Morpheus, a rebel leader who breaks the earth-shattering news to Neo: every moment of his day-to-day reality is, in fact, a CGI dream world created to keep the post-apocalyptic population pacified while tentacled computer-monsters use them for batteries. Again, the threat to humankind is a race of intelligent machines (will we ever learn?) that harvest humans as their energy source. The heavy-duty backstory is told in motion, through

jaw-dropping imagery and narrow escapes from virtual villain Agent Smith that only slow down long enough for us to catch our breath. Then comes the jujitsu.

The film's use of martial arts raised the bar for Hollywood. The directors were inspired by the surreal fighting in Hong Kong cinema, which Lana Wachowski described as "balletic. Everybody has a superhuman, supernatural grace. We wanted to bring that kind of wire work to our movie." Instead of employing stunt doubles, the Wachowskis had the four lead actors (Keanu Reeves, Laurence Fishburne, Carrie-Anne Moss, and Hugo Weaving) spend four months training under the supervision of choreographer Yuen Woo-Ping until they were able to perform incredible stunts in midair while suspended from wires.

With every shot meticulously storyboarded by the filmmakers, *The Matrix* was always intended to be a special-effects film. But the tricks—like super slow motion—are not gratuitous; they're used to enhance the impact of the action, and always within the context of the story. Just when the audience gets used to the off-the-wall kung fu and computer-enhanced visuals, the Wachowskis pull out the big guns for a slam-bang, three-minute

Top: Keanu Reeves
and Hugo Weaving on
wires (above) and the scene
as it appears in
the film (below)

Bottom: Carrie-Anne
Moss fights a policeman
inside the Matrix.

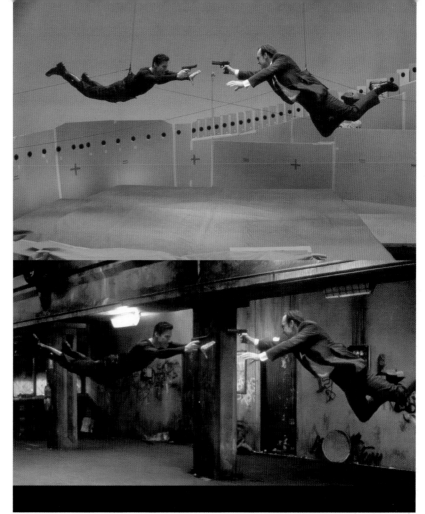

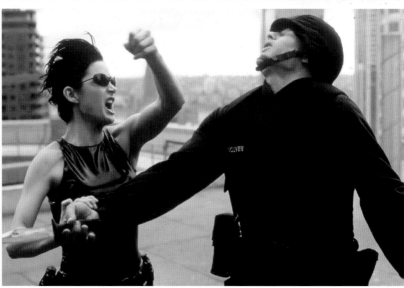

FAR-OUT FACTS

Reeves stepped into the role of Neo after Will Smith and Nicolas Cage both turned it down. Sean Connery, Samuel L. Jackson, and Russell Crowe were offered the part of Morpheus before it was accepted by Fishburne.

To help viewers to distinguish between the film's two realms, the Wachowskis and cinematographer Bill Pope gave all the scenes inside the Matrix a green hue, and tinted the real-world sequences blue.

MIND-BLOWING MOMENT

When fighting with the agents on a rooftop, Neo slows down time so he can dodge the bullets flying directly above him. The panoramic shot of Neo's backbend that introduced the game-changing "bullet time" effect was made using a rig containing two movie cameras and 120 individual digital still cameras to capture the bullets in midair.

shootout that took ten days to film and relied solely on practical effects—no CGI.

The Matrix not only broke boundaries by discarding and rewriting the rules of onscreen reality, it covers a range of cinematic ground by mixing themes, styles, and ideas as never before. Japanese anime, video game–style combat, existentialism, Buddhism, Christianity, scientific advancement, love, and the illusion of reality harmoniously coexist in the film. In 2008, Keanu Reeves recalled his first impression of the script as "something that I'd never seen but, in a way, something that I'd always hoped for as an actor and as a fan of science fiction. . . . It was mythology, philosophy, technology, and truth."

After *The Matrix* and its two follow-ups, a plethora of imitations appeared, along with a crop of original films from various genres that were influenced by the Wachowskis' creation: The *X-Men* series, *Equilibrium* (2002), and *Kill Bill* (2003) are only a few.

KEEP WATCHING

STRANGE DAYS (1995)
INCEPTION (2010)

DIRECTOR: STEVEN SPIELBERG PRODUCERS: KATHLEEN KENNEDY, STEVEN SPIELBERG, AND BONNIE CURTIS SCREENPLAY: STEVEN SPIELBERG, BASED ON A SHORT STORY BY BRIAN ALDISS STARRING: HALEY JOEL OSMENT (DAVID), JUDE LAW (GIGOLO JOE), FRANCES O'CONNOR (MONICA SWINTON), SAM ROBARDS (HENRY SWINTON), WILLIAM HURT (PROFESSOR HOBBY), BRENDAN GLEESON (LORD JOHNSON-JOHNSON), JAKE THOMAS (MARTIN SWINTON), JACK ANGEL (VOICE OF TEDDY)

A.I. Artificial Intelligence

WARNER BROS. • COLOR, 146 MINUTES

An experimental robotic child sets off on a quest to become real when abandoned by his adoptive mother.

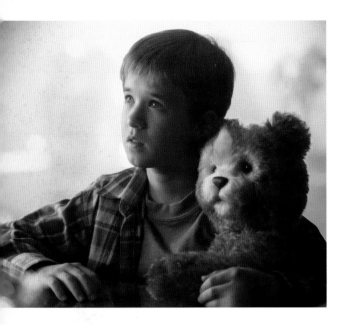

A fearful fascination with technological progress is one of the cornerstones of science fiction. *A.I. Artificial Intelligence* explores both our fear and our fascination with advanced robotics, and bears the distinction of being a landmark collaboration between two major screen visionaries: Steven Spielberg and Stanley Kubrick. With films like *E.T. The Extra-Terrestrial* (1982), Spielberg had become known for optimistic, heartfelt looks at sci-fi, while Kubrick was synonymous with provocative, cynical offerings (*A Clockwork Orange* [1971]). In *A.I.*, the two forces merge. The result is a future fairy tale that swiftly plunges into the dark side as it compares and contrasts humans with the humanlike machines they create.

Twelve-year-old Haley Joel Osment delivers a remarkably nuanced performance as David, an extraordinary mecha (mechanical being) manufactured by the Cybertronics Corporation sometime in the twenty-second century. A child-bot programmed by his creator to express unconditional love, David is adopted by a couple and "imprinted" to love only his mother, Monica. But buyer's remorse sets in almost overnight. Like Teddy (a mecha stuffed bear with a creepier voice than HAL 9000), David becomes a superfluous supertoy when Monica's real son returns from the hospital. Dumped in the woods like a wild animal, David takes up with Gigolo Joe, a "lover" robot (convincingly portrayed by Jude Law) that assists the child in his *Pinocchio*-derived fantasy of becoming a flesh-and-blood boy. Here, as with the replicants in *Blade Runner* (1982), the mechanized creatures seem warmer and more human than the organic ones. When Monica abandons David, she warns him that human beings are the biggest threat to his safety, advising him to "stay away from all people."

Brian Aldiss's 1969 short story "Supertoys Last All Summer Long" was the seed that would blossom into *A.I.* In the mid-1980s, Stanley Kubrick began developing the Aldiss tale into a twisted *Pinocchio* fantasy, an unconventional fable of the distant future. Unsure that he was the right person to direct it, Kubrick discussed

Opposite: Haley
Joel Osment with Teddy

Right: Jude Law as
Gigolo Joe

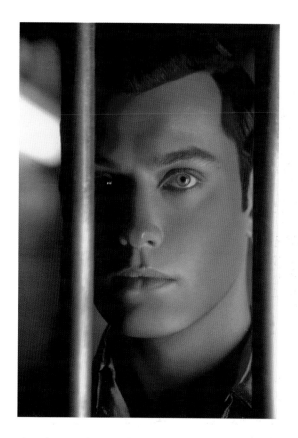

the concept with his friend Spielberg off and on for a decade before saying in 1994, "I have a great idea: I produce it, you direct." But Spielberg hesitated. Finally, when Kubrick died in 1999, Spielberg undertook the project to honor Kubrick and bring his unrealized vision to the screen. "I was like an archaeologist, picking up the pieces of a civilization, putting Stanley's picture back together again," he said.

Because *A.I.* wanders in unexpected (and often uncomfortable) directions, more than one viewing is required to absorb all that runs beneath the film's captivating surface, a shimmering facade flooded with Janusz Kaminski's milky backlighting and spellbinding imagery. Our view of David is frequently filtered through panes of glass, mirrored reflections, and, in one sequence, water, as he lies motionless on the concrete basin of a swimming pool. These shots do more than just dazzle the eyes—they blur the lines between real and unreal, artificial and organic. Virtually everyone in the film—whether human or machine—is sad, lonely, and searching for love. Even the super-advanced species of artificial intelligence that populate the end of David's 2,000-year journey is so desperate for contact with the lost warmth of humanity, they treasure this child as the closest thing to the extinct human race. As Gigolo Joe accurately predicts, "When the end comes, all that will be left is us." Appropriately, the modernist John Williams score is as touching as it is unsettling.

Kubrick's films were often controversial and not fully appreciated in their own time, and *A.I.* follows this pattern. Though written and directed by Spielberg, it is in many ways a Stanley Kubrick film, confounding and dividing audiences and critics. The *San Francisco Chronicle* harshly accused *A.I.* of exhibiting "all its creators' bad traits and none of the good. So we end up with the structureless, meandering, slow-moving endlessness

Top left: Haley Joel
Osment as David

Top right: Jude Law and
Haley Joel Osment in Rouge
City

Bottom: Steven Spielberg
on the Flesh Fair set with
Haley Joel Osment

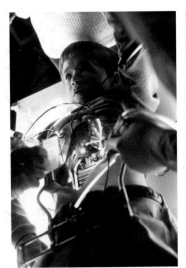

of Kubrick combined with the fuzzy, cuddly mindlessness of Spielberg." *Newsweek* was troubled but awed, calling the collaboration "fascinating—a rich, strange, problematical movie full of wild tonal shifts and bravura moviemaking."

Many assumed Spielberg was behind the poignant ending, but, in fact, it was Kubrick's idea. "The teddy bear, the ending, all of it's in Stanley's script," executive producer Jan Harlan told *Entertainment Weekly* in 2001. "He would be so elated, because the story was so close to his outline. But it still had Steven's handwriting over every frame." The monumental partnership between two of the twentieth century's most significant filmmakers becomes better appreciated as time passes. Perhaps it's a film tailored more for the future than the present. Like its mechanized creations, *A.I.* endures beyond its era.

KEEP WATCHING

Z.P.G. (1972)

EX MACHINA (2015)

FAR-OUT FACTS

One of Kubrick's main obstacles in developing the film was creating a robotic child to play David. The director had an entirely mechanical boy built, but the technology was too primitive to function as a believable human simulation.

Throughout the entire film, David never once blinks his eyes. "That was a little tough to do," Haley Joel Osment later said.

Much of the movie's star power can only be heard, not seen. Meryl Streep voices the Blue Fairy, Robin Williams is the voice of Dr. Know, Ben Kingsley narrates as leader of the advanced mecha species, and Chris Rock makes a bizarre cameo appearance as a robot version of himself.

MIND-BLOWING MOMENT

Hoping to meet his maker in the tradition of *Frankenstein*, David travels to the flooded ruins of New York City and arrives at the office of Professor Hobby, played by William Hurt. There, David encounters himself—another mecha child exactly like him. Horrified, he grabs a lamp and smashes the second David to bits.

DIRECTOR: MICHEL GONDRY PRODUCERS: STEVE GOLIN AND ANTHONY BREGMAN SCREENPLAY: CHARLIE KAUFMAN, BASED ON A STORY BY CHARLIE KAUFMAN, MICHEL GONDRY, AND PIERRE BISMUTH STARRING: JIM CARREY (JOEL BARISH), KATE WINSLET (CLEMENTINE KRUCZYNSKI), KIRSTEN DUNST (MARY), ELIJAH WOOD (PATRICK), MARK RUFFALO (STAN), TOM WILKINSON (DR. MIERZWIAK), JANE ADAMS (CARRIE), DAVID CROSS (ROB)

Eternal Sunshine of the Spotless Mind

FOCUS FEATURES/UNIVERSAL • COLOR, 108 MINUTES

When his girlfriend undergoes a procedure to erase all memory of their relationship, a man decides to purge his memories of her as well.

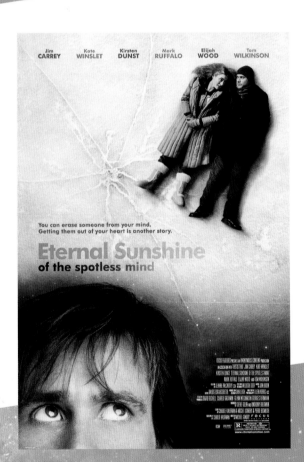

Jim Carrey in the memory-erasing machine

A one-of-a-kind romance with a sci-fi twist, *Eternal Sunshine of the Spotless Mind* has a circular narrative like a time-travel loop. But instead of traveling through time, the comedy-drama takes a loopy ride through a couple's relationship by tracing the patterns of emotional memory inside the human brain. With true-to-life performances and handheld camera work, the film manages to achieve a marked realism, though everything about it is eccentric, upside down, and backward. The love story unfolds in reverse chronology; even the casting reverses our expectations. "Everyone's playing completely against type," Kate Winslet said while shooting the film in 2003. "I'm playing the Jim Carrey part. He's actually playing the sort of Kate Winslet part." As Clementine, Winslet is colorful and outspoken, while Carrey's Joel balances her with sensitive introversion.

Screenwriter Charlie Kaufman and director Michel Gondry developed the project as the antithesis of a traditional romantic comedy. "I have this adverse reaction to Hollywood romances. They've been very damaging to me growing up," Kaufman told journalist Charlie Rose in 2004. "I thought, well, real life is more interesting, and maybe I should try to explore

that and not put more damaging stuff in the world." In keeping with the goal of realism, Gondry shot most of the playful visual tricks as practical effects without the use of green screen or computers. When Joel encounters himself inside his own head, Jim Carrey ran back and forth across the room off camera to create the illusion of two of him. Some of Carrey's real childhood memories also found their way into the movie, such as the disturbing scene when bullies force young Joel to smash a dead bird with a hammer.

As in *A Clockwork Orange* (1971), the science-fiction angle of *Eternal Sunshine* dwells deep in the subtext and is never fully explained. Clementine and Joel both have all

Top: Clementine
and Joel take a bath in the
kitchen sink.

Bottom left: Jim Carrey
and Kate Winslet

Bottom right:
Mark Ruffalo (seated),
Jim Carrey, director Michel
Gondry, Elijah Wood,
and Kirsten Dunst
on the set

Kate Winslet
and Jim Carrey

traces of each other erased by Lacuna, Inc., a low-rent medical facility that has devised a method of selectively obliterating memories of a person or event from the brain. "Technically speaking, the procedure is brain damage, but it's on par with a night of heavy drinking. Nothing you'll miss," Dr. Mierzwiak (surely the screen's most laid-back mad scientist) casually explains to Joel. Lacuna's young, fun-loving employees, played by Kirsten Dunst, Mark Ruffalo, and Elijah Wood, don't exactly instill patients with confidence as they let their own romantic dramas interfere with the high-tech procedures they perform.

After Joel takes a special pill that, according to Kaufman, "knocks you out but keeps your brain activity going," he's wired to a machine that zaps his ex-girlfriend from his mind. Though the science may be fictional, the movie accurately depicts how memories form and the power they hold over us. Following the procedure, the lovers retain emotional connections with their memories that have been eliminated, which is how they know to meet each other in Montauk, and why Clementine senses something is awry with her new boyfriend, Patrick. When they

hear the audio tapes of their memories at the end, as Gondry observed, "It's like a time-travel machine." Since they don't remember having lived them, discovering their lost memories is akin to an eerie glimpse of an alternate reality.

Described by *Los Angeles Times* critic Kenneth Turan as "the bastard child of Philip K. Dick and *It's a Wonderful Life*," *Eternal Sunshine of the Spotless Mind* earned Kaufman an Academy Award for Best Original Story. The offbeat tale flirts with a host of heady concepts, including destiny, the futility of trying to hold on to the past, and the nature of reality and remembrance. "There's no objective reality as far as I'm concerned,"

FAR-OUT FACTS

The snow on the beach, the frozen-solid Charles River, and all of the film's wintry backdrops were fortuitously provided by nature. Though the script was originally written with snow and ice scenes, they would have been changed if the weather hadn't cooperated.

Typical of Michel Gondry's spontaneity, the scene in which Joel and Clementine watch elephants at a circus parade was completely unplanned. When Gondry heard that the circus was coming to town while they were shooting in New York, he packed up the cast and crew and instructed the actors to improvise a new scene at the parade.

MIND-BLOWING MOMENT

During the memory-erasing process, Joel decides he can't bear to lose his memories of Clementine, so he tries to hide her in the depths of buried childhood events. He revisits moments when he was a small boy hiding under the kitchen table and being bathed in the sink—effects that were achieved by building enormous slanted sets in forced perspective.

Kaufman has said. "There's only what takes place in your brain. My brain. We have our perceptions, and that's all we have." In the first draft of the script, it was explained that Joel and Clementine met and erased each other several times throughout their lives. Keeping the relationship perpetually fresh, they continue to fight, erase their memories, and meet all over again to experience the rapture of new love. Ultimately, their bond cannot be obliterated even by the systematic destruction of their brain cells. With wit, whimsy, and emotional authenticity, Kaufman and Gondry pit love against science, and love wins out.

KEEP WATCHING

WAKING LIFE (2001)
SAFETY NOT GUARANTEED (2012)

2008

DIRECTOR: ANDREW STANTON PRODUCER: JIM MORRIS SCREENPLAY: ANDREW STANTON AND JIM REARDON, BASED ON AN ORIGINAL STORY BY ANDREW STANTON AND PETE DOCTER STARRING: BEN BURTT (WALL-E/M-O/ROBOTS), ELISSA KNIGHT (EVE), JEFF GARLIN (CAPTAIN MCCREA), FRED WILLARD (SHELBY FORTHRIGHT), JOHN RATZENBERGER (JOHN), KATHY NAJIMY (MARY), SIGOURNEY WEAVER (SHIP'S COMPUTER)

WALL-E

PIXAR/WALT DISNEY • COLOR, 98 MINUTES

On an abandoned, ecologically destroyed Earth of the future, a janitorial robot falls in love with a high-tech probe droid.

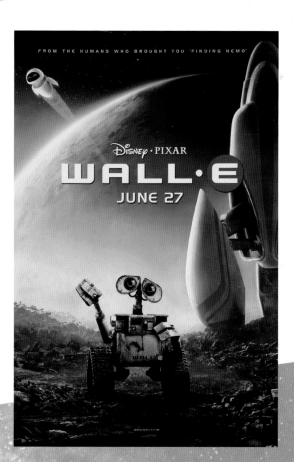

MUST-SEE SCI-FI

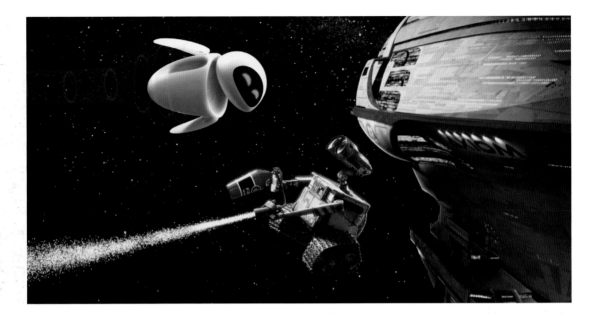

Walt Disney subsidiary Pixar kicked off a winning streak of cream-of-the-crop animated features with *Toy Story* in 1995. After the overwhelming success of the studio's Oscar-winning *Finding Nemo* in 2003, director Andrew Stanton decided to aim his talents at the genre of science fiction with *WALL-E*, an exquisitely rendered futuristic love story that touches on an array of topical themes without moralizing, allowing its engaging robotic characters to drive the vibrant, hope-filled plot forward.

WALL-E, who slightly resembles a mechanical E.T., is the last functioning Waste Allocation Load Lifter–Earth Class on the planet. He has a fondness for collecting junk, and for the movie musical *Hello, Dolly!* (1969) in the form of a sturdy Betamax tape that has survived for centuries. After 700 years of cleaning up the polluted Earth, WALL-E has developed enough sentience to ponder his lonely existence. In the words of director and cowriter Stanton, "If you're doing the same thing day in and day out, year after year, at some point you have to just start asking the question, 'Is there more to life than what I'm doing?'" Without uttering a word, WALL-E conveys a palpable melancholy, a sadness all the more touching because his character is not human, and not as aware of his tragic situation as we are as we watch him stack his neatly compacted squares of rubbish into towering skyscrapers. When each day's work is done, he feeds his pet cockroach a Twinkie, folds down into a box, and rocks himself to sleep.

Stanton, who came up with the premise, first began developing the project in 1994 under the title *Trash Planet*. What eventually emerged was a dystopic romance starring two polar opposites. WALL-E, as executive producer

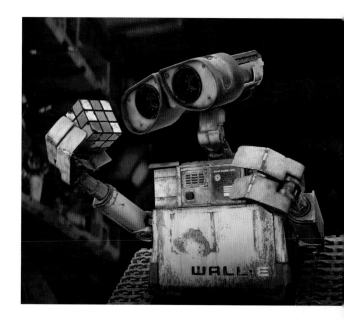

John Lasseter explained, "is ground-based. He is heavy. He's this dirty little bulldozer. Then here's this light, beautiful, airy angel. They are from two worlds." Two worlds collide when the slick, egg-shaped EVE (Extraterrestrial Vegetation Evaluator) probe is sent to WALL-E's city from the *Axiom* ship in deep space, where the evacuated human race lives in cruise-ship comfort. WALL-E has only seen broken-down remnants of the planet's former glory until he lays eyes on this gliding, hovering fembot, designed by Pixar's animators to be everything that WALL-E is not: WALL-E is a square (a traditionally masculine shape) from the rocky, dusty, unpredictable Earth, and EVE is a feminine circle from a polished, ultra-hygienic, fully automated spaceship. When the two meet, as in *Eternal Sunshine of the Spotless Mind* (2004), the irrational force of love conquers science and technology. Despite what computer programs compel the robots to do, their feelings are strong enough to override the systems.

The scene where WALL-E and EVE float in deep space is akin to a mini–dance number, he advancing toward her by spraying a fire extinguisher, she zooming, circling back, until at last they meet and kiss, then crisscross among the stars in a wordless expression of joy. In addition to their feelings for each other, WALL-E and EVE discover a ray of hope for the barren Earth—a single little plant growing in an old boot.

WALL-E is a rarity: a feature-length film with a main character who doesn't speak. (The filmmakers watched practically every silent film Charlie Chaplin and Buster Keaton made while plotting the tale.) WALL-E's minimal noises—and most other sounds in the film— are courtesy of Ben Burtt, the man who created R2-D2's tones for the *Star Wars* trilogy. "One of the things I loved most about *Star Wars* was R2-D2 and how much personality this little robot had, without a face and with just sounds," John Lasseter said. "It was so appealing. It reinforced my feeling that great animation, great characters, don't necessarily come from the dialogue or the voice alone." The charming bleeps are enriched with splashy, nostalgic songs from *Hello, Dolly!* and a note-perfect original score

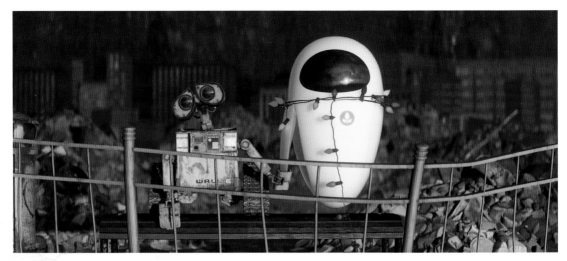

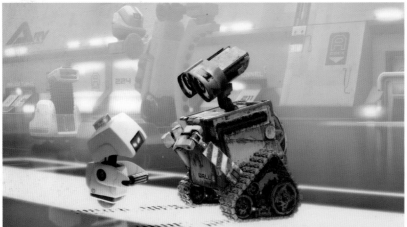

Top: WALL-E and EVE watch the sunset together.

Center: M-O (the Microbe-Obliterator) attempts to clean WALL-E

Bottom: AUTO, Captain McCrea, and EVE aboard the *Axiom*

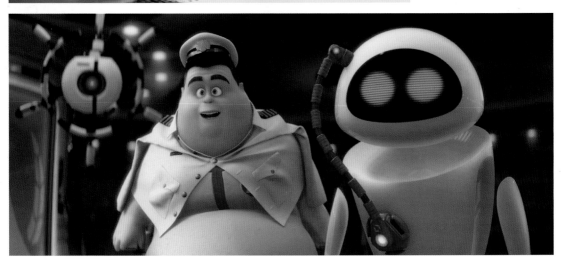

from Thomas Newman. The film also contains shadows of *Silent Running* (1972) and direct nods to *2001: A Space Odyssey* (1968) and the *Alien* franchise (with Sigourney Weaver as the voice of the *Axiom*'s computer).

Punctuating the romance, music, and sci-fi references are nibbles of biting satire. *WALL-E* takes subtle jabs at technology, consumerism, pollution, obesity, and corporate domination, but rarely has a film with so many layers of social critique been so easy to digest. There's no cruelty in its criticism; rather, it treats all its characters—down to the tiniest cockroach—with love and respect. "To be honest," Stanton later revealed, "I didn't have any agenda." His observations about the future of humanity, whether flattering or not, are inherent to the story, not forced upon the audience as moral messages. Audiences ate it up. The film was an enormous hit, and won a Golden Globe, a Saturn, a Hugo, and an Oscar for Best Animated Feature.

KEEP WATCHING

NAUSICAÄ OF THE VALLEY OF THE WIND (1984)
9 (2009)

FAR-OUT FACTS

A self-proclaimed "sci-fi geek," Stanton wanted Sigourney Weaver to be a part of the project from the beginning because, as he put it, "She's the queen of sci-fi."

The gelatinous physical condition of the ship's passengers was based on scientific information from NASA. Due to microgravity and inactivity, their muscles have atrophied—or as production designer Ralph Eggleston said, "They've all been couch-potatoed to death."

MIND-BLOWING MOMENT

When Captain McCrea attempts to return to Earth, AUTO reveals his true colors in a mechanized mutiny that brings back memories of HAL's takeover in *2001*. "All communications are terminated. You are confined to quarters," AUTO commands in his computerized voice, which was generated by the MacInTalk speech synthesis system.

2009

DIRECTOR: NEILL BLOMKAMP PRODUCERS: PETER JACKSON AND CAROLYNNE CUNNINGHAM SCREENPLAY: NEILL BLOMKAMP AND TERRI TATCHELL STARRING: SHARLTO COPLEY (WIKUS VAN DE MERWE), JASON COPE (CHRISTOPHER JOHNSON/GREY BRADNAM), DAVID JAMES (COLONEL KOOBUS VENTER), VANESSA HAYWOOD (TANIA SMIT-VAN DE MERWE), MANDLA GADUKA (FUNDISWA MHLANGA), EUGENE KHUMBANYIWA (OBESANDJO)

District 9

TRISTAR • COLOR, 112 MINUTES

A South African bureaucrat forms an uneasy relationship with a race of insectlike aliens forced into a squalid containment zone.

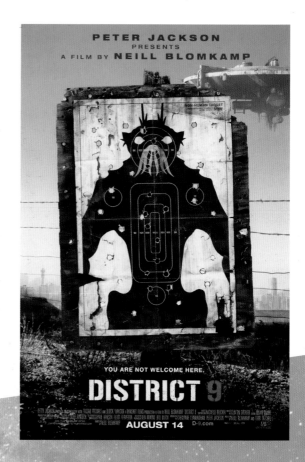

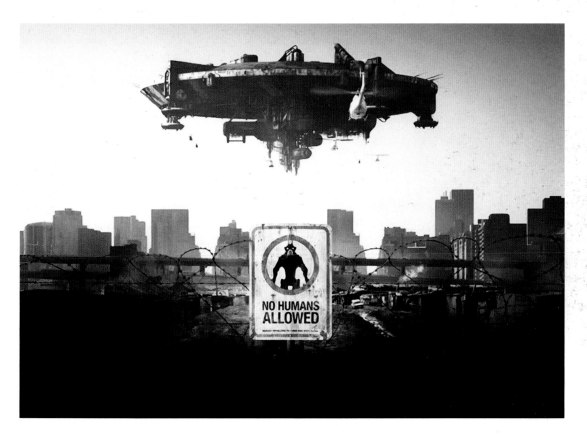

NO HUMANS ALLOWED

With his first feature film, director Neill Blomkamp brought a staggering realism to science fiction by presenting an alien invasion in the guise of a found-footage mockumentary. Smart, abrasive, and laced with satirical humor, *District 9* is an in-your-face assault on xenophobia set in a filthy, violent ghetto in Johannesburg, South Africa. When the giant mother ship arrives and hovers ominously in the polluted air, its stranded space travelers are forced by the government into an encampment that soon becomes rife with gangsters, weapons, and underworld dealings (an aesthetic described by Blomkamp as "bad *Star Wars*").

The tale is told in a series of interviews and vignettes seemingly captured on tape like a news or reality program, grounding the unbelievable in a hard-edged reality that's almost too believable for comfort.

Blomkamp, a native of Johannesburg, first visited the concept in his 2006 short film *Alive in Joburg*, a six-minute prototype of *District 9* that grew out of his desire to see "Western science fiction placed in southern Africa," he said in 2009. Based on the strength of his short, Blomkamp managed to get *Lord of the Rings* director Peter Jackson to produce the feature version scripted by Blomkamp and his wife, Terri Tatchell. Like Jack Arnold's *It Came*

Page 255: The District 9
internment camp

Top: Sharlto Copley
as Wikus van de Merwe

Center: Neill Blomkamp on
the set with Sharlto Copley

Bottom: The alien
Christopher Johnson

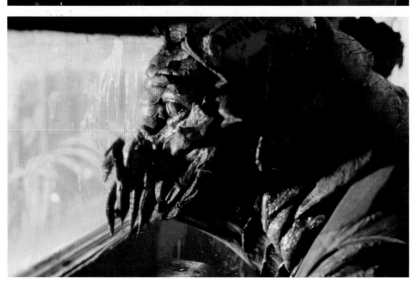

from Outer Space (1953) and the 1988 film *Alien Nation*, *District 9* uses the sci-fi premise of aliens landing on Earth to question the way our civilization sometimes behaves toward minority groups and the underprivileged. It can be viewed as a direct metaphor for District Six—a notorious Cape Town residential area whose population was forcibly evicted during the 1960s under the apartheid regime—or as a criticism of "segregation and xenophobia in general," Blomkamp has said.

Derogatorily referred to as "prawns" because of their bottom-feeder behavior and clawed, crustacean-like appearance, the aliens in the film are sophisticated CGI creations that blend seamlessly into their gritty environment. Through their squidlike mouths, they speak a language of guttural clicks. They're ugly, smelly, and repulsive to humans, and their cuisine of choice is canned cat food. Though the sharpest of the aliens—a male given the hilariously inappropriate name of Christopher Johnson—and his son may be sympathetic, even likable, the prawns as a species are undeniably disgusting, and that's the idea. Nobody wants them in their neighborhood or on this planet; they don't want to be here, either. They just want to repair their ship and travel back home. The prawns have managed to build and operate a complex vessel capable of interplanetary travel, and are, in fact, light-years ahead of humans in their technology, making it seem all the more unfair that they're treated like vermin on Earth.

As smug bureaucrat Wikus van de Merwe, Sharlto Copley gives an intense performance, most of which was improvised by the actor to heighten the sense of urgency and realism in his incredible character arc. When Wikus is accidentally exposed to a fluid that mixes his DNA with that of the aliens, he undergoes a gut-wrenching transformation that recalls the mutation in *The Fly* (1986). But unlike the ill-fated inventor in *The Fly*, Wikus is instantly abandoned by his company, his wife, and everyone in his life when he begins to mutate. Yet his metamorphosis leads to his unlikely redemption. "As he becomes more alien," Blomkamp has observed, "he kind of becomes more human." In the final action sequence, armed with a robotic "exosuit" that looks like the child of a Transformer and ED-209 from *RoboCop* (1987), former uptight office worker Wikus has become a full-fledged sci-fi hero.

FAR-OUT FACTS

Leading man Sharlto Copley was not a professional actor, but a high school friend of Neill Blomkamp who made his film debut in *Alive in Joburg*.

Instead of acting with a stick waved in front of a green screen, Copley performed his scenes with actor Jason Cope playing the part of Christopher. In post-production, Cope was erased from the shots and the alien was painted in.

Neill Blomkamp was first inspired to make a sci-fi movie when he saw *Jurassic Park* (1993) at age thirteen.

MIND-BLOWING MOMENT

Wikus, injured in a raid on District 9, is having his hand examined by a doctor. When the bloody bandage is removed, to Wikus's horror and dismay, a large black lobster claw is revealed. At this point, the film takes on a new dimension of "body horror," a subplot about a man falling apart and restructuring into another being.

Shot on location in an actual shanty township in Johannesburg, the sci-fi/horror/mockumentary affects a distinct tone. Its novel mix of the raw and the ridiculous is evident during the scene in which Wikus hands the seven-foot-tall green monster a clipboard and pen, telling him, "We require your scrawl on this eviction notification," and the signs posted on chain-link fences reading "No non-human loitering." A deeply critical film with an undercurrent of optimism, *District 9* presents a harrowingly close-to-reality scenario of alien-human interaction rarely matched in a century's worth of science-fiction movies. In 2010, it became the first documentary-style film to receive an Academy Award nomination for Best Picture (along with three others for Writing, Visual Effects, and Editing), and one of only a handful of sci-fi titles to earn that distinction.

KEEP WATCHING

ALIEN NATION (1988)
ELYSIUM (2013)

DIRECTOR: DENIS VILLENEUVE PRODUCERS: SHAWN LEVY, DAN LEVINE, AARON RYDER, DAVID LINDE SCREENPLAY: ERIC HEISSERER, BASED ON A STORY BY TED CHIANG STARRING: AMY ADAMS (LOUISE BANKS), JEREMY RENNER (IAN DONNELLY), FOREST WHITAKER (COLONEL WEBER), MICHAEL STUHLBARG (AGENT HALPERN), MARK O'BRIEN (CAPTAIN MARKS), TZI MA (GENERAL SHANG)

Arrival

PARAMOUNT • COLOR, 116 MINUTES

Following a mass
arrival of alien ships,
an expert linguist
is hired by the military
to communicate
with the extraterrestrials
and discover their
intentions.

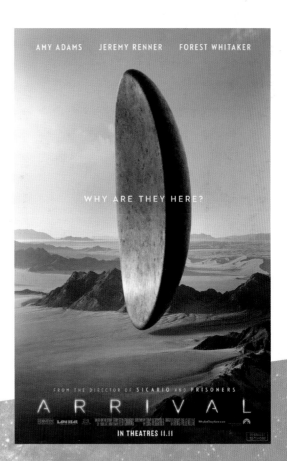

AMY ADAMS JEREMY RENNER FOREST WHITAKER

WHY ARE THEY HERE?

FROM THE DIRECTOR OF SICARIO AND PRISONERS

ARRIVAL

IN THEATRES 11.11

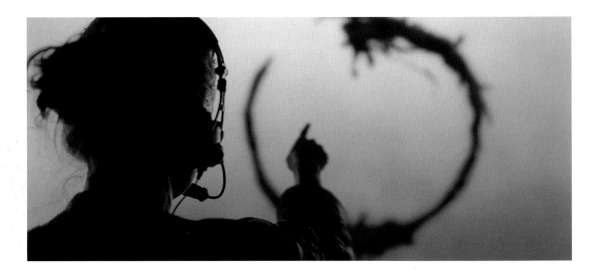

"If you could see your whole life from the start to finish, would you change things?" asks Amy Adams as linguist Dr. Louise Banks in *Arrival*. Offered flashes of the future by extraterrestrial visitors with a nonlinear view of time (and a circle-based written language that reflects this view), Louise courageously decides to embrace life in all its shades of darkness and light. With patience and subtlety, director Denis Villeneuve begins *Arrival* with the well-worn scenario of the world panicking as aliens land, only to take a detour down a less-traveled side road, transitioning into a story about a woman who has a transcendent life experience, thanks to a close encounter with an advanced species.

Québécois filmmaker Villeneuve had long searched for a science-fiction script that didn't follow the expected conventions. "I was dreaming to do sci-fi, I'm not joking, since I was twelve years old," Villeneuve told a reporter in 2016. "I was raised with it, but I was hoping to find the right story to tell, because it's a difficult genre and there's a lot of clichés, a lot of tropes."

Eric Heisserer's screenplay (based on the 1998 short story "Story of Your Life" by Ted Chiang) challenges sci-fi audiences to think a bit, to follow a linguist's learning curve as she deciphers a complicated alien tongue. Working closely with Villeneuve, Heisserer shaped the literary source material in a more cinematic direction, adding a backdrop of geopolitical tension but keeping the core ideas intact. Initially, the project was rejected by several studio executives who feared the story was too cerebral for the mainstream crowd. As Heisserer recalled in 2016, "Some of the notes we got way early were, 'We're not going to buy the film unless you change the lead to a man,' or 'You need to get rid of all the flashbacks' or 'You need to have someone punch an alien at the end of it.'"

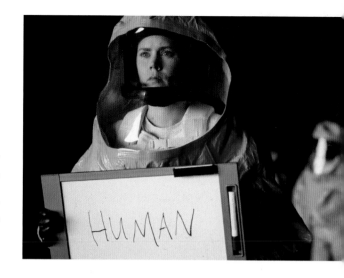

Left: Amy Adams deciphers the heptapod language.

Right: Amy Adams

Heisserer and Villeneuve stuck to their guns, resulting in a very internal type of science-fiction film, rife with "silent moments full of breath and full of awe and full of wonder," as Amy Adams has said. Like its soft-spoken heroine, *Arrival* functions on a quiet, thoughtful plane as it slowly collects shards of information and pulls them together into a complete picture. Each piece of the film's puzzle was conceived to be unique. The two visitors—called heptapods because of their seven legs (and nicknamed Abbott and Costello)—don't closely resemble any previous movie aliens, nor do the mysterious vessels that transport them recall typical Hollywood spaceships. Instead, the stone "shells" look like almonds sliced in half. Even the technology Louise and her partner, Ian (played by Jeremy Renner), use to communicate with the aliens is streamlined and powerful in its simplicity: They write on whiteboards with markers. The shot of Adams in an orange hazmat suit holding a board that reads HUMAN is an arresting image that implies some of the film's unspoken questions: What does it mean to be human? How do we as a species define ourselves? How are we defined by nonhumans? Gradually, the tale reveals itself to be not a standard alien invasion, but a movie with a much broader scope encompassing timely messages about communication, understanding, and cooperation.

The heptapods' mystifying language does more than just express thoughts. "If you learn it, when you really learn it, you begin to perceive time the way that they do," Louise says. "So you can see what's to come." Because of this gift, she foresees that her marriage will fracture over her decision to allow a painful experience to unfold before her instead of avoiding it. But, although Louise knows the outcome will be tragic, she affirms her life by proceeding as if she doesn't know. Here, the film illustrates the paradox inherent in human existence: We are aware that life will someday end, yet we still try to experience it without thoughts of our impending death weighing us down. We know what the future holds, but we choose to focus on the present.

Top: Amy Adams and
Jeremy Renner

Bottom left: Director
Denis Villeneuve

Bottom right: Amy Adams
as Louise Banks

Arrival, along with movies such as Alfonso Cuarón's *Gravity* (2013) and Christopher Nolan's *Interstellar* (2014), fits into a trend the *Washington Post* referred to in 2016 as "a mini–golden age of sci-fi films," a new wave of more mature, introspective blockbusters that use sci-fi to reflect on the human condition, rather than delivering the instant gratification of blowing aliens to smithereens with heavy artillery. *Arrival* provides nourishment for the brain and the heart, while also branching out into notions about destiny, personal choice, and free will.

The film received eight Academy Award nominations, including Best Picture (though it only took home one statue, for Best Sound Editing) and won the Ray Bradbury Award for Outstanding Dramatic Presentation in 2017. Named "science fiction's brave new hope" by *Wired* magazine in 2017, Villeneuve followed *Arrival* with *Blade Runner 2049* (2017) and plans for a reboot of Frank Herbert's sci-fi saga *Dune*.

KEEP WATCHING

GRAVITY (2013)
INTERSTELLAR (2014)

FAR-OUT FACTS

Artist Martine Bertrand designed and illustrated the distinctive, eye-catching "logograms" of the written heptapod language by painting with ink on paper. One hundred unique ink-splattered rings were created for the film.

Squids, octopi, and other undersea beasts inspired the physical appearance of the heptapods, while the noises they emit are based on the cries of whales. Composer Jóhann Jóhannsson echoed this by incorporating whalelike sounds into his haunting score.

MIND-BLOWING MOMENT

By flashing-forward, Louise sees herself at a banquet in the future, receiving an important message from Chinese leader General Shang that drastically alters the outcome of the present-day alien conflict. In Mandarin, Shang whispers to Louise his wife's dying words—which Eric Heisserer later revealed to be: "In war there are no winners, only widows."

BIBLIOGRAPHY

In addition to the sources listed, information came from production files, press books, clippings, and studio publicity notes held at the Academy of Motion Pictures Arts and Sciences' Margaret Herrick Library, and from clippings and production notes in the personal collection of Matt Tunia.

Books

Agel, Jerome, ed. *The Making of Kubrick's 2001*. New York: New American Library, 1970.

Baxter, John. *Science Fiction in the Cinema*. New York: A.S. Barnes & Co., 1970.

———. *Stanley Kubrick: A Biography*. New York: Carroll & Graf, 1997.

Bogdanovich, Peter. *Who the Devil Made It*. New York: Ballantine Books, 1997.

Bradbury, Ray. *Conversations with Ray Bradbury*. Edited by Steven L. Aggelis. Jackson: University Press of Mississippi, 2004.

Burgess, Anthony. *A Clockwork Orange*. New York: W.W. Norton & Co., 1963.

Christie, Ian, ed. *Gilliam on Gilliam*. London: Faber and Faber, 1999.

Ciment, Michael. *Conversations with Losey*. London: Methuen, 1985.

Clarke, Arthur C. *The Lost Worlds of 2001*. New York: Signet Classics, 1972.

Curtis, James. *William Cameron Menzies: The Shape of Films to Come.* New York: Pantheon, 2015.

Darke, Chris. *Alphaville*. Urbana and Chicago: University of Illinois Press, 2005.

Douglas, Kirk. *The Ragman's Son: An Autobiography*. New York: Simon & Schuster, 1988.

Eagan, Daniel. *America's Film Legacy: The Authoritative Guide to the Landmark Movies in the National Film Registry*. New York: Continuum International Publishing Group, 2010.

Finney, Jack. *Invasion of the Body Snatchers: A Novel*. New York: Simon & Schuster, 1954.

Fischer, Dennis. *Science Fiction Film Directors 1895–1998*. Jefferson, N.C.: McFarland & Co., 2000.

Fonda, Jane. *My Life So Far*. New York: Random House, 2005.

French, Sean. *The Terminator*. London: BFI, 1996.

Hardy, Phil, ed. *The Overlook Film Encyclopedia: Science Fiction*. Woodstock, N.Y.: The Overlook Press, 1995.

Harrison, Stephanie, ed. *Adaptations: From Short Story to Big Screen*. New York: Three Rivers Press, 2005.

Hauser, Tim. *The Art of WALL-E*. San Francisco: Chronicle Books, 2008.

Hirsch, Foster. *Joseph Losey*. Boston: Twayne, 1980.

Johnson, John. *Cheap Tricks and Class Acts: Special Effects, Makeup, and Stunts from the Films of the Fantastic Fifties*. Jefferson. N.C.: McFarland & Co., 1996.

Kael, Pauline. *The Age of Movies: Selected Writings of Pauline Kael*. Edited by Sanford Schwartz. New York: Penguin, 2011.

Lampley, Jonathan Malcolm. *Women in the Horror Films of Vincent Price*. Jefferson. N.C.: McFarland & Co., 2011.

Lax, Eric. *Conversations with Woody Allen*. New York: Alfred A. Knopf, 2007.

Mason, James. *Before I Forget*. London: Hamish Hamilton, 1981.

Mathews, Jack. *The Battle of Brazil*. New York: Crown, 1987.

McCarthy, Kevin. *"They're Here . . ." Invasion of the Body Snatchers: A Tribute*. Edited by Ed Gorman. New York: Berkley, 1999.

Minden, Michael. *Fritz Lang's Metropolis: Cinematic Visions of Technology and Fear*. Edited by Holger Bachmann. Rochester, N.Y.: Camden House, 2000.

Nollen, Scott Allen. *Boris Karloff: A Critical Account of His Screen, Stage, Radio, Television, and Recording Work*. Jefferson, N.C.: McFarland & Co., 1991.

Phillips, Gene D., ed. *Stanley Kubrick Interviews*. Jackson: University Press of Mississippi, 2001.

Rickman, Gregg, ed. *The Science Fiction Film Reader*. New York: Limelight Editions, 2004.

Russo, Joe, and Larry Landsman, with Edward Gross. *Planet of the Apes Revisited: The Behind-the-Scenes Story of the Classic Science Fiction Saga*. New York: Thomas Dunne Books, 2001.

Salewicz, Chris. *George Lucas Close Up: The Making of His Movies*. New York: Thunder's Mouth Press, 1998.

Sammon, Paul M. *Future Noir: The Making of Blade Runner*. New York: HarperPrism, 1996.

Skal, David J. *Screams of Reason: Mad Science and Modern Culture*. New York: W.W. Norton & Co., 1998.

Solomon, Matthew, ed. *Fantastic Voyages of the Cinematic Imagination: Georges Méliès's Trip to the Moon*. Albany: State University of New York Press, 2011.

Weaver, Tom, Michael Brunas, and John Brunas. *Universal Horrors: The Studio's Classic Films, 1931–1946*. Jefferson, N.C.: McFarland & Co., 2007.

Welch, Raquel. *Raquel: Beyond the Cleavage*. New York: Raquel Welch Productions, 2010.

Wells, H. G. *The Time Machine*. New York: Henry Holt & Co., 1895.

———. *The Island of Dr. Moreau*. New York: Bantam, 1994.

Willis, Donald, ed. *Variety's Complete Science Fiction Reviews*. New York and London: Garland Publishing, 1985.

York, Michael. *Accidentally on Purpose: An Autobiography*. New York: Simon & Schuster, 1991.

Articles

"32 Top-Budget Films Brighten RKO '51 Horizon." *Independent Exhibitors Film Bulletin*, December 18, 1950.

"Also Ran." *Time*, July 26, 1976.

Ardagh, John. "Godard—France's Brilliant Misfit." *Los Angeles Times*, April 17, 1966.

Boutilier, James G. "Alien Anniversary." N.p., n.d.

Brody, Richard. "Martin Scorsese on 'Hugo.'" *The New Yorker*, December 15, 2011.

Broesky, Pat H. "Happy Tenth, 'Star Wars.'" *Los Angeles Times*, May 23, 1987.

Caulfield, Deborah. "Sigourney Weaver: Just Call Me Rambolina.'" *Los Angeles Times*, July 13, 1986.

Champlin, Charles. "'Space Odyssey' at Warner Cinerama." *Los Angeles Times*, April 5, 1968.

———. "'Star Wars' Hails the Once and Future Space Western." *Los Angeles Times*, May 22, 1977.

Douhaire, Samuel, and Annick Rivoire. "Rare Marker: An Interview." Accompanying booklet for DVD release of *La jetée/Sans soleil*. The Criterion Collection, 2007.

Elliott, David. "Hype-o-saurus: It's a Monster of a Movie." *Night & Day*, June 10, 1993.

Epstein, Andrew. "Melinda [sic] Mathison: The Hands of 'E.T.'" *Los Angeles Times*, July 24, 1982.

"Film 'War of Worlds.'" *The Film Daily*, June 20, 1926.

Friend, Tim. "Dinosaur Had 'to Move with an Attitude.'" *USA Today*, June 11–13, 1993.

Grant, Lee. "Lucas: Feet on Ground, Head in the Stars." *Los Angeles Times*, December 10, 1977.

Higgins, Bill. "In 1979, Scott's 'Alien' Brought Screams to Space." *The Hollywood Reporter*, May 10, 2017.

Hornaday, Ann. "Sleek, Sophisticated, and Thoughtful 'Arrival' Joins a Mini-Golden Age of Sci-Fi Films." *Washington Post*, November 10, 2016.

Hyams, Joe. "Yvette Steals the Show: A Year Ago She Was on Our Cover. Now Look at the Girl . . ." *Los Angeles Times*, December 6, 1959.

Kart, Larry. "Harrison Ford Revives Image of Classic Hero." *Los Angeles Daily News*, June 25, 1982.

Kaufman, Debra. "T-Rex Effects." *The Hollywood Reporter*, N.d.

Knoedelseder Jr., William K. "'*Alien*'s Sigourney Weaver: The Hero Is a Woman." *Los Angeles Times*, June 4, 1979.

Kurosawa, Akira. "Tarkovsky and *Solaris*." Accompanying booklet for the DVD release of *Solaris*. The Criterion Collection, 2011.

Lee, Felicia R. "At Home with Joe Morton; All Ten Toes on the Ground." *New York Times*, May 18, 1995.

Mank, Gregory. "Mae Clarke Remembers James Whale." *Films in Review*, May 1985.

Mann, Roderick. "'Blade' Director Keen on L.A." *Los Angeles Times*, July 1, 1982.

Moore, Lee. "Alien Invades U.S.A." *Circus Weekly*, N.d.

Nathan, Ian. "Empathy Test." *Empire*, August 2007.

Pollock, Dale. "'Brother' Director Is an Alien to Hollywood." *Los Angeles Times*, October 20, 1984.

Rosenfield, Paul. "Lucas: Film-Maker with the Force." *Los Angeles Times*, June 5, 1977.

Rosenthal, Lee. "The Empire Talks Back." *Details*, February 1997.

Ryfle, Steve. "Godzilla's Footprint." Accompanying booklet for DVD release of *Gojira*, Toho Co., Ltd., 2006.

Schallert, Edwin. "Flying Finns Proposed; Maxwell, Cooper Roles; Metro into Space." *Los Angeles Times*, July 21, 1954.

———. "Wanger Sets Headliner; 'Wheel' Plans Arranged; Morgan, Randell in Deals." *Los Angeles Times*, December 23, 1954.

Scheuer, Philip K. "Eerie Cinema Proffered: 'Isle of Lost Souls' Screened at Paramount, with Laughton and Arlen in Leading Roles." *Los Angeles Times*, January 10, 1933.

———. "Seeing His Worst Film After Ten Years Assures Michael Rennie Part as Jean Valjean Is His Best." *Los Angeles Times*, November 18, 1951.

———. "Wail of Tortured Electrons Provides Eerie Film Score." *Los Angeles Times*, February 26, 1956.

———. "Submarines in Blood Stream!" *Los Angeles Times*, March 14, 1965.

Scott, John L. "Director Walks on Ocean Floor to Film 'Leagues.'" *Los Angeles Times*, December 12, 1954.

"Some Universal Films of Today." *Motion Picture Herald*, February 6, 1932.

"Star Wars: The Year's Best Movie." *Time*, May 30, 1977.

Thomas, Kevin. "Technology's Impact on Society Woven into 'Silent Running.'" *Los Angeles Times*, March 14, 1971.

Thompson, Howard. "The Screen: Hair-Raiser: 'The Fly' Is New Bill at Local Theatres." *New York Times*, August 30, 1958.

Toscas, George. "Director Doug Trumbull Provides Some Insight into His First Picture, 'Silent Running.'" *International Photographer*, June 1972.

Turan, Kenneth. "Blade Runner II." *Los Angeles Times Magazine*. September 13, 1992.

Warga, Wayne. "Holography Makes Screen Debut in 'Logan's Run.'" *Los Angeles Times*, September 21, 1975.

Wuntch, Philip. "Unusual Cycle of Logan's Run." *Dallas Morning News*, May 28, 1975.

———. "Straight Weller: Actor Calls 'RoboCop' a Beauty of a Story that Was a Beast to Film." *Dallas Morning News*, July 16, 1987.

Online Articles

"15 Facts About 'The Matrix' That Will Shatter Your Reality." *IFC*. Accessed August 30, 2017. http://www.ifc.com/2014/12/15-things-you-probably-didnt-know-about-the-matrix.

"Arnold Schwarzenegger Says 'Terminator' Will 'Never Be Finished.'" *Esquire*. April 4, 2017. Accessed May 13, 2017. http://www.esquire.co.uk/culture/film/news/a14092/arnold-schwarzenegger-new-terminator-film/.

Bishop, Brian. "'Arrival' Director Denis Villeneuve on the Politics of the Year's Best Sci-Fi Film." *The Verge*, December 21, 2016. Accessed September 9, 2017. https://www.theverge.com/2016/12/21/14035620/arrival-denis-villeneuve-interview.

Bonin, Lian. "EW.com Answers Your Burning Questions about 'A.I.'" *Entertainment Weekly*, July 10, 2001. Accessed August 22, 2017. http://ew.com/article/2001/07/10/ewcom-answers-your-burning-questions-about-ai/.

Choi, Charles Q. "How 'Star Wars' Changed the World." *Space.com*, August 10, 2010. Accessed July 14, 2017. https://www.space.com/8917-star-wars-changed-world.html.

"David Bowie: Bowie at the Bijou." *Movieline*, April 1, 1992. Accessed July 9, 2017. http://movieline.com/1992/04/01/david-bowie-bowie-at-the-bijou/.

Ebert, Roger. "Sleeper." *Roger Ebert.com*, December 17, 1973. Accessed June 26, 2017. http://www.rogerebert.com/reviews/sleeper-1973.

———. "Great Movie: 'Alien.'" *Roger Ebert.com*, October 26, 2003. Accessed July 31, 2017. http://www.rogerebert.com/reviews/great-movie-alien-1979.

Hoad, Phil. "How We Made: Paul Mayersberg and Tony Richmond on 'The Man Who Fell to Earth.'" *The Guardian*, June 25, 2012. Accessed July 10, 2017. https://www.theguardian.com/culture/2012/jun/25/how-we-made-man-fell.

McGurk, Stuart. "'Blade Runner 2049' Director Denis Villeneuve Is Science Fiction's Brave New Hope." *Wired*, September 15, 2017. Accessed September 15, 2017. http://www.wired.co.uk/article/blade-runner-2049-denis-villeneuve.

Rohter, Larry. "Footage Restored to Fritz Lang's 'Metropolis.'" *New York Times*, May 4, 2010. Accessed August 22, 2017. http://www.nytimes.com/2010/05/05/movies/05metropolis.html.

Vary, Adam B. "Invasion of the Big-Brained Sci-Fi Blockbuster." *Buzzfeed*, November 10, 2016. Accessed September 9, 2017. https://www.buzzfeed.com/adambvary/invasion-of-the-big-brained-sci-fi-blockbuster.

Wolfe, Clarke. "James Cameron and Gale Anne Hurd Discuss 'The Terminator' 30 Years Later." *Nerdist*, October 20, 2014. Accessed August 1, 2017. http://nerdist.com/james-cameron-and-gale-anne-hurd-discuss-the-terminator-30-years-later/.

Video/Audio

"Amy Adams: 'Arrival' Is a Mom Telling the Story of Her Life—Close Up with THR." YouTube video, 5:09, posted by The Hollywood Reporter, November 22, 2016. https://www.youtube.com/watch?v=3CulyFD9N_0.

Anderson, Michael, and Michael York. "Audio Commentary," and "A Look into the 23rd Century." *Logan's Run*, DVD. Directed by Michael Anderson. Burbank, CA: Warner Home Video, 2004.

Behind the Planet of the Apes. Directed by David Camtois and Kevin Burns. Hollywood, Calif.: Image Entertainment, 1998. DVD.

Behlmer, Rudy. "Feature Commentary." *Frankenstein*, DVD. Directed by James Whale. Universal City, Calif.: Universal Studios, 1999.

Blomkamp, Neill. "Commentary." *District 9*, DVD. Directed by Neill Blomkamp. Culver City, Calif.: Sony Pictures Home Entertainment, 2009.

Bondarchuk, Natalya. "Interviews." Disc 2. *Solaris*, special edition DVD. Directed by Andrei Tarkovsky. The Criterion Collection, 2011.

Bowie, David, Nicolas Roeg, and Buck Henry. "Audio Commentary." Disc 1. *The Man Who Fell to Earth*, special edition DVD. Directed by Nicolas Roeg. The Criterion Collection, 2005.

"Charlie Kaufman Interview on 'Eternal Sunshine of the Spotless Mind.'" YouTube video, 17:24, posted by "FilMagicians," May 12, 2017. https://www.youtube.com/watch?v=3vhsStpeKfE.

"Creating A.I." Disc 1. *A.I. Artificial Intelligence*, special edition DVD. Directed by Steven Spielberg. Hollywood, Calif.: Paramount Home Entertainment, 2002.

Dante, Joe, Bill Warren, and Bob Burns. "Commentaries." *The War of the Worlds*, collector's edition DVD. Directed by Byron Haskin. Hollywood, Calif.: Paramount Pictures, 2005.

"Day at Night—Vincent Price." YouTube video, 28:45, from an interview televised on April 25, 1974, posted by "Vincent Price," February 26, 2014. https://www.youtube.com/watch?v=YfpUbNgr6Qc.

Fleischer, Richard, and Rudy Behlmer. "Audio Commentary." Disc 1. *20,000 Leagues Under the Sea*, special edition DVD. Directed by Richard Fleischer. Burbank, Calif.: Walt Disney Studios Home Entertainment, 2003.

Georges Méliès: Cinema Magician. Directed by Luciano Martinengo and Patrick Montgomery. Kino Video, 2011.

Gondry, Michel, and Charlie Kaufman. "Commentaries." Disc 2. *Eternal Sunshine of the Spotless Mind*, collector's edition DVD. Directed by Michel Gondry. Universal City, Calif.: Focus Features, 2004.

Harris, Jack. "Commentaries." *The Blob*, DVD. Directed by Irvin S. Yeaworth. The Criterion Collection, 2000.

Kalat, David. "Audio Commentary." *Things to Come*, DVD. Directed by William Cameron Menzies. The Criterion Collection, 2013.

"Keanu Reeves on 'The Matrix,'" YouTube video, 1:42, posted by "American Film Institute," December 12, 2008. https://www.youtube.com/watch?v=MrXCHQBINUc.

Landis, John. "Landis, Baker, and Burns." *Island of Lost Souls*, DVD. Directed by Erle C. Kenton. The Criterion Collection, 2011.

Lucas, George, and Walter Murch. "Audio Commentary." *THX 1138*, director's cut DVD. Directed by George Lucas. Burbank, Calif.: Warner Home Video, 1998.

Mank, Gregory. "Audio Commentary." *Island of Lost Souls*, DVD. Directed by Erle C. Kenton. The Criterion Collection, 2011.

McCarthy, Kevin. "Kevin McCarthy Interview." *Invasion of the Body Snatchers*, DVD. Directed by Don Siegel. Santa Monica, Calif.: Artisan Entertainment, 2002.

McDowell, Malcolm, and Nick Redman. "Commentaries." Disc 1. *A Clockwork Orange*, special edition DVD. Directed by Stanley Kubrick. Burbank, Calif.: Warner Home Video, 2007.

"Meeting Andrei Tarkovsky: Cinema Is a Mosaic Made of Time," (English subtitles), YouTube video, 53:53, posted by "FilmKunst," May 13, 2016. https://www.youtube.com/watch?v=4JRfeshEbol.

"Now You See Him: The Invisible Man Revealed." *The Invisible Man*, DVD. Directed by James Whale. Universal City, Calif.: Universal Home Entertainment, 2002.

Ryfle, Steve, and Ed Godziszewski. "Audio Commentaries." Disc 1. *Gojira*, collector's edition DVD. Directed by Ishirô Honda. Japan: Toho Co., Ltd., 2006.

Scott, Ridley. "Audio Commentary." *Alien*, 20th anniversary edition DVD. Directed by Ridley Scott. Beverly Hills, Calif.: Twentieth Century-Fox Home Entertainment, 1999.

"Siskel & Ebert Movie Review E.T. (1982) (Review #1)," YouTube video, 10:55, posted by "Gokcek Atan," June 19, 2016. https://www.youtube.com/watch?v=-JRPt2Rwc3AE.

Spielberg on Spielberg. Directed by Richard Schickel. Turner Classic Movies, 2007.

"Standing on the Shoulders of Kubrick: The Legacy of *2001*." *2001: A Space Odyssey*, special edition DVD. Directed by Stanley Kubrick. Burbank, Calif.: Warner Home Video, 2007.

Stanton, Andrew. "Audio Commentary." *WALL-E*, DVD. Directed by Andrew Stanton. Burbank, Calif.: Buena Vista Home Entertainment, 2008.

"The E.T. Reunion." Disc 1. *E.T. The Extra-Terrestrial*, anniversary edition DVD. Directed by Steven Spielberg. Universal City, Calif.: Universal Home Entertainment, 2002.

"The Making of *Close Encounters of the Third Kind*." Disc 2. *Close Encounters of the Third Kind*, collector's edition DVD. Directed by Steven Spielberg. Culver City, Calif.: Columbia/TriStar Home Entertainment, 2001.

"The Making of *Metropolis*." *Metropolis*, restored authorized edition DVD. Directed by Fritz Lang. New York: Kino Video, 2002.

"The Making of *Silent Running*." *Silent Running*, DVD. Directed by Douglas Trumbull. Universal City, Calif.: Universal Home Entertainment, 2009.

"The Matrix Revisited." Disc 2. *The Matrix*, special edition DVD. Directed by The Wachowskis. Burbank, Calif.: Warner Home Video, 2003.

"The Sky Is Falling: The Making of *The War of the Worlds*." *The War of the Worlds*, collector's edition DVD. Hollywood, Calif.: Paramount Pictures, 2005.

"The Terminator: A Retrospective," and "Other Voices." *The Terminator*, special edition DVD. Directed by James Cameron. Santa Monica, Calif.: MGM Home Entertainment, 2001.

"The Time Machine: The Journey Back." *The Time Machine*, DVD. Directed by George Pal. Santa Monica, Calif.: MGM Home Entertainment, 2000.

"Thirty Years of *Close Encounters*." *Close Encounters of the Third Kind*, 30th anniversary edition DVD. Directed by Steven Spielberg. Culver City, Calif.: Sony Pictures Home Entertainment, 2009.

Verhoeven, Paul, Ed Neumeier, and Jon Davison. "Audio Commentary" and "Flesh and Steel: The Making of *RoboCop*." Disc 1. *RoboCop*, 20th anniversary collector's edition DVD. Beverly Hills, Calif.: Twentieth Century Fox Home Entertainment, 2007.

Watch the Skies! Directed by Richard Schickel. Turner Classic Movies, 2005.

"What Is *Brazil*?" *Brazil*, DVD. Directed by Terry Gilliam. The Criterion Collection, 2006.

Wise, Robert, and Nicholas Meyer. "Audio Commentary." *The Day the Earth Stood Still*, special edition DVD. Directed by Robert Wise. Beverly Hills, Calif.: Fox Home Entertainment, 2002.

Zemeckis, Robert, and Bob Gale. "Q & A." Disc 2. *Back to the Future*, special edition DVD. Directed by Robert Zemeckis. Universal City, Calif.: Universal Home Entertainment, 2009.

Websites

www.afi.com/members/catalog

www.chrismarker.org

www.dallaslibrary2.org

www.imdb.com

www.lapl.org

www.mediahistoryproject.org

www.tcm.com

www.wikipedia.org

INDEX

ACKNOWLEDGMENTS

This book was made possible by many helpful and talented people. For his vision, generosity, and support, I am eternally thankful to Manoah Bowman, who gave me a chance to prove myself and asked nothing in return. Thanks to the legendary Roger Corman for being part of this book. I also thank Matt Tunia, David Del Valle, Camilla Jackson, Jasmine Berezich, Marc Wanamaker, and David Wills for their friendship and contributions.

Heartfelt thanks to Gary Lynn De Forest, Kathleen De Forest, Jill Watkins, Fred Damiano, and Jackie Greenfield for spotting my potential and encouraging me to write.

I am also deeply grateful to everyone at Running Press for their unwavering faith in a first-time book author. In addition to the invaluable assistance and kindness of my editor, Cindy De La Hoz, I extend my gratitude to Jason Kayser, Katie Hubbard, Kristin Kiser, Jennifer Kasius, and Seta Zink.

Many thanks to Aaron Spiegeland at Parham Santana, and to the wonderful Turner Classic Movies staff, especially John Malahy, Eileen Flanagan, Heather Margolis, Pola Changnon, Genevieve McGillicuddy, and Jennifer Dorian.

Finally, thanks to Jeremy Arnold for establishing a standard of excellence with his book, *The Essentials*. It not only served as a template for this book, but inspired me to work harder to match its superior quality.